BEYOND
CONTEMPORARY
ART

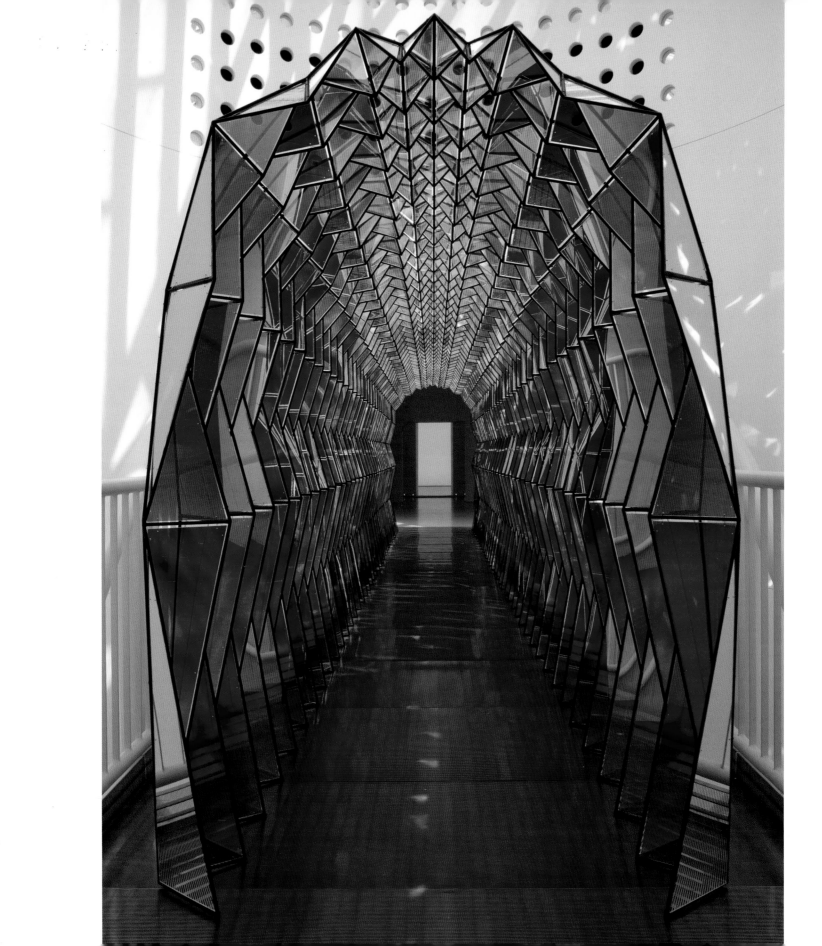

BEYOND CONTEMPORARY ART

ETAN JONATHAN ILFELD

VIVAYS PUBLISHING

To the three great women in my life: My sweetheart, Marianna, my sister, Tali, and my mom, Rachel.

Published by Vivays Publishing Ltd
www.vivays-publishing.com

Every effort has been made to ensure that the information in this
book was correct at the time of going to press, should any errors or
omissions be found please contact the publisher and we will
undertake to make such corrections, if appropriate, but without
prejudice.

A catalogue record for this book is available from the British Library.

ISBN 978-1-908126-22-1

Publishing Director: Lee Ripley
Designer: Raymonde Watkins
Frontispiece: One-way colour tunnel © Olafur Eliasson
Cover: Flight Pattern, 2008 © Aaron Koblin
Printed in China

Contents

Introduction

THIS BOOK was designed to tempt the palate of anyone who is curious about the trends that are challenging and expanding the boundaries of contemporary art. As you read through the entries in the book, or just skip around and explore, you may notice that the artists surveyed combine a diverse range of disciplines, media and genres. The main thesis is that 'contemporary art' is almost indefinable, and that contemporary artists are constantly reinventing themselves and synthesizing previously isolated fields and ideas. As such, the artists in this book are organized alphabetically rather than by unifying themes or categories. So, open your mind, hop around and enjoy!

The Current state of the art world

The contemporary art world has been transforming rapidly over the last decade, claiming new territories and assimilating novel creative practices. Tate Modern was only established in 2000 and already feels like a century-old institution, and over the last decade video game art and iPhone art apps have begun circulating, while street art has blossomed led by artists such as Banksy and Invader. The ever-expanding contemporary art sphere has become increasingly integrated into popular culture. Contemporary art's ecosystems are more networked than ever before, and world capitals continually vie for global market share. The first Frieze Art Fair was held in 2003 in London with a modest 27,000 visitors, and has since grown into an annual global affair showcasing contemporary art galleries from all over the world. In 2012 Frieze Art Fair New York was launched. Meanwhile, New York's Armory Show has also grown significantly and boasts almost $100 million in sales, and the Venice Biennale has gained a political aura akin to the United Nations with pavilions curated by various governments (the US Department of State chooses a public gallery to assign the responsibility to represent the USA for each Venice Biennale). The pretentious sensibilities of sleek corporate-sponsored art fairs are being challenged by alternative fairs and happenings ranging from the Ars Electronica Festival in Vienna, and the Kinetica Art Fair in London, which is devoted to kinetic art, to the self-reliance and community art at Burning Man, a festival during which participants gather in the Black Rock Desert to create Black Rock City, which for one week becomes the third most populated city in Nevada.

It's worth noting how important a vibrant art ecosystem is for networking and cultural interaction. From art schools, museums and fairs to galleries, artists, corporate and private collectors, the contemporary art world depends on a range of ecosystems and metropolises that are becoming increasingly globalized. As a result, successful formats are reproduced and successful blockbuster art exhibits often become travelling exhibitions that are recreated in leading museums across the globe. As such, the artist retrospectives shown at MoMA, Tate Modern, or the Centre Pompidou often reflect a homogeneously globalized

London Art Fair

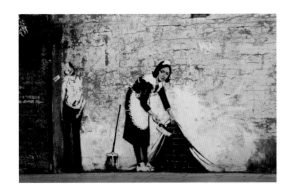

Banksy, Maid: sweeping it under the carpet, London, 2006

network. Nevertheless, a cursory glance at the names of artists exhibited in major biennials reveals that new artists are perpetually emerging and that cross-disciplinary discourse is becoming ever more prevalent.

Leading art schools such as California Institute of the Arts, Rhode Island School of Design (RISD), Goldsmiths, University of London, Central St. Martins, and Tisch School of the Arts (NYU), to name a few, are constantly introducing new disciplines and programs. In the meantime, the interdisciplinary fad in academia has given rise to new types of scholars, and also fostered better communications across departments. Academia has assimilated novel artistic practices and major art schools have begun granting PhDs in practice-based art research. At the same time, the boundaries between 'high' and 'low' art are constantly blurred, and the distinctions between critics and bloggers have disintegrated. The Young British Artists of the 90s are not as young anymore, while the Stuckist backlash denounces conceptual art and advocates a return to figurative painting. The constantly evolving legitimization and de-legitimization of various visual canons and practices is generating a perpetual theoretical crisis. One can only speculate about which art theory books will be re-read two hundred years from now.

Contemporary art has expanded to include digital painting, virtual reality and computer art. The Internet has cultivated virtual art, online art auctions for both physical and virtual goods, and web-based art fairs. The online-only VIP Art Fair was launched in 2010 and has featured some of the top galleries including Gagosian Gallery, White Cube and Hauser and Wirth. The VIP Art Fair is currently led by CEO Lisa Kennedy and the former head of sales at Artnet, Liz Parks, as the fair director, and has launched several offshoots in 2012 such as VIP Photo and VIP Paper.

The notion of scarcity value doesn't always translate well into hi-tech artwork. Whereas a painting is a one of a kind object, the code of software or digital images can be copied and reproduced with very little effort (indeed, that's one of the major reasons why the music and film industries are so wary of digital piracy). Nevertheless, akin to limited editions of photographs or artist DVDs, virtual art can also be editioned. For example, s[edition] distributes digital art – for iPhones and other digital media – produced by leading artists such as Damien Hirst, Tracey Emin, Shepard Fairey and Wim Wenders. s[edition] also maintains a centralized system of digital certificates, which keep track of the owner of each edition with the goal of creating a secondary marketplace for the digital works to be resold. At this stage it's hard to tell if s[edition] will be commercially successful, but it's certainly a radical model that is changing the perception of virtual art. Concurrently, innovatively designed apps such as Björk's *Biophilia* and Stefanie Posavec's *MyFry* are sold on iTunes while The Pirate Bay has added a 'physibles' category for printable 3D objects to be freely shared and disseminated.

Just as the virtual world has opened new spheres for exploration, the physically

interconnected urban and global village is continuously manifesting and layering alternative art practices. There has been an increased sense of democratization in art, often bypassing traditional structures. Guerrilla street art and pop-up art galleries are prevalent in almost every city. In London, The Museum of Everything has showcased a number of exhibitions featuring 'outsider art' in temporary locations such as a former dairy and a recording studio. The idea of James Brett's The Museum of Everything is to highlight the creativity involved in producing work that usually isn't recognized within the fine art markets; the artworks shown often involve incredible craftsmanship and patience. However, as The Museum of Everything has gained in popularity it has inevitably become part of the system it attempted to challenge. Today, artists such as Damien Hirst are also exhibited there, and curators are picked from the traditional art sphere. Nevertheless, Brett's museum and similar ventures across the globe illustrate how the art world is in a constant state of expansion despite its exclusive nature. Whenever a project resonates and becomes extremely popular-even if it challenges a dominant system-it will tend to become part of the system of which is was initially critical. Indeed, it is becoming harder and harder to distinguish between underground counter culture, popular culture and contemporary art.

What is contemporary art?

While the term 'contemporary art' is temporally specific to recent artistic creations, it is also deliberately obscure and all-encompassing. After all, what is 'art' and what is 'contemporary'?

Chronologically, 'contemporary' refers to present day, and 'contemporary history' is often defined as the history that has occurred during the lifetime of most living adults – approximately the last forty years. Of course, anything that happened in history was contemporary at some point in time. However, the last forty years feature a range of unique characteristics both in terms of scientific accomplishments and cultural developments. Prominent events and trends include the introduction of the Information Age, the struggle for civil liberties, the emergence of the European Union, Asian mega-cities, and increased cosmopolitanism.

The definition of art remains fluid and polemic with numerous contemporary theorists suggesting that art is completely context-dependent. In other words, anything can become a work of art if someone claims that it is an artwork (à la Duchamp's readymades). Whereas 'art' can be just about anything, the term 'contemporary' restricts it to recent events. 'Contemporary art' often harks back to the conceptual art of the 1960s, and has replaced the terms 'modern art' and 'post modern art'. Of course, any temporal boundary retains a certain fuzziness and is blurred by its inability to distinguish itself from its antecedents. Even the most erudite art

myFry, an interactive biography of Stephen Fry, 2011. Design by Stefanie Posavec.

blurred by its inability to distinguish itself from its antecedents. Even the most erudite art historian might fail to notice a switch between a Dadaist artwork and an artwork from the third millennium. Although the term 'art' insufficiently isolates itself from neighboring disciplines, the term 'contemporary' shines a much clearer lens on whether or not an art-object is 'contemporary art', or just 'art' or just 'contemporary'. Curiously, although the term 'contemporary art' has replaced 'modern art,' leading Western art institutions still employ the term 'modern art' in name (e.g. Tate Modern, the Museum of Modern Art (MoMA) etc...), but refrain from applying 'modern' to their cutting-edge exhibitions. However, it has become increasingly common since the second half of the 20th century to incorporate the term 'contemporary' into new art museums (e.g. Tokyo's Museum of Contemporary Art, founded in 1995, or the Museum of Contemporary Art in Taipei, which opened in 2001). Contemporary art practices are constantly creating new visual dialects and integrating a diverse set of art practices including performance, sculpture, architecture, painting, graffiti, design, and new media.

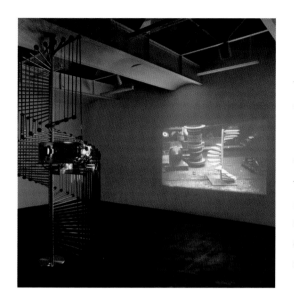

Wilhelm Noack oHG, 2006

Synthesizing the virtual and the physical

Technological advancements have championed concepts such as de-materialization, reflexivity, and digitization in contemporary art practices. While Vuk Cosic digitizes iconic films including *Star Trek* and *Psycho* into ASCII art animations, Simon Starling's *Wilhelm Noack oHG* nostalgically and reflexively projects footage from the factory that built the projector, and exemplifies conceptual aesthetics. Meanwhile, artificial intelligence, robotics and genetic engineering have also spawned innovative artworks ranging from the Aikon robot that recognizes faces and has a unique portrait style to Eduardo Kac's fluorescent rabbit-implanted with the genes of a jellyfish.

 While conceptual artists of the 60s had already incorporated elements of chance and noise into their artworks, technological advances have recently elevated the levels of computational complexity to new heights. Jeremy Wood has pioneered the act of digital drawing and mapping with satellite navigation technology by treating himself as a geodesic pencil since 2001, and tracking all of his journeys to create personal cartographies. Aaron Koblin uses software to visualize data ranging from flight patterns to crowd-sourced projects such as the *Johnny Cash Project* that enabled fans to integrate their own illustrations into an ever-evolving music video. Contemporary art has appropriated the counterculture of the 1960s with the cyberculture of the 1990s, with 'gift economies', hacking', and 'crowd sourcing' becoming commonplace. The concept of 'emergence' refers to the unforeseen patterns that arise from the reiterations of basic interactions. New technologies such as the Internet have resulted in innovative collaborations, artificial intelligence, alternative economies, and collective intelligence. Biological and environmental artists such as Natalie Jeremijenko have produced

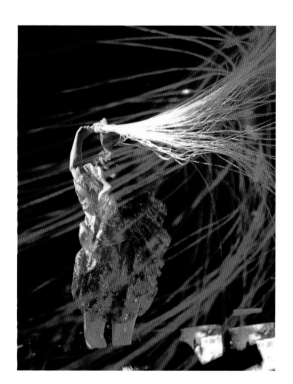

Björk performing at the Sydney Opera House, 2008

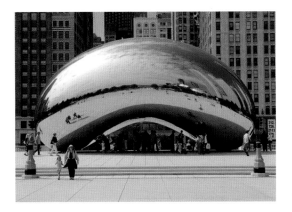

Cloud Gate, 2004, **Anish Kapoor**

Menstruation Machine, Takashi's Take, **Sputniko!**
Photographed by Rai Royal

interfaces and platforms for interspecies communication, and experiment with urban interventions that improve 'environmental health'.

Contemporary artists are increasingly working in a range of media and defying standard categorization. Artists such as Anish Kapoor, Antony Gormley, Usman Haque, Do Ho Suh, and Ai Weiwei dissolve the boundaries between sculpture, design and architecture. Just as the invention of photography created an ontological crisis for realist paintings, 3D computer modeling and printing technologies are transforming contemporary sculpture and architecture. Meanwhile, creative couples such as Matthew Barney and Björk, or Miranda July and Mike Mills cross fertilize each other's work and disintegrate traditional categories, such as film, music, sculpture and graphic design.

Experimentation and hybridization blur boundaries and challenge traditional hierarchies. With time anything becomes possible. The distinction between YouTube videos and avant-garde cinema is evaporating, and emergent forms of creative production such as machinima, which utilizes video game engines to create films, are constantly emerging. Will a computer-generated character ever win an Academy Award, or will a human ever win both the Best Actor and Best Actress Oscars, which are awarded based on the gender of the actor rather than the performed gender? Even if a sex change is necessary, radical filmmakers and artists are capable of almost anything. Performance artists such Marina Abramović, Sputniko! and Nelly Agassi continually contest the boundaries of the human body, and Turner Prize winners such as Grayson Perry illustrate that cross-dressing doesn't have to be a drag. In the meantime, celebrity artists such as Takashi Murakami have also become high-end fashion designers while anti-consumerist artists such as Lisa Anne Auerbach use DIY practices ranging from knitting political slogans on sweaters to distributing zines that promote the cycling culture. Any sphere of expression can become a contested battleground that contemporary artists can appropriate and hack, and that spectators and/or consumers can re-appropriate and re-present.

As post-conceptualism takes on consumerism and the information age, emerging practitioners will often work on advertising or fashion campaigns in their corporate day job, but moonlight on their more edgy and subversive projects. Richard Ansett exemplifies the polished photographer who has perfected his craft and become a visual storyteller who questions our notions of reality and authenticity. Filmmaker and graphic designer Mike Mills works on both big-budget media campaigns and on his own range of posters, products and indie films. Similarly, artists such as Steve McQueen have successfully launched dual careers as both contemporary artists and commercial filmmakers, while Ryoji Ikeda is an example of an artist who is critically acclaimed as both a musician and as a visual installation artist. As cross-pollination becomes the norm, the boundaries of contemporary art are constantly expanding, leading to the emergence of novel disciplines and practices.

Marina Abramović

Born 1946 in Belgrade, Serbia (former Yugoslavia)
Academy of Fine Arts, Belgrade, Serbia, 1970
Post-diploma studies, Academy of Fine Arts, Zagreb, Croatia, 1972
Lives and works in New York City, USA.

"My art professor told me that I had completely deserted art and that what I was doing was bullshit [...] My function is to be an artist. As an artist, I am free – it's a wonderful feeling – to take any tools." Marina Abramović, *Vice Magazine* (2011)

MARINA ABRAMOVIC is an internationally acclaimed performance artist whose works often probe the physical and mental limitations of the human body. Abramović's solo performances have incorporated ascetic elements such as whipping and burning herself, and self-mutilation. Her collaborations with Uwe Laysiepen (Ulay) in the 70s and 80s included breathing and exhaling each other's breath until they both passed out after seventeen minutes, and walking the Great Wall of China from opposite ends until they met each other in the middle after walking a combined total of over 5,000 kilometers.

Abramović's stamina and ability to endure pain are only surpassed by her ingenuity. In *Rhythm 5* (1974), she ritualistically cut her nails, toenails and hair and threw them into a flaming petroleum-drenched pentagram, reminiscent of the communist star; finally she leapt into the center of the star and lost consciousness from the smoke. Similarly, during her performance in *Rhythm 2* (1974), she took a series of psychoactive pills until her body was completely immobilized. In *Freeing the Voice* (1975) she literally screamed repeatedly for three hours until she lost her voice.

During her retrospective at MoMA, Abramović performed *The Artist is Present* (2010), which entailed sitting still for seven hours a day for six days a week from March 14 to May 31, 2010. Within those 736.5 hours museum visitors were invited to sit in front of Abramović and stare at her while she returned their gaze. *The Artist is Present* became a sensational hit and visitors lined up for hours to sit across from Abramović. The MoMA retrospective included 'performances' where younger artists recreated Abramović's performance pieces and investigated the reproducibility of performance art.

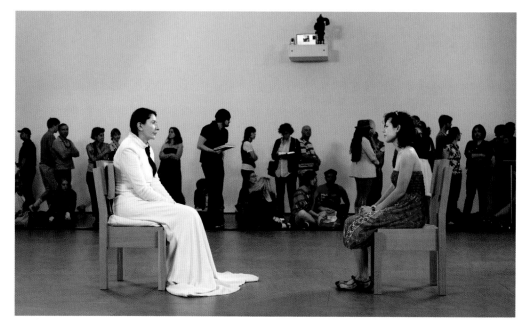

Abramović stares down a visitor at MoMA, 2010

OPPOSITE **Golden Mask by Marina Abramović, 2009**

12

Nelly Agassi

www.nellyagassi.com

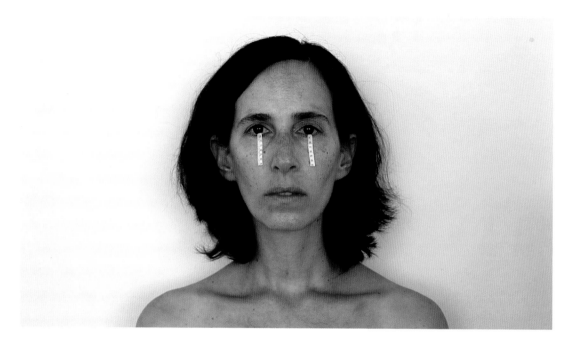

Tear Meter, 2009,
video, 02:44

Born 1973 in Israel
BFA Sculpture, Central St. Martins, London, UK, 1998
MFA, Chelsea College of Art and Design, London, UK, 2001
Lives and works in Tel Aviv, Israel.

"The body is an instrument through which I experience life, and record my biography and personal history. It is a physical tunnel, through which I transform mental emotional processes, and with it, this recording device, I transmit in the exhibition space. The body is a storage space to gather life experiences, fears, passions, excitements." Nelly Agassi, *NY Art* (Spring 2011)

"Time is another material for me, and it is a very important ingredient. Standing or not moving makes the non-activity into an activity. When I'm standing with a specific image – the stones connected to me or the wood strings coming out of my mouth – time becomes the action." Nelly Agassi interviewed by Vardit Gross (January 2010)

NELLY AGASSI is an Israeli contemporary artist best known for her performance art. Her performances often extend the scale of her petite human form and explore the potentials of the body. Agassi also creates videos, installations, and works on paper.

The colors red and white are a recurring motif in Agassi's work, and seem to combine elements of innocence and sexuality. For *Bedroom* (2005) Agassi produced a gigantic white bed, which takes over an entire room, and she occasionally rested in the far corner. In her video and performance *No Stepping Outside the Lines* (1999), Agassi continually circles her neck and face with lipstick until she is completely masked in red. Curiously, her drawings also retain a surreal and creepy quality, which both seduce and disorient the spectator.

Agassi's extreme and surreal performances have a sort of Alice-in-Wonderland meets Marina Abramović quality, and include instances when she has rubbed her skin with sandpaper to the point of bleeding, as in *Sand it Better* (2002). Agassi has performed her piece *More* internationally, during which she repeatedly vomits and re-swallows large green strings. Her work can also be quite playful; during the private view to her show at the Bat Yam Museum of Art, Agassi handed out white T-shirts reading "I'm My Mother's Masterpiece."

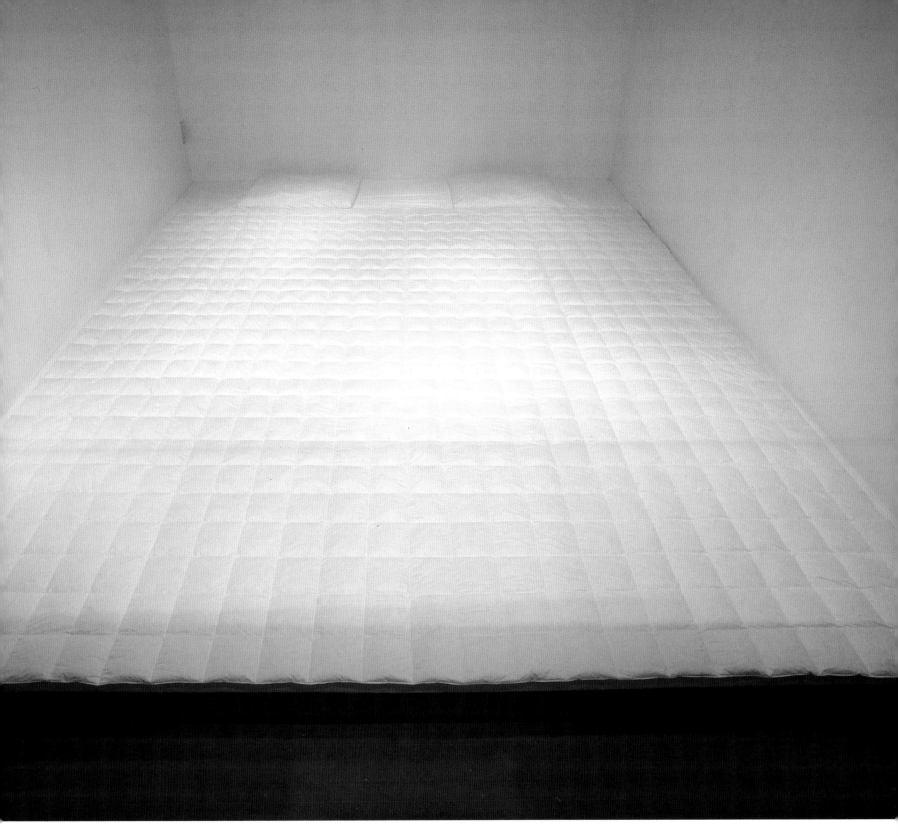

Bedroom, 2005,
wood construction, mattresses, quilt, pillows, 8.6 x 11.3 m

Ai Weiwei

www.aiweiweiblog.com

Born 1957 in Beijing, China
Enrolled at the Beijing Film Academy, China, 1978
Enrolled at Parsons School of Design, New York City, 1982.

AI WEIWEI is much more than a contemporary artist – he is a polymath whose creativity has the power to transform the social, cultural and political foundations of Eastern and Western societies. Ai (Chinese names begin with the family name – in this case 'Ai') is a controversial figure in China. Hailed by activists as a hero, Ai has unflinchingly criticized the Chinese government for corruption and lack of human rights including free speech. In 2011, Ai spent two and a half months under arrest by the Chinese police while his fans and colleagues petitioned heavily for his release. That same year, *ArtReview* claimed that he was the most powerful figure in the contemporary art world.

Ai's exhibitions include the 48th Venice Biennale in Italy (1999), the 2010 Venice Architecture Biennale, the *29th* Sao Paulo Biennial in Brazil (2010), Documenta 12 in Germany (2007), and the Tate Modern Turbine Hall in London (2010). He has worked in media ranging from conceptual art, photography and sculpture to film, design, publishing and architecture. The home he designed for collectors André Stockamp and Christopher Tsai was nominated by *Wallpaper** as one of the 'best new private houses'. Many of his architectural projects have received critical acclaim, and the Bird's Nest stadium in Beijing has become an icon for the 2008 Olympics. Ai would later denounce the Olympics, but explained that he designed the structure because he loves the creative challenge of architecture.

Ai's conceptual art is often a satire of contemporary culture, and alters readymade objects. In *Dropping a Han Dynasty Urn* (1995), he smashes an ancient Chinese urn (or at least an excellent copy of

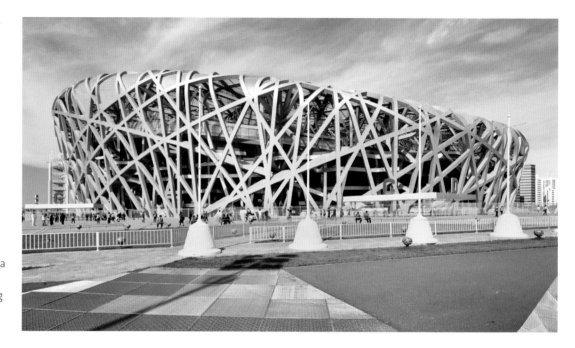

Beijing National Stadium (aka Bird's Nest), 2008

one – no one really knows) and illustrates the creative potential of destruction. For his exhibition, *Sunflower Seeds* (2010), at Tate Modern's Turbine Hall, Ai commissioned 1,600 Chinese artisans from Jingdezhen to create and hand-paint one hundred million porcelain seeds. Sunflower seeds are symbols from the Cultural Revolution, and Ai's installation poignantly experiments with the politics, materialism and economics of Chinese manufacturing.

As an aside, amongst Ai's many talents, he is also a world-class blackjack player and would often visit casinos in Atlantic City.

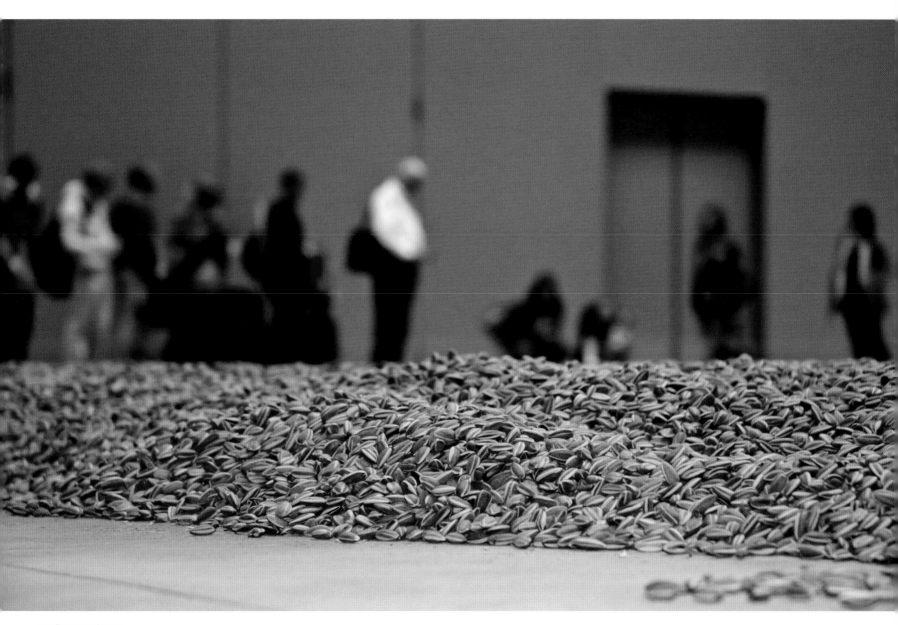

Sunflower Seeds, 2010
Tate Modern Turbine Hall

Azra Aksamija

www.azraaksamija.net

Born 1976 in Sarajevo, Bosnia and Herzegovina
Faculty of Architecture at the Technical University, Graz,
Austria, 2001
M.Arch. Princeton University, USA, 2004

AZRA AKSAMIJA is an Austrian artist and architectural historian. Her works have been exhibited internationally including at the Manifesta 7 (Italy), the Biennial de Valencia (Spain), the Stroom (Belgium), and the Berlin Art Fair (Germany). She is currently pursuing a PhD at MIT on the architecture of mosques in post-socialist Bosnia and Herzegovina.

In *Fallen Angel*, Aksamija collaborated with craftsmen in Sarajevo to transform artillery shells into vases and dishes. Wood and textile used to create additional coffee-related products such as tablecloths and furniture. By converting objects of destruction into everyday objects *Fallen Angel* offers an alternative way to visit tragic memories. Meanwhile, supporting local craftsmen helps sustain traditional manual skills and labor.

The Frontier Vest is a wearable vest designed by Aksamija that can also be easily modified into a tallit, a Jewish prayer shawl, or into an Islamic prayer rug. As Aksamija explains: "While Judaism, Christianity and Islam share the belief in one God, belonging to one implies a level of exclusion from the others. Based on different religious practices, socio-psychological boundaries often generate spatial ones, which in turn reinforce these divisions further. *The Frontier Vest* allows for individual expressions of different belief systems. This individual wearable architecture can also be combined to generate a communal space. For this, it needs a congregation of minimally ten in Judaism (minyan), two in Islam (masjid) and three in Christianity. Yet, more importantly, this individual territory can only become collective through overcoming the fear of the mutual otherness."

Identities are constantly formed of memories and cultural systems are in flux, influenced by variables such as political, social, economic and symbolic capital. Aksamija's practice explores the manners in which these cultural histories are formed, structured and rewritten. By researching and documenting how 250 Bosnian mosques were destroyed between 1992-1995 (out of the 1000 mosques destroyed in total by Croatian extremists), Aksamija's *Monument in Waiting* provides a safe and alternative platform to re-engage this tumultuous period. *Monument in Waiting* resulted in a woven carpet featuring traditional kilim symbols, re-telling how this destructive process was carried out; symbols embedded into the carpet include grenades and barbed wire.

Fallen Angel, 2003

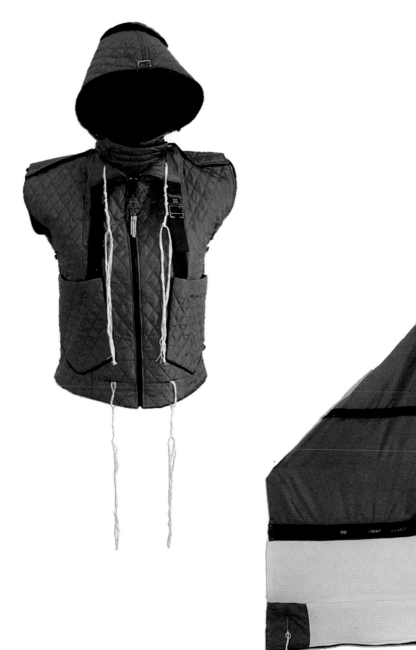

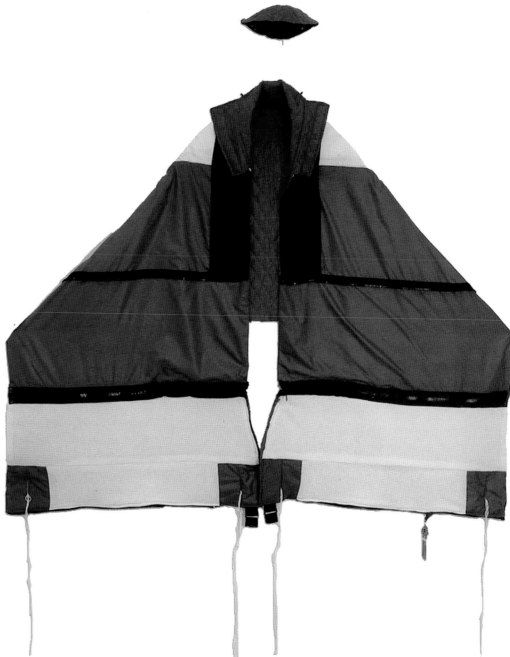

Azra Akamija, *The Frontier Vest*, 2006
textile
Produced within the group show *Liminal Spaces / Grenzräume*,
Gallery for Contemporary Art Leipzig, Germany / Oct. 28, 2006
– Jan. 21, 2007 / Exhibition is a part of the project *Liminal
Spaces,*organized as a collaboration of the Israeli Centre for
Digital Art Holon, the Palestinian Association for Contemporary
Arts PACA and the University of the Arts Berlin / Curated by
Galit Eilat, Reem Fadda, and Philipp Misselwitz.

Anonymous

Originated as an Internet meme in 2003

ANONYMOUS is a powerful artistic entity that has created several visual memes. Anonymous functions as a de-centralized collective of vigilante hackers who challenge some of the biggest corporations and governments while fighting for free speech and against inequality. They have popularized the wearing in public of Guy Fawke's masks from the comic book *V for Vendetta*. Anonymous have even created their own flag, with a suit devoid of a head, symbolizing that Anonymous is a leaderless and anarchist organization. Their aesthetics are often based on shock humor, surrealism and black comedy.

During the 2011 Arab Spring, Anonymous attacked several Arab government websites in order to overthrow dictators in Tunisia, Libya and Egypt. They were able to keep Egypt's National Democratic Party website offline until Mubarak stepped down. Anonymous also publicized the emails of top government officials in Bahrain, Jordan and Morocco.

The activist group recently attacked the Mexican government's websites in protest at a bill against Internet file sharing. Their attack was strong enough to take the website of the Mexican Interior Ministry offline, and they left a YouTube message regarding the incident: "We demand the Mexican government not continue with this law because they will take away our freedom of speech and file sharing." Anonymous is also closely affiliated with the hack group The People's Liberation Front.

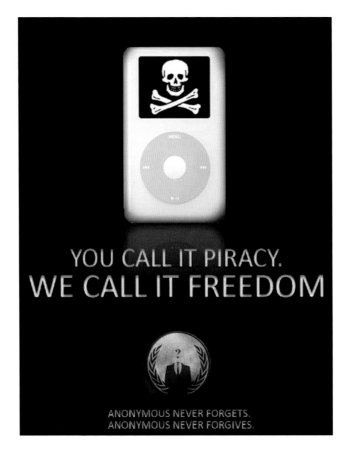

You Call It Piracy, We Call It Freedom

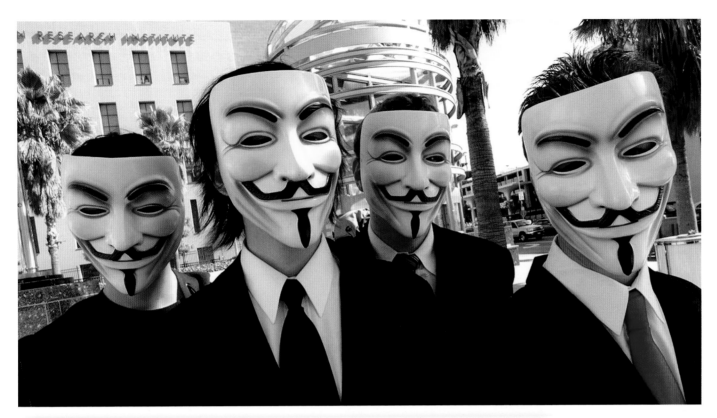

Operation Payback, 2008

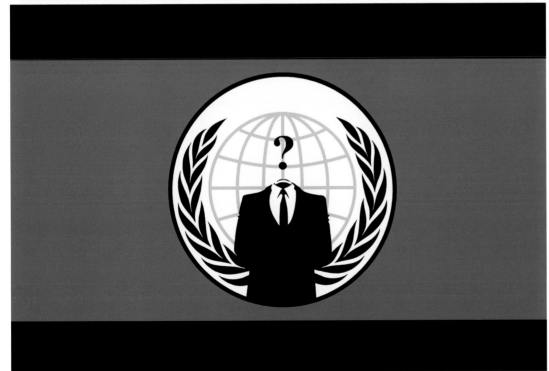

Flag

Richard Ansett

http://richardansett.com

Born 1966 in Britain
Studied photography at Kent Institute of Art and Design
Lives and works in London.

RICHARD ANSETT'S surreal photos explore the myths of documentary image making, calling into question the assumed complicity between photographer and subject. Ansett often restructures his subjects' environments using tools such as dislocation and unfamiliarity, which in turn shed light on narratives that would have otherwise remained hidden. Ansett was adopted from birth and has no information about his biological parents. His own genealogical narrative remains unattainable, and, perhaps as a result, his work obsessively explores the interplay between a subject's environment, history and identity. While creating a portrait, Ansett often shifts around props and other elements that significantly alter the composition of a subject's environment; the motivation of each alteration is to reveal or create an otherwise obscure feature, which destabilizes the viewer's notions of reality and authenticity.

Despite their sleek finish, Ansett's works are often difficult to look at. This ambivalence is due to the difficult subject matter that is often incorporated, ranging from rare medical conditions to extreme obesity. His *Big Society* series documents the living conditions of the obese before and after they undergo liposuction. Images such as *Woman in Backyard with Rocking Horse* convey a sense of both sympathy and repulsion while highlighting the weaknesses of the human condition.

Woman With Electrode Cap #1 won Ansett second place in the Single Image/Fine Art section of the 2010 *FotoWeek* DC International Awards. *Woman With Electrode Cap #1* both celebrates the incessant progress of science, and highlights the sterile coldness of technology and civilization. This ambivalence generates a stunning image and composition, while creating a work that is challenging, evocative and impossible to ignore.

His photographs appear regularly in major global exhibitions, and are in several museum collections including the National Portrait Galleries of London and Canada, and the Smithsonian, Washington DC. In 2011, Ansett completed a residency in Ukraine and received a gold award at Prix de la Photographie, Paris. Ansett also reviews portfolios for the World Photography Organization. Among his influences, Ansett mentions Otto Dix (his Labrador is named Otto), Joel Peter Witkin, Irving Penn, Jan Van Eyck and Cindy Sherman.

OPPOSITE *No Coat On Fatal Attraction #9*

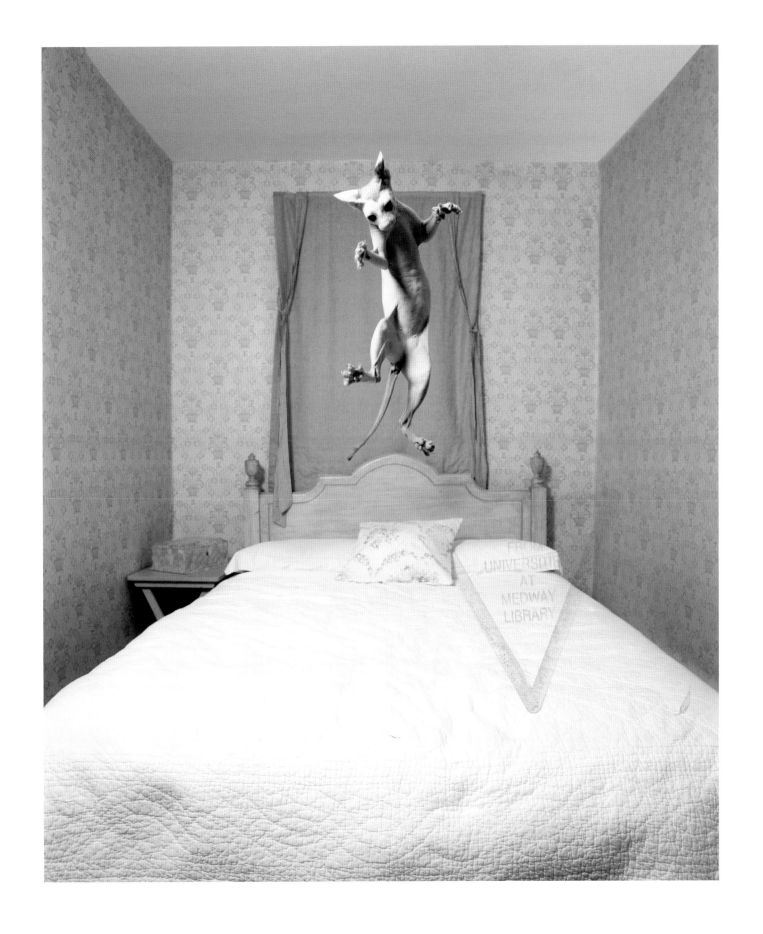

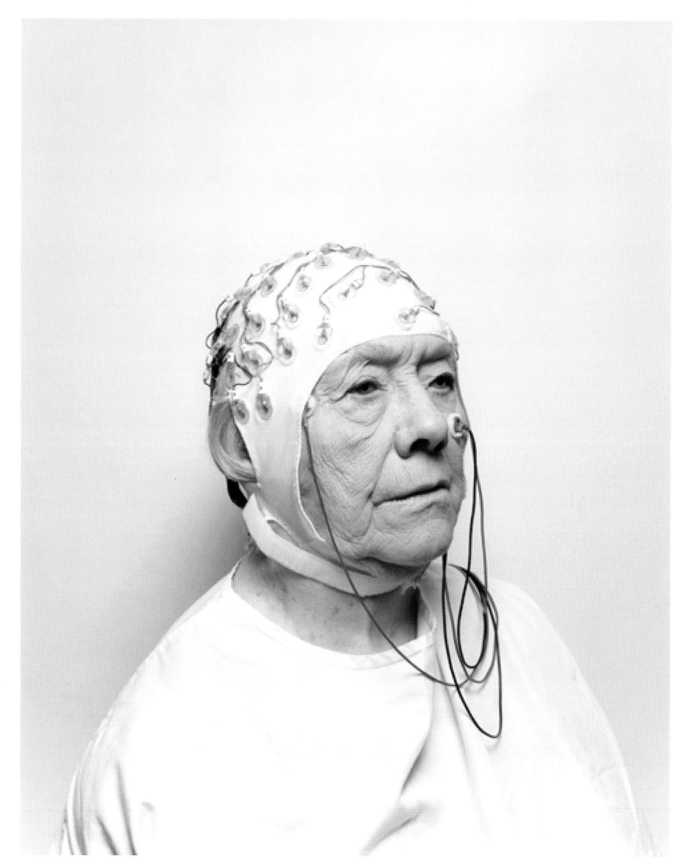

Woman with Electrode Cap #1, **2008**
© Richard Ansett
Exhibited at:
Tenderpixel, London, 2009
PX3 La Prix de la Photographie, Paris
2009
Taylor Wessing Portrait Prize,
National Portrait Gallery, London,
2009
Russian Art Week International,
Moscow/ St Petersburg 2009
Shortlisted – Royal Academy
Summer Exhibition, London 2010
FotoWeek DC International,
Washington, USA 2010

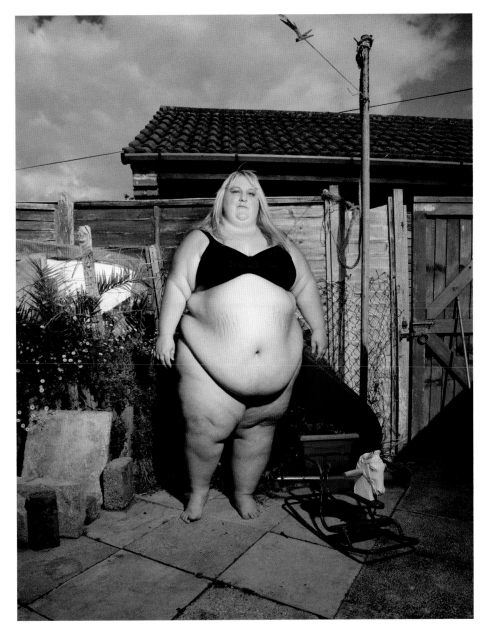

Sascha (aka Woman in Back Yard with Rocking Horse), 2007

Lisa Anne Auerbach

lisaanneauerbach.com
www.stealthissweater.com

Born 1967 in Ann Arbor, Michigan, USA
MFA in Photography, Art Center College of Design,
Pasadena, California, USA, 1994
BFA at the Rochester Institute of Technology,
Rochester, New York, USA, 1990
Lives and works in Los Angeles, California, USA.

"Those corporations who promote D.I.Y. have co-opted our spirited movement by the same name, transforming an idealistic, anti-consuming, pro-independent, pro-active ethos into an opportunity to shop. Stealing D.I.Y. from zines, communes, artists, and denizens of the avant-garde underworld, the new corporatized D.I.Y. movement attempts to make the individual feel as though they are in control of their lives and environment in a disparate, disconnected world [...] Our D.I.Y. exuberance for cooking unfamiliar cuisines fills our cabinets with jars of exotic spices, specialized contraptions, bamboo steamers, Moroccan tagines, the requisite fondue set; all items that will flood thrift stores shortly after whichever particular cooking trend is succeeded by the next." Lisa Anne Auerbach, 'Don't Do It Yourself', *Journal of Aesthetics and Protest*, Issue 6

LISA ANNE AUERBACH is an artist, activist, educator and author. She has a grass-roots sensibility that fosters an independent bottom-up approach towards bettering the world. Auerbach utilizes a range of media in her work, from contemporary technology such as digital photography and blogging, to low-tech such as sewing, knitting and pamphlets. She often combines politics with art, and her knitted sweaters relay slogans such as "Keep Abortion Legal" and "Steal this sweater off my back". While she enjoys knitting, she also uses a knitting machine, which helps sustain her prolific practice.

Auerbach expresses herself just as well in her writing as she does in her visual projects. Whether she's writing for a blog, zine, book, or journal, she maintains a persuasive and witty tone that often serves as a call to action: "Reclaim knitting! It is a noble craft; it is NOT the new yoga. Repetitive and unthinking motions will kill the soul" (*KnitKnit 6*, Winter 2005). She is also an avid cyclist (even though she lives in Los Angeles!), and her zine, *Saddlesore*, is a psycho-geographic diary that celebrates cycling culture. Her flyers range from discussing evolution (in contrast to religious pamphlets) to *Insidious Scourge*,

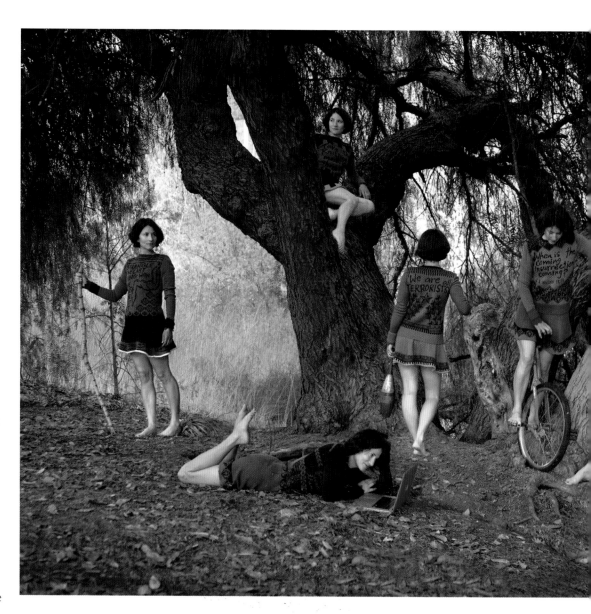

a tract that satirically suggests that toilet seats are bad for the planet and that everyone should squat while using the restroom. While she vacillates between being a DIY advocate and a critic, Auerbach is a big believer in empowering everyday citizens to be more creative and self-aware.

26

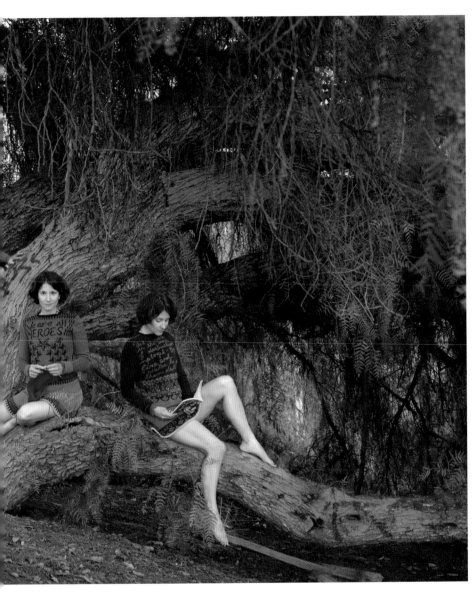

Lisa Anne Auerbach's hand-made sweaters and skirts convey slogans such as "Strangle the last king with the entrails of the last priest." Nottingham Contemporary, 2009

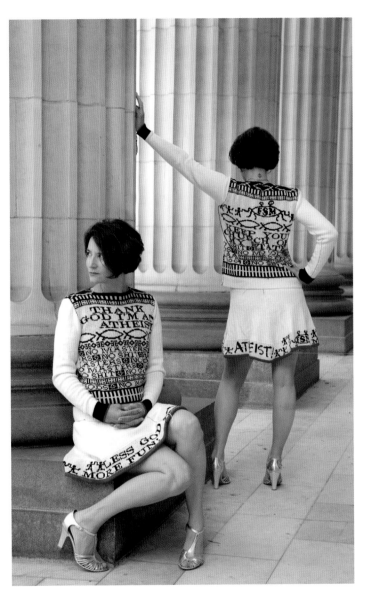

Thank God I'm an Atheist (Ghost Version, 2009)

Eric Ayotte

http://ericayotte.com

Born 1980 in Oceanside, California, USA
BFA, Rhode Island School of Design, 2002
MFA, Goldsmiths, University of London, 2007.

ERIC AYOTTE experiments with visual interruptions and analytical abstractions.

He has perfected his own unique and meticulous painting process, which combines multiple polymer resin layers with oil paint onto an aluminium base. His works appropriate media events and question notions of historical significance while illustrating how meaning can oscillate and mutate as it becomes interwoven with time.

Ayotte is also a filmmaker, designer and all-around tinkerer who can create just about anything. While honing his artistic skills, he worked as a technician at Jay Joplin's White Cube gallery, and learned to construct flawless and incredibly sleek artworks. Gazing into one of Ayotte's paintings is like staring into a post modern fireplace; the resin, which embalms the painting's elaborate processes, reflects light like a computer monitor or plasma screen while permeating an alternative space imbued with fractal distortions and moments of urgency. Works such as *Media Event* (2010) and *Untitled* (2010) exemplify the unique look of Ayotte's works and their saturated visuals, which engage and draw the audience into the frame, like moths to a fire.

In 2009, Ayotte collaborated with Etan Ilfeld on an exhibition entitled *Breaking Point*. Ilfeld and Ayotte incorporated Stephen Wolfram's *A New Kind of Science* methodology in their *Breaking Point* body of work by testing aesthetic-algorithms, and processing the media images using Mathematica software. *Manila/Rule 524* relates to riots, tear gas and general societal conflicts within a landscape. It references many of the global protests that have been

Urumqi/Iran, 2009, by Eric Ayotte
and Etan Ilfeld

documented within the contemporary media-scape. Their conceptual underpinning is the juxtaposition of the emergence
of human patterns (e.g. riots and protests) alongside computational emergence such as cellular automata. Ilfeld and Ayotte refer to their collaboration as 'neo-futurist', explaining that the machine becomes an integral element of the creative process itself, and generates the emergence of artistic modes that would have been impossible prior to computer technology. As a result, their collaboration relates a meta and microcosmic synthesis of computer-creativity, mathematics, optics, art history and painting.

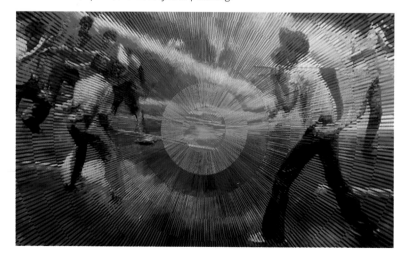

The Breaking Point Oil, 2010
Spray-paint, resin, collage on aluminium

Conversations with History, 2008
Oil, spray-paint, resin, collage on aluminium

{{L'Arroseur,0},{0, Arrosé}}, 2009
by Eric Ayotte and Etan Ilfeld

Banksy

www.banksy.co.uk

Allegedly born 1974 in Bristol, UK.

ALTHOUGH BANKSY is best known for his street art, he is also a painter, conceptual artist and filmmaker, and was nominated for an Oscar for his film *Exit Through the Gift Shop* (for Best Documentary). He has published several books of photography on his street interventions and exhibitions, along with his own essays.

Banksy was inspired by the drawings of 3D from Massive Attack, and cites Käthe Kollwitz as his favorite artist of all time. Banksy's satiric graffiti often uses dark humour and has an anarchistic sensibility. His street interventions are usually critical of authority and capitalistic consumerism. Typical slogans include:

> "Sorry! The lifestyle you ordered is currently out of stock."
> "One Nation Under CCTV."
> "I can remember when all this was trees."

Exit Through the Gift Shop was first screened at the 2010 Sundance Film Festival, and achieved both critical acclaim and box office success. The film follows Thierry Guetta, Invader's cousin, as he films street artists such as Shepard Fairey, Sweet Toof, Monsieur André Zevs, and Banksy himself. One of the scenes in *Exit Through the Gift Shop* documents Banksy placing a human-size doll in an orange Guantanamo Bay jumpsuit in Disneyland alongside the Big Thunder Mountain Railroad ride.

Banksy's guerrilla-style interventions include climbing into the penguin section of London Zoo and painting "We're bored of fish" in seven-foot high letters. In 2005, he hung - without permission - several of his subverted paintings in MoMA, at the American

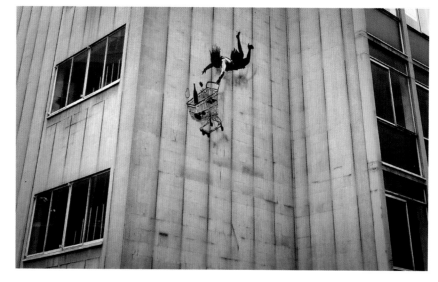

LEFT *Shopping Trolley Girl*, London, 2011

BELOW *Red Phone Box*, London, 2006

Museum of Natural History, and at the Metropolitan Museum of Art. He also placed a painting at the British Museum of an animal pushing a shopping card, which the museum agreed to add to its permanent collection. In addition that same year, Banksy painted nine works on the Western Bank barrier between Israel and the Palestinian territories, suggesting that the wall should be removed or at least the viewer should transcend it through their imagination.

His subversive sculptures include versions of Michelangelo's *David* wearing a suicide belt, and a bust of a Catholic priest with a pixelated face – alluding to Church attempts to hush child abuse cases. He also placed a sculpture of a mangled and bleeding red phone box in central London, which remained on view for several days until the local council removed it.

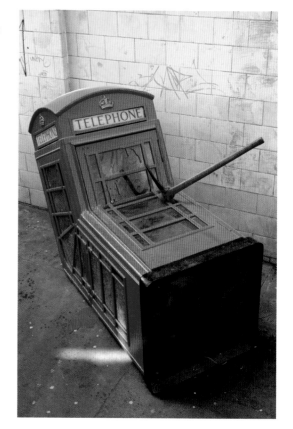

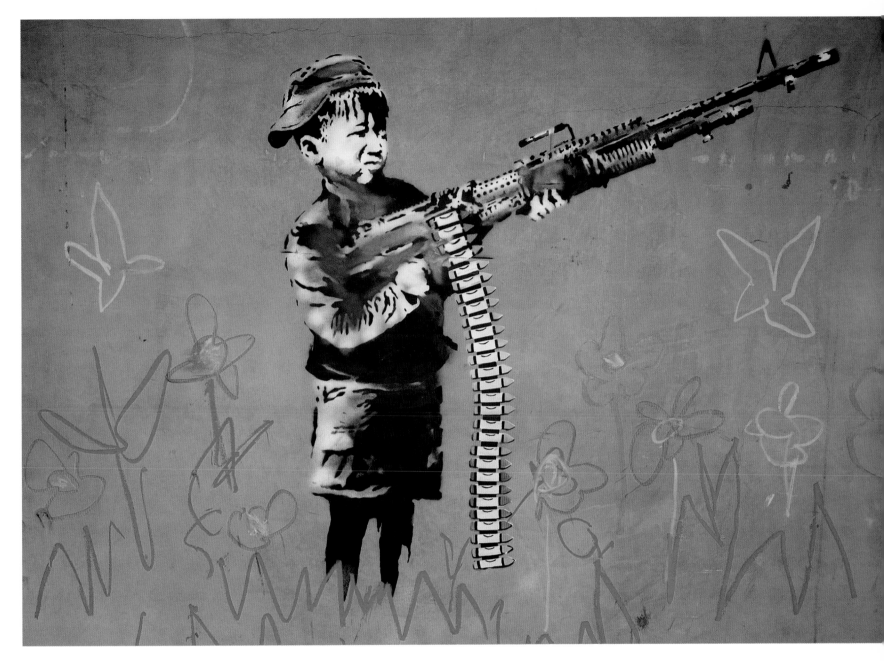

Crayola Shooter, Los Angeles, 2011

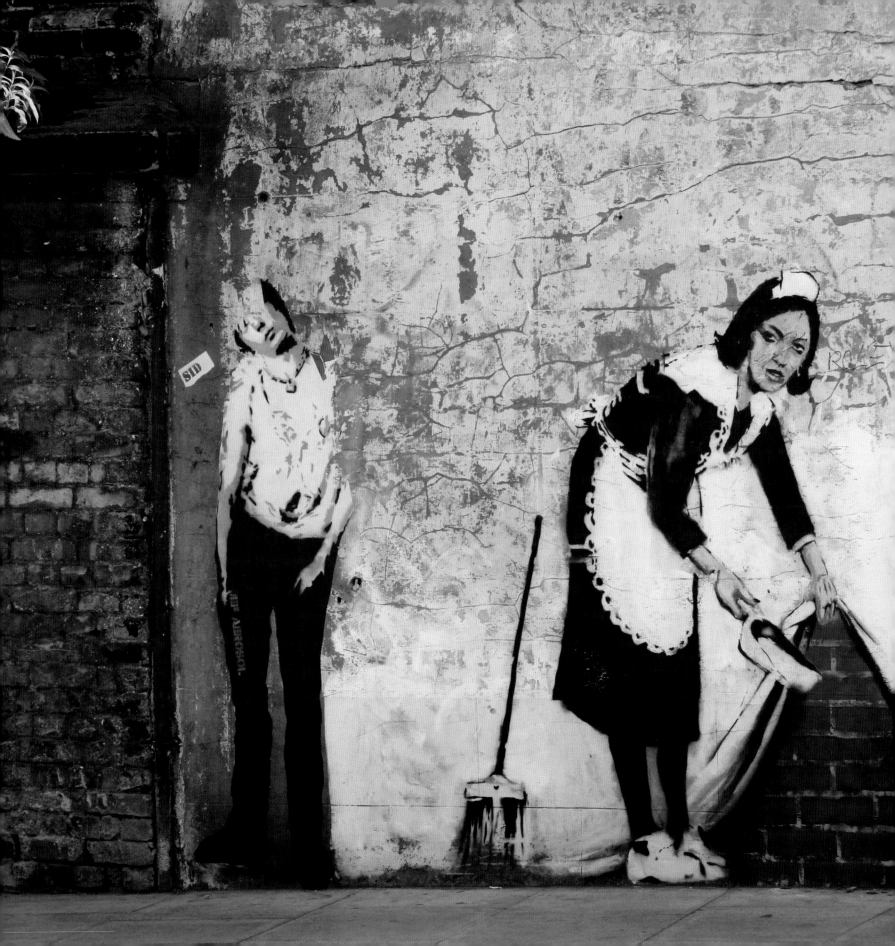

Maid: Sweeping it Under the Carpet, London, 2006

Matthew Barney

www.cremaster.net
www.drawingrestraint.net

Born 1967 in San Francisco, California, USA
BA, Art Major, Yale University, New Haven, Connecticut, USA
Lives and works in New York City.

"There was a kind of system that I laid out before *Cremaster*, which started in a place called 'Situation', a sexual place trying to define drive or desire. That impulse would then pass through a kind of visceral funnel, called 'Condition', that would shape that raw drive. And then 'Production' was an anal or oral output that would be bypassed by connecting those two orifices and making a circular system. 'Situation', the sexual station, was always drawn as a reproductive system, before its embryonic point of differentiation between male and female." Matthew Barney, *Tate Magazine*, Issue 2, 2003.

WORKING PRIMARILY in sculpture, photography and film, Matthew Barney has won numerous accolades including the Hugo Boss Prize awarded by the Guggenheim Museum (1996) and the Europa 2000 Prize at the Venice Biennale (1993). His international exhibitions include major shows at the Serpentine Gallery in London, the Kunsthalle in Vienna, the Centre Pompidou in Paris, and the 21st Century Museum of Contemporary Art in Kanazawa, Japan.

Barney often cross-dresses in his own works which attempt to transcend conventional boundaries such as gender and sex. His aesthetics have been referred to as hermetic, clinical, mythological, docu-fragments, sepulchral, and sublime. His *Cremaster Cycle* is an eight-year project that explores the multiplicity of ways that life can form (the title was inspired by the cremaster muscle, which regulates testicular contractions), and appropriates narratives from mythology, anatomy, geology and biology. The *Cremaster Cycle* includes five feature films and a range of artefacts such as artist books and drawings. Jonathan Jones wrote in *The Guardian* that it "is the first truly great piece of cinema to be made in a fine art context since Dali and Bunuel filmed *Un Chien Andalou* in 1929."

Barney's *Drawing Restraint* series features photographs, performances, sculptures and films all of which are centered around the concept of restraint and resistance as a necessary factor for development. *Drawing Restraint 7* was showcased at the 1993 Venice Biennale, and *Drawing Restraint 8* was screened at the 2005 Venice Film Festival. *Drawing Restraint 9* consists of a feature-length film, sculptures, drawings and books; it takes place mostly in a Japanese whaling vessel that traverses the Sea of Japan towards Antarctica as its guests engage in a range of surreal rituals – a climactic moment includes Björk's and Barney's characters cutting and eating each other's flesh.

Barney lives with Björk in New York, and they have a daughter, Isadora (born in 2002). Barney and Björk's unconventional creativity has clearly cross-pollinated, and they have collaborated on several works. Björk and Barney have an iconic photograph of them kissing one another in his *Drawing Restraint* series (*Drawing Restraint 9: Shimenawa*, 2006). Björk makes notable appearances in Barney's *Cremaster Cycle*, and has composed music for his *Drawing Restraint* series.

OPPOSITE *CREMASTER 3*: Mahabyn, 2002
1 of 3 C-prints in acrylic frames, 42 x 34 inches (107 x 86 cm)

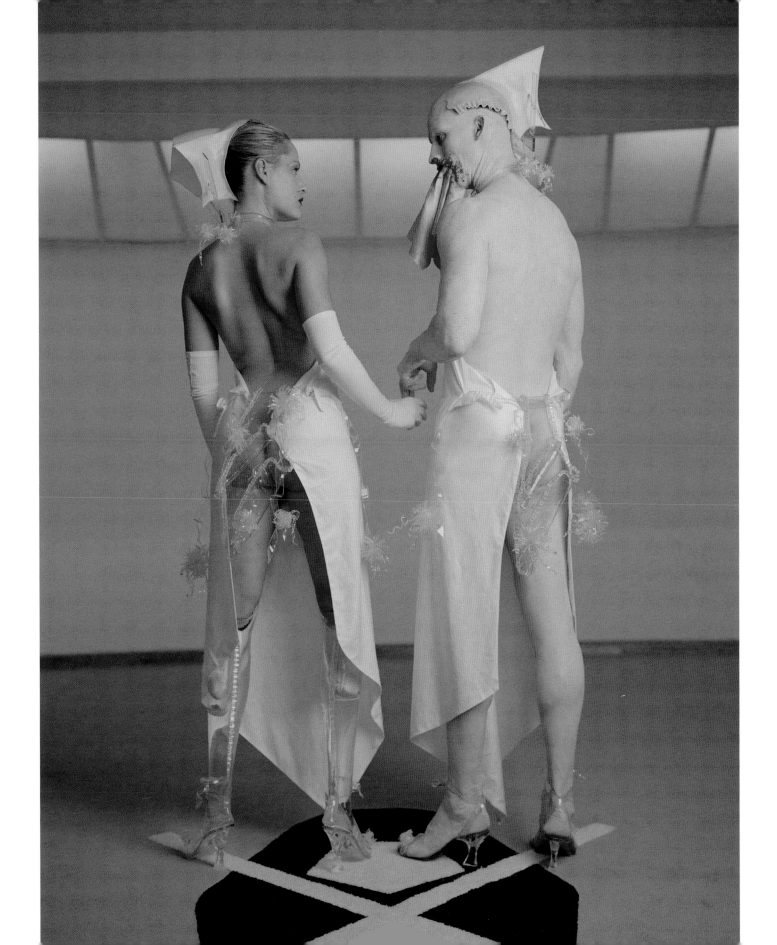

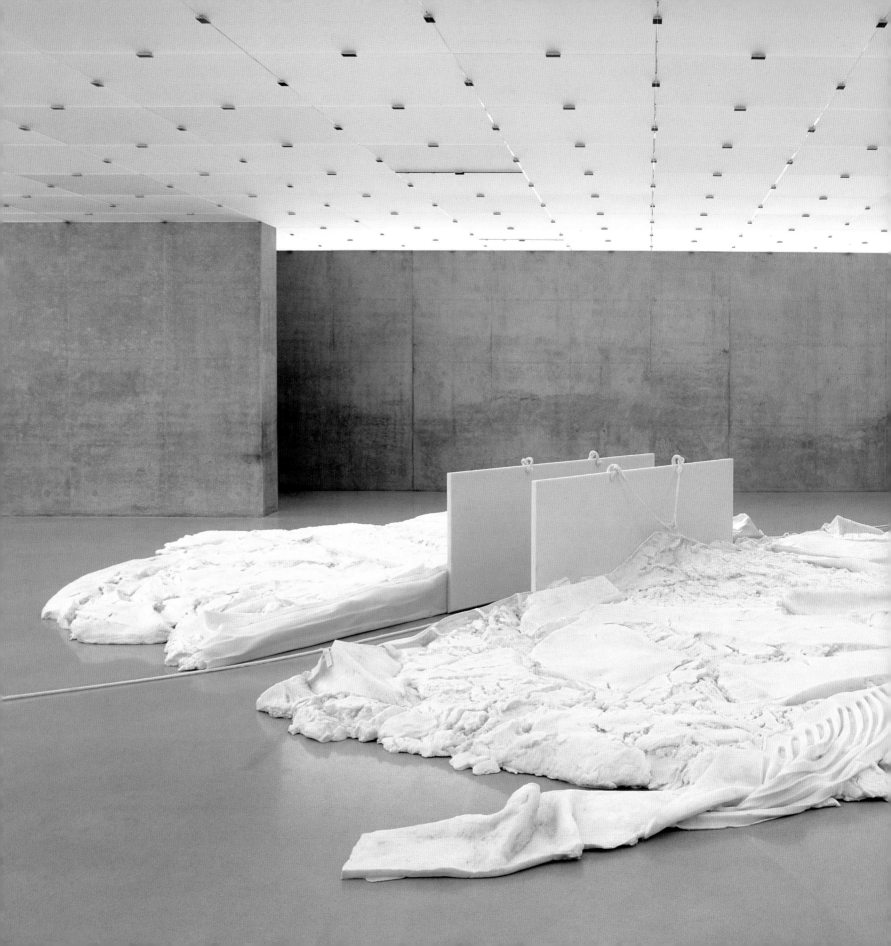

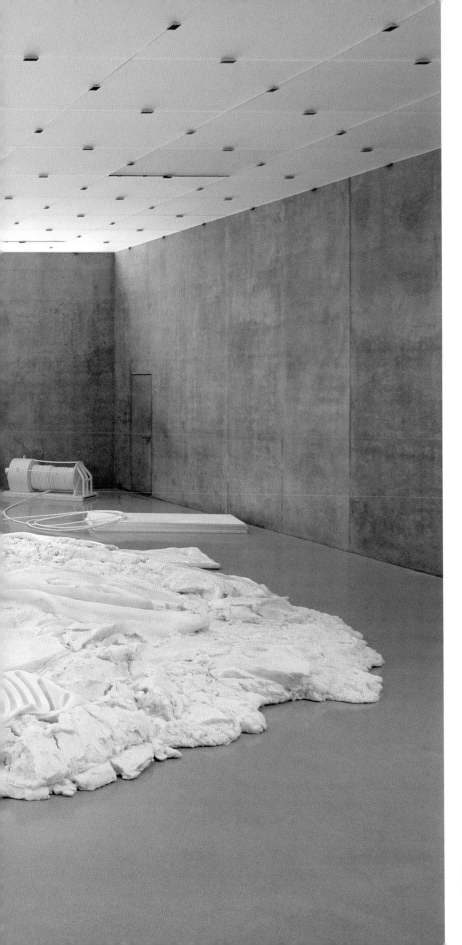

Cetacea, 2005.
Cast polycaprolactone thermoplastic, self-lubricating plastic, vivac
34 1/4 x 480 inches.

Aram Bartholl

www.datenform.de

Born 1972 in Bremen, Germany
Architecture, Berlin University of the Arts, 2001
Lives and works in Berlin, Germany.

ARAM BARTHOLL is a conceptual multi-media artist whose work often integrates the virtual with the physical. His public interventions challenge conventional boundaries and highlight the interdependency of information and materiality.

In *Dead Drops*, Bartholl has cemented USB sticks onto public walls as a sort of interactive hardware graffiti. Any passer-by is able to access and alter the memory on each USB stick, resulting in an anonymous and offline public network. Initially, each USB stick contained a single readme.txt file inviting newcomers to interact. Bartholl also posted an online manifesto for *Dead Drops* and an open invitation for enthusiasts to add more USB sticks: "A Dead Drop must be public accessible. A Dead Drop inside closed buildings or private places with limited or temporary access is not a Dead Drop. A real Dead Drop mounts as read and writeable mass storage drive without any custom software. Dead Drops don't need to be synced or connected to each other. Each Dead Drop is singular in its existence. A very beautiful Dead Drop shows only the metal sheath enclosed type-A USB plug and is cemented
into walls."

For *Map*, Bartholl juxtaposed digital data with a physical landscape by creating a giant Google Maps icon that he installed in several cities ranging from Tallinn to Taipei. Bartholl identified which point in the city Google Maps considered to be the city center, and had the larger-than-life-sized icon planted right there. Reminiscent of Lewis Carroll's *Sylvia and Bruno Concluded* and Jorge Luis Borges' *On Exactitude in Science*, Bartholl's *Map* self-reflexively attempts to re-frame and map the frontiers of our imaginations.

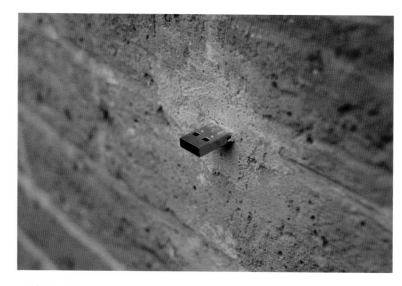

Dead Drops, 2010

40

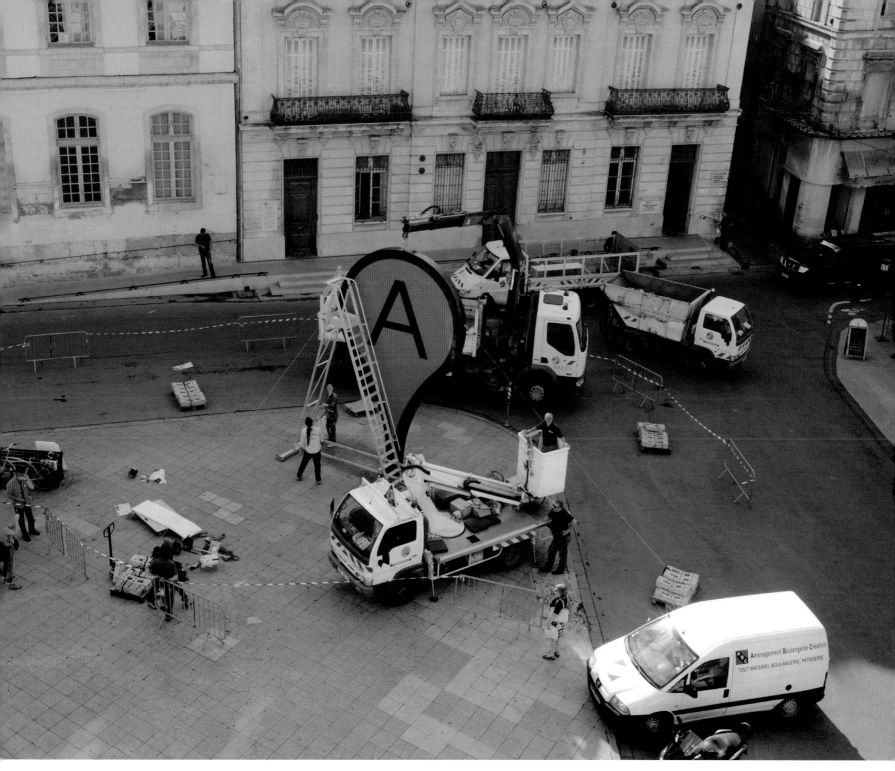

Map, 2006 to 2010

Björk

www.bjork.com

Born 1965 in Reykjavik, Iceland.

"Singing is like a celebration of oxygen." Björk (1996)

BJÖRK is a contemporary performance artist. From acting and modeling to singing, songwriting and composing, Björk has maintained a distinctive aesthetic that mixes genres and blurs boundaries. She has collaborated with some of the world's most creative people including music video directors Michel Gondry and Chris Cunningham, designers M/M (Paris), photographer Nick Knight, filmmaker Lars von Trier, and music producer Graham Massey. Björk's collaborations with her romantic and creative partner Matthew Barney include composing the soundtrack and performing in his film *Drawing Restraint 9*. Björk has also written and illustrated a limited edition Icelandic fairytale and poetry book.

Björk began studying classical piano at the age of eleven but soon cultivated her own distinct and alternative style, and by the age of fourteen had already formed an all-girl punk band, Spit and Snot. Her songs often incorporate howling and shrieking and combine musical genres such as house music, Gothic rock, jazz, sound art, folk, electronic and classical. Björk is also an accomplished songwriter (she even co-wrote Madonna's *Bedtime Story*), composer, and actress - winning the Best Actress Award at the 2000 Cannes Film Festival for her performance in Lars Von Trier's *Dancer in the Dark*, and being nominated for an Oscar for the film's song, *I've Seen It All*. From acting to performing at musical festivals (and even at the opening ceremony of the 2004 Olympics in Athens) to mentoring upcoming artists, Björk's sphere of influence knows no bounds. An environmental activist, she has raised funds for marine conservation and tsunami relief; Björk has also founded a venture capital fund aimed at cultivating sustainable industries in Iceland. Her political activism includes supporting Kosovo's independence and bravely chanting "Tibet" at a performance of her song *Declare Independence* during a live performance in Shanghai.

Björk has embraced new media and was the first major performer to record and perform with the Reactable electronic instrument developed by the Music Technology group. She was also the first artist to release a DVD single in the USA for her song *All is Full of Love*, which was directed by Chris Cunningham. Her cutting-edge iPad/iPhone app *Biophilia* intertwines songs from her *Biophilia* album with game-based interfaces that enable the user to both play and interact with her music. For example, the *Biophilia* app renders the song *Crystalline* into a series of lunar gauges with which the user can modify the melody and create their own versions. Similarly, *Virus*, which features lyrics about a virus and a cell, enables the user to play a game in which they may protect the cells from being infected and halt the song. Of course, in 'real life' there's no stopping Björk's contagiously explosive creativity.

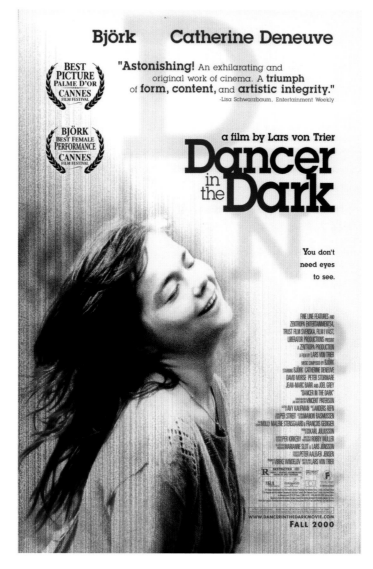

Björk starred in
Dancer in the Dark, **2000**

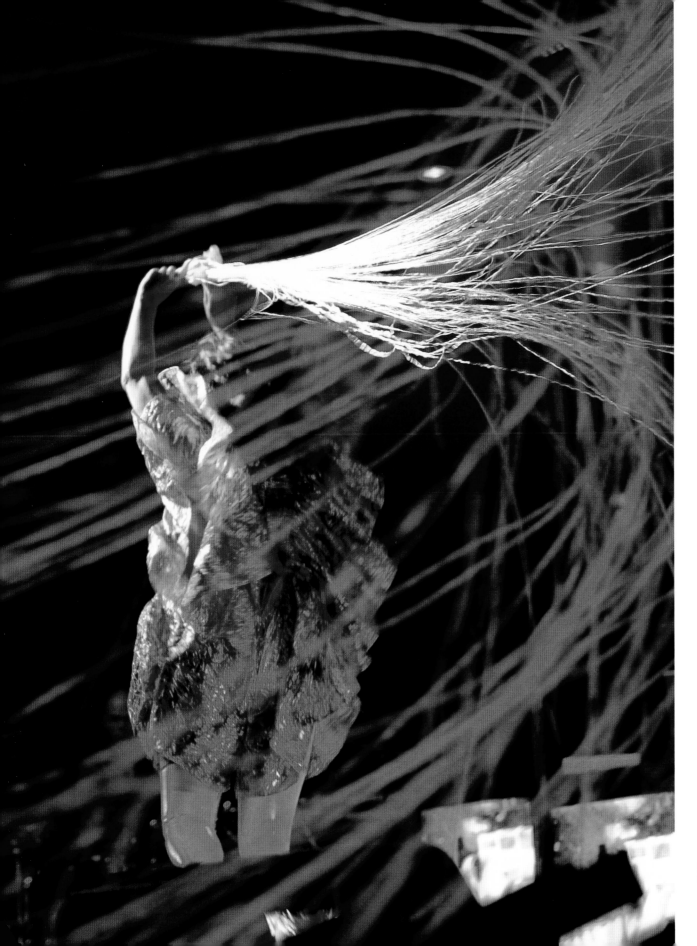

Björk performing at the Sydney
Opera House, 2008

Céleste Boursier-Mougenot

Born 1961 in Nice, France
Conservatoire de Nice, France
Lives and works in Sète, France.

CÉLESTE BOURSIER-MOUGENOT is a French artist and composer. His sound art has included the natural sounds of trees blowing in the wind and the artificial sounds of vacuum cleaners. His work has been exhibited internationally and is in the permanent collections of the Centre Pompidou, the San Diego Museum of Contemporary Art, and at the Fonds National d'Art Contemporain, Paris.

Céleste Boursier-Mougenot has been compared to John Cage. Boursier-Mougenot has continued Cage's exploration of composing sound and visual forms out of acts of chance. Like Cage, Boursier-Mougenot is also a trained musician. In the late 80s, Boursier-Mougenot composed a series of experimental works for the Pascal Rambert theatre company; in the 90s he started creating site-specific installations within an art gallery context, which had the advantage of generating compositions for a longer time-scale (e.g. a month long show rather than a two hour performance). Boursier-Mougenot's momentum within the contemporary art world has been growing steadily, and in 2010 he had a blockbuster exhibition at the Barbican's Curve gallery, and was nominated for the Marcel Duchamp Award.

Boursier-Mougenot's diverse oeuvre includes a series of works enabling natural phenomena to produce music. The installation at the Barbican's Curve was composed of an aviary embedded with Gibson guitars. The birds, Zebra Finches, were able to fly freely within the space, encouraged to perch on the guitar strings, and consume bird-food scattered among cymbals. Only 25 visitors were allowed into the space at any time in order not to startle the birds, which led to huge lines outside the exhibition as humans flocked to see the show.

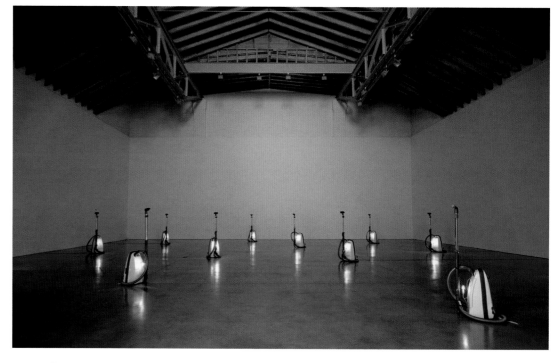

Harmonichaos 2.1, **2006**
13 vacuum cleaners, each outfitted with one tuner, one harmonica and one lightbulb. Overall dimensions variable; dimensions of one vacuum cleaner: 49 x 18 x 17 inches (124.5 x 45.7 x 43.2cm)

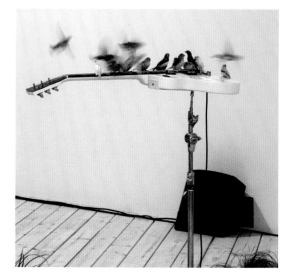

RIGHT AND OPPOSITE *From Here to Ear*, **1999 – ongoing**
20 female, 20 male zebra finches, 5 Gibson Les Paul guitars, 5 Gibson SG bass guitars, 5 pedal effect processors, 8-channel amp, speakers, nests, cables, dimensions variable

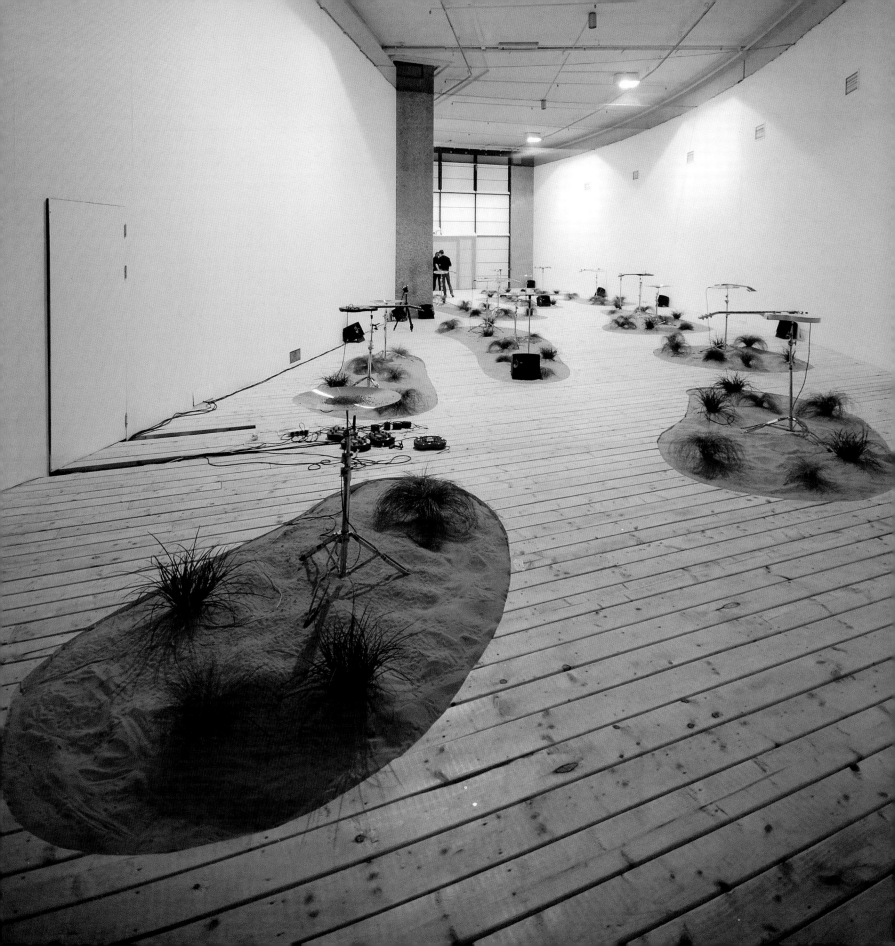

Candice Breitz

www.candicebreitz.net

Born 1972 in Johannesburg, South Africa
PhD candidate in Art History, Columbia University,
New York, 1998 to 2002
MPhil, Art History, Columbia University, New York City, 1997
MA, Art History, University of Chicago, Illinois, 1995
BFA, University of the Witwatersrand, Johannesburg,
South Africa, 1993
Lives and works in Berlin, Germany.

CANDICE BREITZ exemplifies a truly global and 21st century artist. Breitz was born in South Africa, attended graduate school in the US, and currently lives and teaches in Germany. Her artist residencies include cities such as San Antonia, Paris, Linz and Stockholm; her works are part of several public collections including MoMA, the Guggenheim, Musée d'Art Moderne Grand-Duc Jean in Luxembourg, and the Hamburger Kunsthalle.

As a professor of Fine Art at the Braunschweig University of Art, Breitz is just as interested in combining theory with practice as she is in educating a new crop of artists. Her films and photographs deconstruct and re-assemble the congeneric while exploring alternative representations of popular culture and individuation. Her *Rorschach* series of photographs illustrate that even pornographic images can easily be taken out of context and re-hashed into a multiplicity of forms and meanings. Contrapositively, Breitz's *Factum* films delineate the similarities and differences of identical twins and triplets as they explore their personalities and identities.

Breitz's films often appropriate the aesthetics of Andy Warhol, Dziga Vertov, Dada, Futurism and postmodern pastiche while organically developing into an improvisational language. Many of her multi-channel films sample tribute performances of pop idols such as Bob Marley, John Lennon, Madonna, Michael Jackson and Annie Lennox. For *Working Class Hero (A Portrait of John Lennon)* (2006), Breitz created a 25-channel piece by juxtaposing the recordings of 25 Lennon fans each singing in a professional sound studio. Similarly, Breitz's *King (A Portrait of Michael Jackson)* (2005) combines 16 fan performances of the album *Thriller*, and her *Legend (A Portrait of Bob Marley)* (2005) features 30 Jamaicans singing Bob Marley's album *Legend*.

Aiwa to Zen is a short film made by Breitz that was based on her limited knowledge of Japanese; before visiting Japan, she wrote down all of the Japanese words she could recall, which consisted of 150 words (mostly of brands such as Sony or Panasonic), and then got five native Japanese speakers to improvise a series of scenes constrained by her vocabulary. *Mother + Father*, both of which were shown at the 2005 Venice Biennale, consist of clichéd parental stereotypes that highlight Hollywood caricatures.

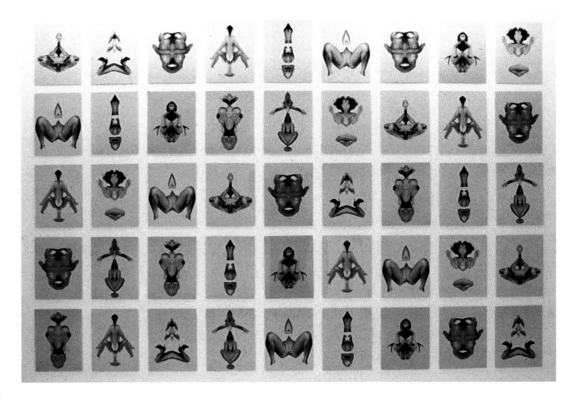

Rorschach Installation, **1997**
45 Chromogenic Prints. Each photograph: 50,8cm x 40,6cm
Installation View: South African National Gallery, Cape Town

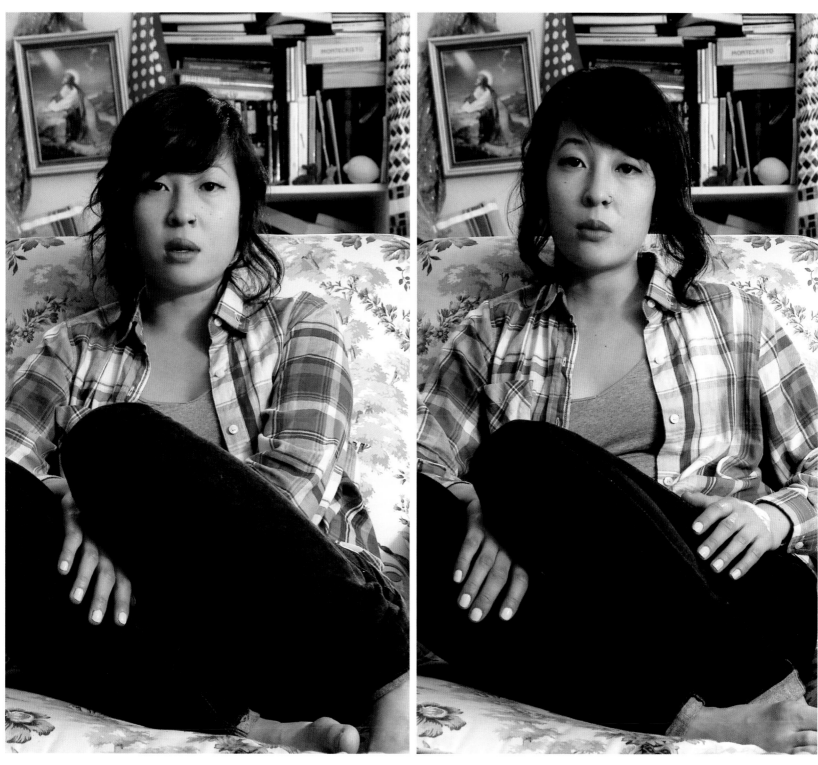

Factum Kang, 2009. From the series *Factum*, 2009
Dual-Channel Installation; 2 Hard Drives Duration of loop; 69
minutes, 10 seconds

Christophe Bruno

www.christophebruno.com

Born 1964 in Bayonne, France.

"Words already had some kind of exchange value, but we hardly realized it: if I insult somebody, I will get something in return, such as a punch in my face for instance. But now there is no doubt anymore. The word "sex" is worth $3,837, the word "art" $410, "net art" is only $0.05 (prices on April 11 2002). And the most expensive word is "free"! Prices are determined according to the number of search requests and an average Cost-Per-Click." Christophe Bruno

CHRISTOPHE BRUNO wears a lot of hats: new media artist, hacker, activist, curator, lecturer, theorist, and the list goes on. Bruno's projects often explore unconventional digital transactions. For example, within his *Non Conservation Laws* series, Bruno produced a digital artwork that expires if the collector doesn't respond to a daily validation email.

Bruno's Google *AdWords Happenings* playfully destabilizes and re-negotiates the capitalistic commodification of web searches by purchasing ads for non-commercial 'spam poems'. Rather than making money, Bruno's *AdWords* campaign was meant to surprise readers. For the keyword, "symptom", Bruno's ad read "Words aren't free anymore", followed by the nonsensical "bicornuate-bicervical uterus, one-eyed hemi-vagina", and linking to his website. Before Google disapproved and suspended his campaign, over 12,000 people saw his poems. Curiously, displaying ads costs nothing unless the user clicks on an ad, which was a rare occurrence in Bruno's contextually incoherent intervention.

Bruno's *Fascinum* (2001) displays live images from different national Yahoo portals. *Fascinum* is a sort of infotainment panopticon that reminds the viewer/user that the media generates distinct ontological frameworks for each demographic. For instance, while yahoo.com displays NBA results, yahoo.co.uk may prefer to highlight the latest soccer scores.

Human Browser is a series of performances conceived by Bruno. Actors were asked to verbalize a stream of live audio that only they could hear via a headset, which was generated by a text-to-audio program pulling textual data from the Internet. *Human Browser* subverts the traditional consumption of digital information by creating a human-to-human interface, and suggests that there are a multiplicity of alternative networks and interactive channels.

Prices of some words			
Keyword	Clicks / Day	Average Cost-Per-Click	Cost / Day
anal	390.0	$0.83	$319.90
art	800.0	$0.52	$409.67
capitalism	30.0	$0.10	$2.74
communism	2.1	$0.16	$0.33
death	92.0	$0.47	$42.66
dream	390.0	$0.17	$63.07
free	5700.0	$1.33	$7,569.23
freedom	5.1	$0.37	$1.88
gay	2200.0	$1.02	$2,239.56
hemorroid	0.5	$0.16	$0.08
language	650.0	$0.37	$237.30
lesbian	740.0	$0.80	$584.62
love	730.0	$1.74	$1,264.72
mankind	8.0	$0.59	$4.70
money	350.0	$0.81	$281.46
net art	0.9	$0.05	$0.05
self	80.0	$0.85	$67.72
sex	7500.0	$0.52	$3,836.79
suicide	18.0	$0.27	$4.72
symptom	23.0	$0.30	$6.83

Prices of some famous people			
Keyword	Clicks / Day	Average Cost-Per-Click	Cost / Day
bin laden	250.0	$0.10	$24.37
britney spears	490.0	$0.30	$144.20
bruno	96.0	$0.06	$5.50
cosic	0.6	$0.05	$0.03
einstein	27.0	$0.18	$4.62
etoy	0.6	$0.05	$0.03
freud	35.0	$0.09	$3.13
god	40.0	$0.27	$10.46
grancher	0.3	$0.05	$0.02
jesus	160.0	$0.16	$25.59
jimpunk	0.1	$0.05	$0.01
jodi	32.0	$0.07	$2.08
lacan	8.0	$0.07	$0.53
manetas	0.2	$0.05	$0.01
marx	24.0	$0.10	$2.36
mouchette	0.2	$0.05	$0.01
napier	17.0	$0.13	$2.15
pavu	< 0.1	$0.05	$0.00
picasso	280.0	$0.12	$32.61
randolph	19.0	$0.05	$0.95
shulgin	0.8	$0.05	$0.04
warhol	150.0	$0.11	$15.95
witten	14.0	$0.12	$1.56

ABOVE *The Google AdWords Happenings*, 2002

OPPOSITE *Fascinum*, webpage, 2001

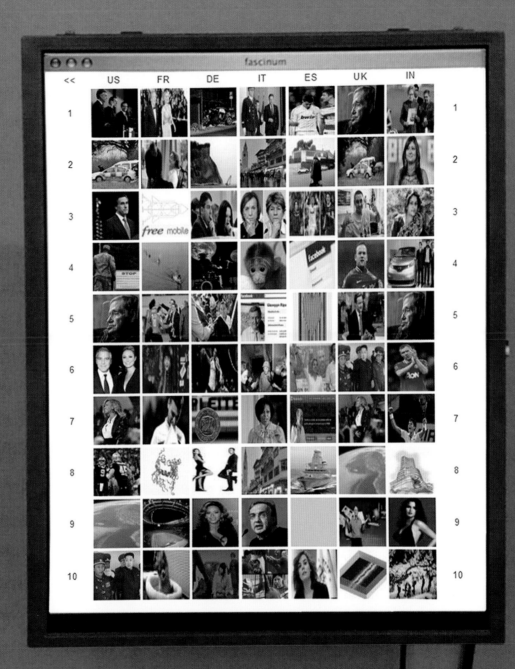

Roisin Byrne

www.roisinbyrne.co.uk

Born 1981 in Dublin, Ireland
GETIS, Moscow, Russia, 2000
BA in Photography and Critical Theory, DIT, Dublin, 2004
MFA in Fine Art, Goldsmiths, University of London, 2009
Lives and works in London, UK.

BYRNE'S practice involves a range of post-conceptual interventions, often appropriating/stealing the works of well-known artists. By tampering with the legal and ethical structures of the contemporary art markets, Byrne provocatively exemplifies the interplay between ideas, property and freedom within elitist culture. While her work may at first appear to be an artistic excuse for a kleptomaniac's habits, she has developed a highly complex and poignant intellectual oeuvre.

In *You Don't Bring Me Flowers Anymore*, Byrne tracked down and stole Simon Starling's Rhododendron ponticum plants from Parque Los Alcornocales, Spain; Starling had originally rescued and transported the plants from Scotland to Spain, returning the plants to the location where they were first cultivated by Claes Alstroemer in 1763. After locating the plants, Byrne smuggled them back in to Britain. Byrne's re-supplanting of the rhododendron functions as a rhizomatic challenge of ownership in contemporary aesthetics.

For *Golden Brown*, Byrne appropriated Santiago Sierra's controversial 160cm *Line Tattooed on 4 People*. In 2000, Sierra had paid four sex workers who were addicted to heroin, with a shot of heroin each, to sit side-by-side each other whilst one large line was tattooed across their backs. Posing as an art journalist, Byrne tracked down one of the original sex workers and the tattoo artist that Sierra had used, and paid to have the tattoo removed by laser from the sex worker, and to have an identical line tattooed onto her back. In effect, Byrne took over the sex worker's role in the artwork. *Golden Brown* encompasses both the final product and the appropriation process that Byrne initiated.

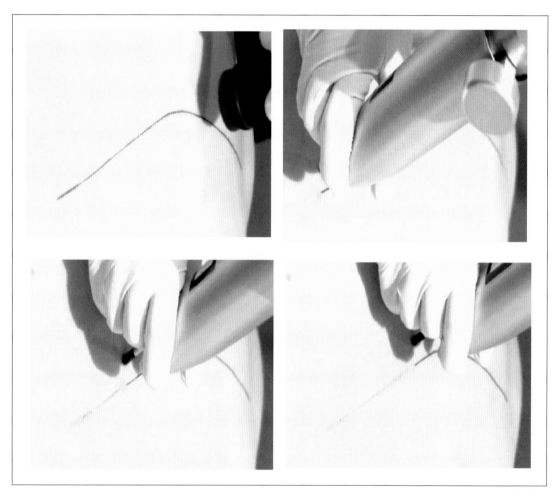

Golden Brown, 2010

RE: your work

From: ▮▮▮▮▮▮▮▮▮▮▮▮▮▮▮▮▮▮▮▮▮▮▮▮
Sent: 31 August 2010 23:37:30
To: ▮▮▮▮▮▮▮▮▮▮▮▮▮▮

Dear Santiago Sierra

So sorry for the delay in my questions to you i really meant to get back to you straight away but with one development and another
i have been waiting for something amazing to come through that might interest you just a little bit i hope!!

Briefly back in 2004 i was introduced to your work through not neccesarily pedagogical nor art related channels, a brief relationship with a massively charismatic and thoroughly unscrupulous charactor who went by the name of Mick liked to tell me stories. I was in Dublin at the time and him just back from Madrid where he bragged that he had made a living, fuelled a habit and got himself by one way or another (ill omit the details!) for nigh on 5 to 6 years. I have to say Mick wasn't neccesarily clean by the time i met him but he told a good story liked a pint and did his business in private and was unfortunatly for me incredibly attractive so we stuck together... for a while at least.

What he told me and how it refers to you Mr. Sierra was that during his time in Spain living on and off with various women -all thoroughly co-dependent in the way that it gets- a time was spent waking stuporously morning noon or night to the visual results of an incident of which no one could remember having ever taken place!! You guessed it, your 160 cm black tattooed line sitting squarely between the 2 points of his ladies shoulder blades which now through him, through you, your work, through 'it' the line has become part of my history also. I guess a mixture of relational jealousy and now after time intrigue partnered with a current fascination in what you do has helped stick this line in my mind like a glue which i haven't been able to shake to date

I met Mick a while back for one reason or another, asked a few questions told him about my article on your work, he made a few calls tracked his ex down and on the 6th of September a meeting has been organised to view the work in Madrid. Flights are booked accomodation is organised and i am as excited as hell and hoping of course that she won't pull out.

So now i am thinking, if it's ok with you, that i fly to Madrid see your work come back and mail you the questions that no doubt will have been informed massively by this incredibly exciting visit.... I CAN NOT WAIT!!! oh and let me know if you'd like a picture............

Best and I'll mail soon
RB

Subject: Re: your work
Date: Wed, 25 Aug 2010 14:36:12 +0200

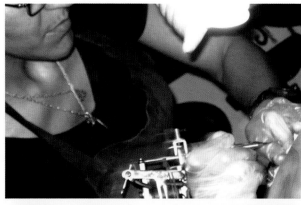

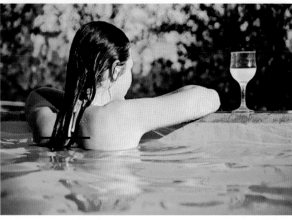

51

Peter Callesen

www.petercallesen.com

Born 1967 in Denmark
Aarhus School of Architecture, Denmark, 1993
Art Foundation, Aarhus School of Architecture, Denmark, 1994
Det Jyske Kustakademi, Arhus, Denmark, 1997
Goldsmiths, University of London, UK, 2000.

"By taking away all the information and starting from scratch using the blank white A4 paper sheet for my creations, I feel I have found a material that we are all able to relate to, and at the same time the A4 paper sheet is neutral and open to fill with different meaning. The thin white paper gives the paper sculptures a frailty that underlines the tragic and romantic theme of my works." Peter Callesen

DANISH CONTEMPORARY artist Peter Callesen often incorporates white paper into his sculptures, drawings, papercuts, installations and performances. With solo exhibitions at the Mjelby Art Museum in Sweden and the Sørlandets Art Museum in Norway, Callesen has also had his works exhibited internationally.

He is unrivaled in his use of negative and positive space in his papercuts, which emphasize the idea that form and content are intertwined. These artworks mystify the viewer as the cutout sculptures play off their incongruent and complementary paperworks and drawings. *Fall* (2008) exemplifies Callesen's tragicomic storytelling and features a silhouette of a blossoming tree from which a three-dimensional sculpture of a skeleton emerges created by using only the paper-sheet from its corresponding tree.

Callesen's performances range from the absurd to the spiritual and profound, and often employ cyclical narratives. In his *Little Peter Spiderman* series he taunts a live spider while singing the 'Itsy Bitsy Spider' nursery rhyme, and in another video he wears a human-size spider suit while repeatedly climbing and falling down. Callesen began experimenting with his *Swan Duckling* character while studying at Goldsmiths, and explains that his *Dying Swan* performances are meant to convey a sense of self-destruction and self-creation. In his performance of *The Dying Swan is Back* (1999) he wore a duck suit while awkwardly attempting to penetrate a man-sized egg, which he eventually breaks and reveals his costume inside.

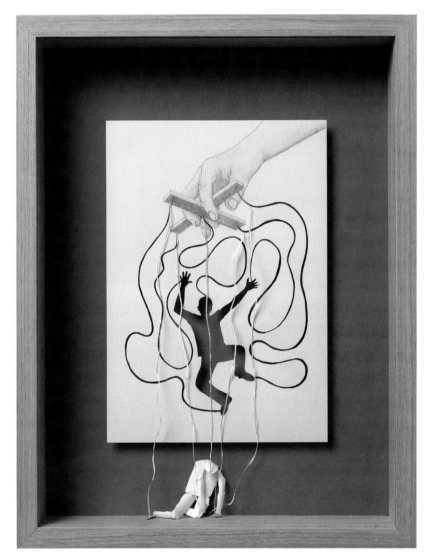

Bound To Be Free, 2006

OPPOSITE *Fall*, 2008

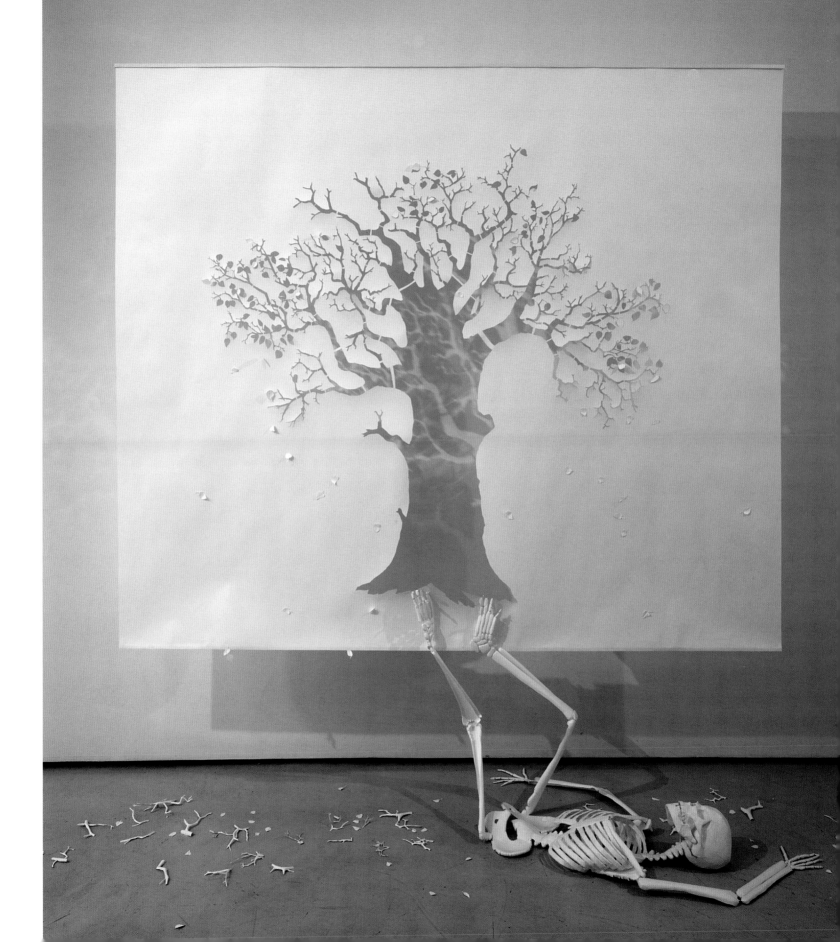

Asger Carlsen

www.asgercarlsen.com

Born 1973 in Denmark
Lives and works in New York City.

"I don't want my pictures to look like diseases from the 1700s. The true challenge is finding the balance between fiction and reality to create something so subtle it almost feels real."
Asger Carlsen, *Vice Magazine* interview, 2011

"When you will have made him a body without organs, then you will have delivered him from all his automatic reactions and restored him to his true freedom."
Antoin Artaud, *To Have Done with the Judgment of God*, 1947

ASGER CARLSEN'S photos are often surreal and visually disorienting. His projects range from art gallery exhibitions of his work to editorial and brand advertising. His work has been featured in publications such as *Wallpaper**, *Vice*, *Esquire*, *Wired* and *Dazed & Confused*. He began his career as a crime photographer and his images are often akin to a Dali-esque crime scene. His photographs exemplify the fact that all images in the digital age are part of an alternative reality. Carlsen experiments heavily and photoshops his images as he fuses limbs with torsos, or interjects a secondary pair of breasts, eyes or toes.

His first photo book, *Wrong*, was a critical success and sold out. *Wrong* featured a diverse body of images ranging from human bodies with wooden feet to unearthly bodies with bulging eyes and eerie appendages. His second book, *Hester*, is composed of a series of works relating to the female nude. The images in *Hester* deconstruct the female form in both a horrific and visually stunning manner. *Hester* resonates with philosopher Gilles Deleuze's *Body without Organs*, a concept that refers to a body that has the 'virtual' potential of mutating and becoming anything. A typical image in *Hester* amalgamates four or five separate bodies into one body, fueling the viewer's imagination.

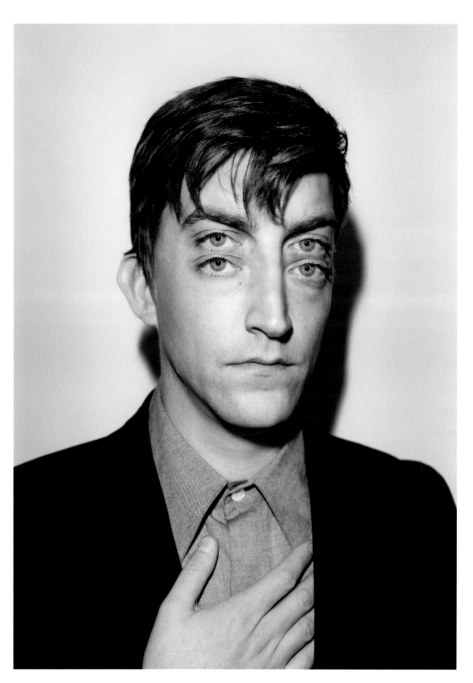

Tim Barber, 2011

Hester, 2011

Aristarkh Chernyshev

Born 1968 in Voroshilovgrad, USSR
Engineering,The Moscow State Technical University, Russia, 1991
Lives and works in Moscow, Russia.

ARISTARKH CHERNYSHEV often works with new media, exploring the manipulation and visual appropriation of data. Also a lecturer and curator, Chernyshev ran Moscow's National Center for Contemporary Arts' Media Lab from 2000 to 2004. He co-founded the Electroboutique gallery in 2004 with artist Alexei Shulgin with whom he has collaborated on projects such as *wowPod* (2008) – a distorted human-sized iPod as a parody of consumerist capitalism. Chernyshev has also collaborated with Vladislav Efimov on projects such as *Bubbles* (2003), an interactive video installation, and *Genetic Gymnastics* (2000–2001), a stop motion film which mocks modernity's positivist aspirations.

Chernyshev's *Urgently* (2007) is referred to as an 'info-sculpture,' and streams live news feeds onto a sinuous LED display board that has been placed in a trash can. *Urgently* can be interpreted as a humorous metaphor for the overload of information in contemporary society, which may only be solved by throwing away the extraneous content that is constantly pushed out by the news. Similar conceptual trajectories emerge from Chernyshev's LED works such as *Lyric Economy* (2005), *Data Leak* (2006), and *Knode* (2009). His *3G International* (2010) helix-sculpture appropriates Tatlin's constructivist *Monument to the Third International* and highlights the affinities of consumerist culture in both socialist and capitalist societies.

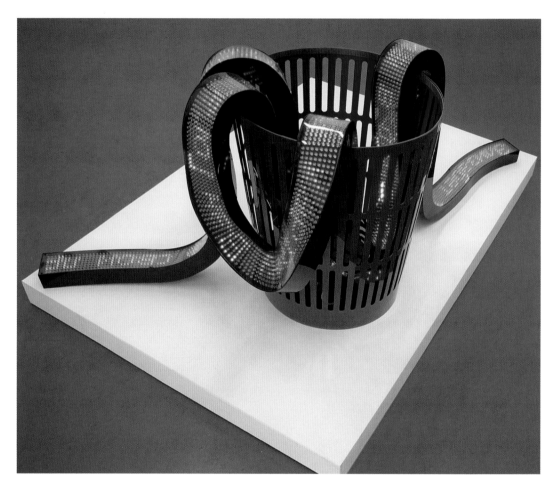

Electroboutique Urgently! info-sculpture, 2007

OPPOSITE *Electroboutique 3G International* Light Sculpture, 2010

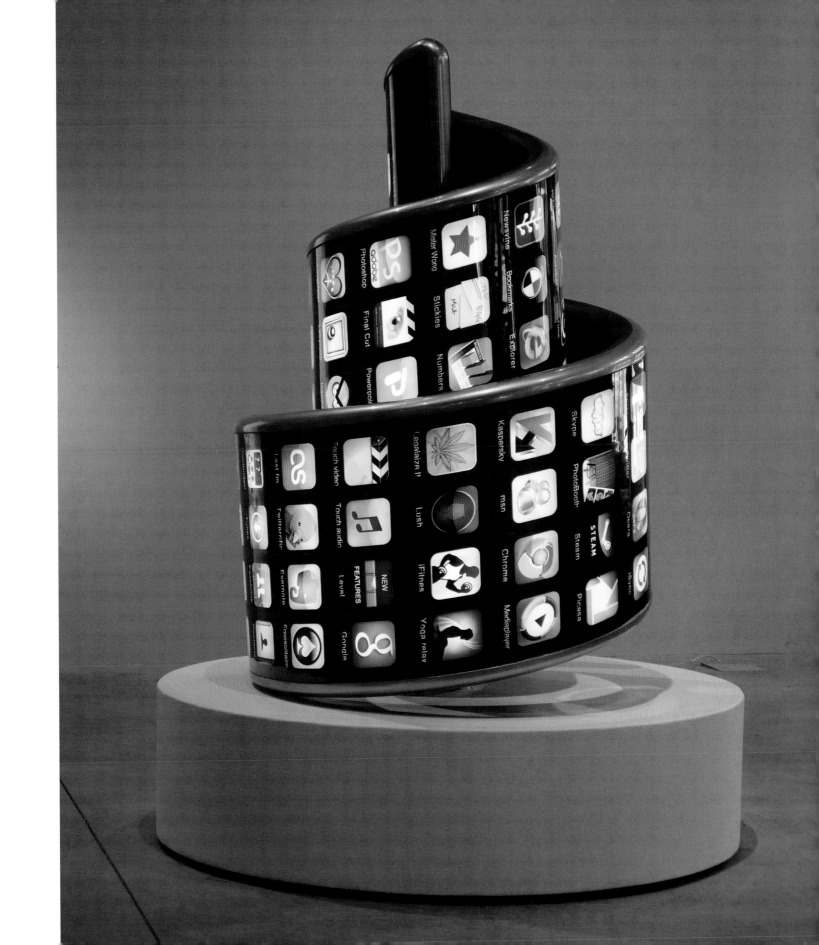

Dan Collier

http://dancollier.co.uk

Born 1986 in Bedford, Bedfordshire, UK
BA, Graphic Design, University of Lincoln, 2007
Living and working in London, UK.

DAN COLLIER is a graphic designer and art director. His clients have included O2, London 2012 Olympics, Sony Play Station, Samsung and the BBC. He was awarded Best New Blood by D&AD in 2007, and his projects have been shortlisted for the Cannes Cyber Lions in 2008 and an IAB Creative Showcase in 2009.

Typographic Links was showcased at the *Talk To Me* exhibition at the MoMA in 2011. Originally created in 2007, *Typographic Links* features a hand-sewn book in which the threads act as physical hyperlinks guiding the reader through the book. Juxtaposing elements of incongruency with textual aesthetics, *Typographic Links* is a truly postmodern art-book.

From innovative posters and social media campaigns to ingenious web design, Collier seamlessly integrates digital data with enticing visuals. In *Apple Z*, Collier created a series of posters that visualize thousands of keystrokes from various design projects. At Syzygy, he designed and led the Avis ArtCar campaign, which invited artists to create custom paint-jobs on a series of rental cars via a Facebook App.

Typographic Links, 2007

59

Typographic Links, 2007

and typography. A appears

compose *sorts* on a frame

which a page would be

This is believed to have

phrases 'Out of sorts' and

your P's and Q's. The

framework of typesetting

inexplicably created the

and other typographic

works. His name roughly

translates to 'Freddy Goosefat of

Goosefat.' Another interesting

name is **Mrs Eaves**. **Frederic**

Goudy Old Style was

by Froben capitals that

believed to have been cut by

Peter Schoeffer the younger, son of

Johann Gutenberg's apprentice.

42-line bible

(1455)

The earliest book in the Western

World to have survived. Consisting

of 1,286 pages and published in two

volumes. There are thought to have

Vuk Ćosić

www.ljudmila.org/~vuk/

Born 1966 in Belgrade, Serbia
BA, Archaeology , University of Belgrade, 1991.

VUK ĆOSIĆ is pioneer of Net.Art and the co-founder of the Ljudmila digital media lab in Slovenia. His philosophical and political art practice challenges contemporary notions of intellectual property, authorship, and emergent behavior. In addition to exhibiting via the World Wide Web, Ćosić has also shown his work internationally in 'physical' locations, including representing Slovenia at the Venice Biennale in 2001.

ASCII History of Moving Images synthesizes Ćosić's interest in film and art history with both antiquated and contemporary technology. In this body of work Ćosić digitized classic films and TV shows – such as Psycho, King Kong, Star Trek, and Deep Throat (as Deep ASCII (1998)) – into animations in which ASCII characters substitute pixels. Conceptual Net.Art has cultivated an alternative – albeit virtual – platform and infrastructure for the Information Age's social and economic systems. Ćosić's Net.Art initiatives range from File Extinguisher (an online service that will ensure the destruction of any file you upload) to 'stealing' the Documenta X 1997 website (by copying before it was shut down and keeping it available on the ljudmila.org website). According to post-structural theorist Maurice Blanchot, 'power' cannot mark its own limit or 'conceive' of a mode of 'non-power', and yet, a non-utilitarian playfulness might provide an alternative – as a form of 'non-power' – that is neither active nor passive, but rather a mode of letting be. Viewed in this light, Ćosić's work synthesizes Dionysian and Apollonian creativity, and illustrates the playful potential of ASCII text.

Duchamp (Nude Descending a Staircase), **1997**

ASCII History of Moving images – Star Trek, **1998**

ASCII History of Moving images – Psycho, 1998

ASCII History of Moving images – Deep ASCII, 1998

e-flux

www.e-flux.com

e-flux was founded in 1999 by Anton Vidokle
e-flux journal is edited by Brian Kuan Wood, Anton
Vidokle and Julieta Aranda.

ANTON VIDOKLE

Born 1965 in Moscow, Russia
Lives and works in Berlin, Germany.

Anton Vidokle was born in Russia, raised
in the USA and currently lives in Germany.
His artwork has been exhibited intern-
ationally including at Tate Modern and at
the Venice Biennale. He is a founding
director of e-flux and has organized and
curated numerous events including the
sixth Manifesta.

JULIETA ARANDA

Born 1975 in Mexico City, Mexico
MFA, Master of Fine Arts, Columbia University
School of the Arts, New York, 2006
BFA, School of Visual Art, New York, 2001.
Lives and works in Berlin and New York.

Juliet Aranda is a co-director of e-flux and
a contemporary artist, writer and curator.
Aranda's practice often relates to social
interactions, circulated mechanisms and
the poetics of time and labor. Her work
has been exhibited internationally
including at the Solomon Guggenheim
Museum, MOCA Miami, the Moscow
Biennial, and the Museum of
Contemporary Art in Chicago.

BRIAN KUAN WOOD

Born 1978 in Seattle, Washington, USA
Lives and works in New York City.

Brian Kuan Wood is the editor of *e-flux
journal*. He is also a prolific writer and critic
on topics ranging from politics, philosophy
and art to literature and architecture. "It
might be useful to think a bit about ways
in which art can be less subject to conditions
that are often conflicting and confusing
by advancing some form of universal
significance to be found in the artistic
act." Brian Kuan Wood, *A Universalism for
Everyone*, e-flux journal, 2011.

E-FLUX is the leading contemporary art email
information service, but it is much more than that:
it also functions as an artistic entity and cultural
incubator. Its news-wire services are used by clients
ranging from museums and art fairs to independent
curators and publishers. e-flux readers include over
45,000 visual arts professionals, of which 18% are
writers/critics, 16% are galleries, another 16% are
curators, 15% are museum affiliated, 12% are artists,
10% consultants, and 8% are collectors. e-flux has
grown to include sister services that also target the art
education market and the commercial gallery industry.
However, what makes e-flux so impressive is its ability
to connect the capitalist and commercial art markets
with radical and alternative art movements. In short,
if you have something to say relating to contemporary
art, e-flux is a great channel to broadcast your
message on - the anarchists and collectors are all ears.

e-flux publishes its own journal, which is filled
with essays from leading critics and writers. And it
publishes books in collaboration with Stenberg Press.
e-flux has also launched a series of special projects
such as *East.Art.Map* (exploring 50 years of visual art
in Eastern Europe) and *Martha Rosler Library* (a library
comprising of over 7,000 books owned by Martha
Rosler from her academic office, art studio and home).
It has even opened a brick and mortar 'art pawnshop'

in New York's Chinatown, where artists can flog their
works for cash; the Pawnshop has been replicated
in several locations including Thessaloniki, Greece.

e-flux's *Time/Bank* project platform enables
anyone to trade their time and skill, and issues a
time-based-currency. In contrast to bartering, *Time/
Bank* focuses solely on the amount of time spent on a
project rather than the end product: "Through *Time/
Bank*, we hope to create an immaterial currency and a
parallel micro-economy for the cultural community, one
that is not geographically bound, and that will create a
sense of worth for many of the exchanges that already
take place within our field - particularly those that do
not produce commodities and often escape the
structures that validate only certain forms of exchange
as significant
or profitable." Julieta Aranda and Anton Vidokle

During Art Basel in 2011, e-flux was given the
opportunity to occupy the Kopfbau (head building),
which has been slated to be demolished. e-flux
converted the space into a constellation of art projects,
including a series of shops (including a reincarnation of
e-flux's Pawnshop), a bar, a hotel, and additional spaces
for artists-in-residence to program. The *Agency of
Unrealized Projects* (AUP) was one of the major exhibits,
which showcased a growing archive of unrealized
projects that were submitted to e-flux via an open call.

A. K. Burns at the launch of *Are You
Working Too Much? Post-Fordism,
Precarity, and the Labor of Art*, Book
Co-op, PS1, New York, October, 2011

TOP LEFT AND RIGHT: *Time/Food* facade, Abrons Arts Center, New York, October, 2011

BOTTOM LEFT: View of *Agency of Unrealized Projects*, Kopfbau, Basel, June 2011

BOTTOM RIGHT: Liam Gillick at the launch of *Are You Working Too Much? Post-Fordism, Precarity, and the Labor of Art*, Book Co-op, PS1, New York, October, 2011

Olafur Eliasson

www.olafureliasson.net

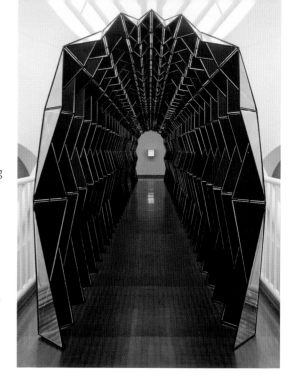

Born 1967 in Copenhagen, Denmark
Royal Danish Academy of Fine Arts in Copenhagen,1995
Lives and works in both Berlin and Copenhagen.

"It's not interesting to make distinctions in this case between architecture and artwork. I have a lot of respect for architectural languages because with them you can say things that you can't say with art and vice versa."
Olafur Eliasson, *Domus* issue 950, September 2011

ELIASSON is an installation artist who has gained international critical acclaim. Eliasson won the Joan Miro prize and his major exhibitions include Tate Modern's Turbine Hall, representing Denmark at the 50th Venice Biennale, and exhibiting at the Hara Museum of Contemporary Art in Tokyo. Eliasson's projects incorporate multiple disciplines and a broad range of collaborators ranging from artists and activists to historians and scientists. He founded Studio Olafur Eliasson, which consists of over 40 people, in order to research and develop his complex projects and spatial research. He has also worked with commercial clients such as Louis Vuitton (designing their Fifth Avenue store) and BMW (a concept car that is framed by layers of ice). His diverse publications include seminal essays and artists' books such as *Your House*, which is a large format, hand-bound volume with 454 digital cross-sections of his home shrunk to a scale of 85 to 1.

Eliasson often utilizes elements such as glass, mirrors, and water, and entices the spectator to experience his works from different angles and modes of spectatorship. Eliasson's *Antispective Situation* at the Venice Biennale created a sort of anti-gravitational time machine, which visitors were able to walk into and explore as the multiple mirrors warped time and space. *Antispective Situation's* kaleidoscopic geometry of spiky forms and odd irregular hexagonal cones generates an awe-inspiring antispective mode for those who enter its reflexive space. Indeed, many of

Eliasson's works mention 'your' in their title, suggesting that the viewer always plays an active role. His *Antispective Situation* also featured in London's 2012 Cultural Olympiad.

His waterfalls challenge traditional Newtonian physics, and include reversed cascading waterfalls and a series of large-scale urban installations. Eliasson's *New York City Waterfalls* were funded by the Public Art Fund at $15.5 million and constructed of 64,000 square feet of scaffolding. Other epic projects include designing the facade of the Harpa Concert Hall in Reykjavik; the facade consists of a quasi-brick structure inspired by Einar Thorsteinn and Buckminster Fuller's crystallographic principles.

ABOVE *Your cosmic campfire*, 2011
Aluminum, color foil, glass, motors, tripod. Dimensions variable. Installation view at SESC Belenzinho, Sao Paulo, 2011

TOP AND OPPOSITE *One-way colour tunnel*, 2007
Stainless steel color effect filter, and mirror 98 1/3 x 67 x 472 1/2 inches; 250 x 170 x 1200 cm.

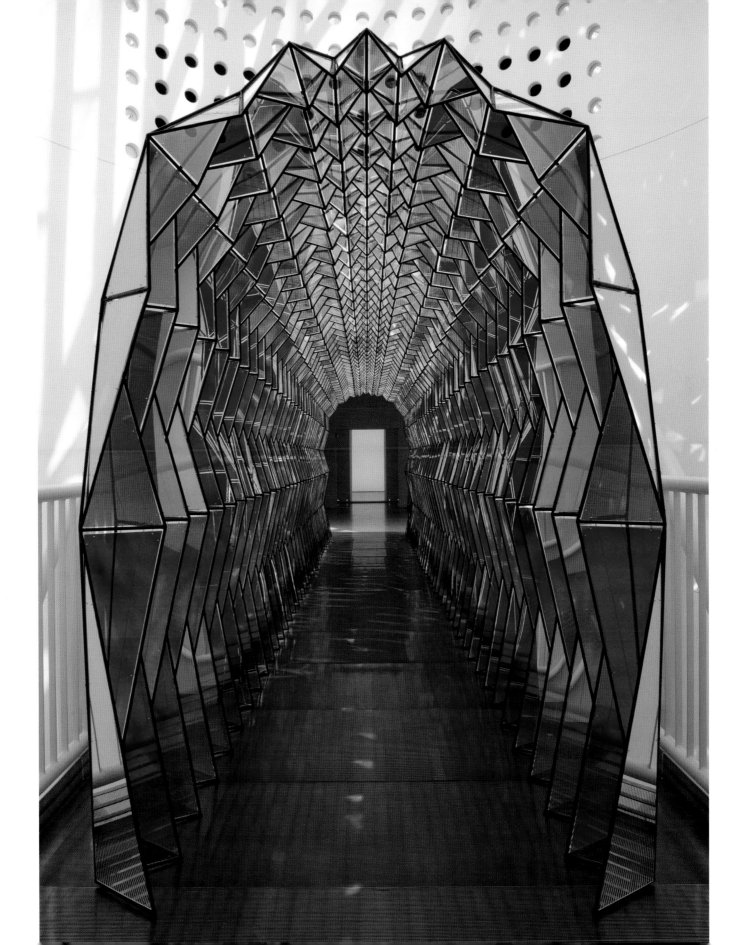

ABOVE AND OPPOSITE *La situazione antispettiva,* 2003

Shepard Fairey

Born 1970 in Charleston, South Carolina, USA
BFA in Illustration, Rhode Island School of Design, USA, 1992
Idyllwild Arts Academy, California, USA, 1998
Lives and works in Los Angeles, California, USA.

"Because people are not used to seeing advertisements or propaganda for which the product or motive is not obvious, frequent and novel encounters with the sticker provoke thought and possible frustration, nevertheless revitalizing the viewer's perception and attention to detail. The sticker has no meaning but exists only to cause people to react, to contemplate and search for meaning in the sticker."
Shepard Fairey

SHEPARD FAIREY is one of the most influential living visual artists. He has worked in a variety of media creating illustrations, stickers, screen-prints, collages, canvas and stencils. Fairey has exhibited internationally and his works are in the permanent collections of leading cultural institutions such as MoMA in New York City, the Victoria and Albert Museum in London, and the Los Angeles County Museum of Art.

Fairey's artistic endeavors began within the skateboarding scene of the 1980s, and he would place his illustrations on T-shirts and skateboards. His countercultural *Andre the Giant* 'OBEY' stickers street campaign elicited a great deal of reaction, and appealed to a much larger and more mainstream audience than he had initially expected. His *Obama Hope* poster became one the iconic symbols of Obama's 2008 election campaign, and was a major factor for *GQ* naming Fairey as a Person of the Year for 2008.

Fairey is also an entrepreneur and started his own small printing business right out of college; Alternate Graphics, which specialized in silkscreens and T-shirts. In 2003, he co-founded a design agency with his wife, Amanda Fairey, which produced the artwork for a Black Eyed Peas' album, a poster for Joaquin Phoenix's *Walk the Line* film, and the cover for a Smashing Pumpkins' album. Fairey also started *Swindle Magazine* with Roger Gastman, which highlighted street artists such as Banksy, Invader and Grandmaster Flash.

His cultural influence has been widespread – from stylizing Lance Armstrong's racing bike and creating a Google Doodle for MLK's birthday to Djing at nightclubs to raise awareness of diabetes, and appearing in a Simpson's episode. His graphic designs have been featured twice on the cover of *Time Magazine*'s Person of the Year issue (honoring the 'protester' in 2011 and featuring his *Obama Hope* poster in 2008).

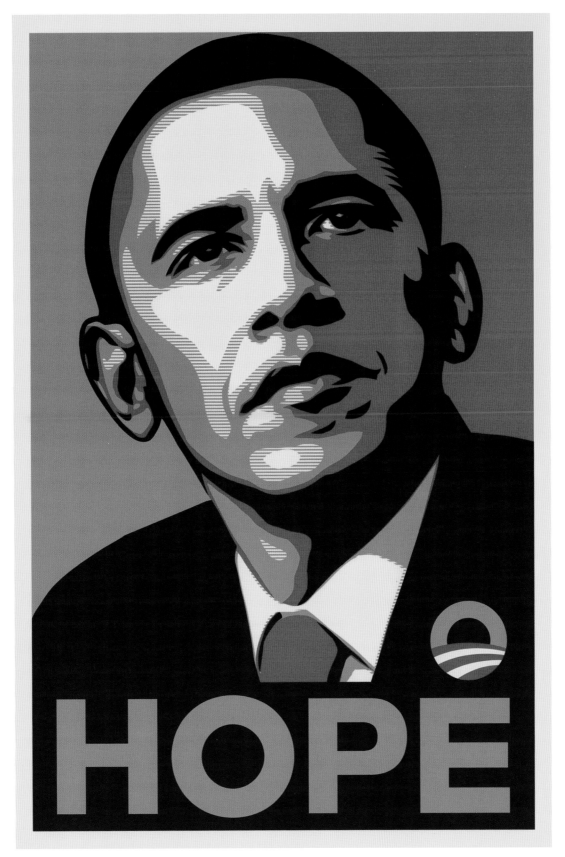

Obama Hope poster, 2008

Sunshine Frère & Jenny Pickett

http://sunshinefrere.wordpress.com
http://www.apo33.org/pow

SUNSHINE FRÈRE
Born 1979 in Canada
BFA, Studio Arts/Electroacoustics, Concordia
University, Montreal, 2005
MA, Interactive Media, Goldsmiths,
University of London, 2007
Lives and works in Vancouver, Canada.

Sunshine Frère was an active curator at Tenderpixel Gallery from 2007 to 2011. Frère was also the co-founder and co-curator of Dirty Square Gallery from 2009-2010. She is currently working on a book documenting the Dirty Square Gallery project due for publication in 2012.

JENNY PICKETT
Born 1978 in England
MA, Interactive Media, Goldsmiths,
University of London, 2007
Lives and works in France.

Jenny Pickett is a British artist based in Nantes, France, where she is an artist and researcher at APO33. She is also a former director of the A10: Media Lab.

JENNY PICKETT AND SUNSHINE FRÈRE met while studying in the same class on Goldsmiths' Interactive Media MA. They began collaborating almost immediately and have produced a range of interventions and exhibitions. Their creations share an open-source ideology and experimental sense of cultural subversiveness that serves both as a critique and a satire of post modern capitalism. Their collaborations include *Putting It Out There*, *If I Can't Have You No One Can*, *Exquisite Corpse Program*, and *Hack Job*.

In *Putting It Out There*, they created ten Myspace identities, which corresponded to ten unique and hand-made electronic sculptures that had been created and discarded in public locations – similar to their *Exquisite Corpse* project that also entailed cultural hacking and the dissemination/destruction of the artwork. The discoverers of each object were encouraged to log-on to Myspace (passwords were provided on the object) and hack into a 'virtureal' space with interlinked identities; indeed, all of the objects were already Myspace friends. For example, *Bless-You* is described as "A digital hand-grenade, *Bless-You* sneezes when squeezed. He embodies a heady mix of sonic and biological weaponry. Aimed at mass audio and viral communications, *Bless-You* is the epitome of a violently sexy media bomb!"

Pickett and Frère's playful antics further challenged notions of contemporary commerce by encouraging gallery visitors to destroy art – as a form of creation – in their exhibition *If I Can't Have You No One Can*. The artists offered buyers and gallery enthusiasts the choice of either paying full price for an object, or paying a fraction of the price to have the object destroyed – thereby preventing someone else from owning the object. Each destroyed item underwent a random and documented destruction process ranging from burning in fire to drowning in resin. Finally, the buyer was presented with a 'destroyed' object, beautifully packaged, along with a DVD documenting the object's destruction. Many of the objects, which included sculptures of icons such as Bill Gates and Michael Jackson, were destroyed throughout the exhibition, and the act of destruction became an inseparable element of the artwork.

Wheel of Death, If I Can't Have You No One Can, 2008

Broken Soldiers, If I Can't Have You No One Can, 2008

Alexandra Daisy Ginsberg

www.daisyginsberg.com

Born 1982 in the UK
MA in Design Interactions, Royal College of Art, London, UK, 2009
MA in Architecture, Cambridge University, UK, 2004.

ALEXANDRA DAISY GINSBERG is an artist, theorist and designer who explores the alternative futures in which we 'design nature.' She is an advocate of synthetic biology and has led a series of projects and workshops that foster relationships between artists and scientists. She has also lectured at TED Global and PopTech, written for *Wired* magazine and published several academic articles and sci-fi short stories.

Early Exit is a short film by Ginsberg that posits a future in which citizens have the option of receiving cash while they are young if they pledge to be euthanized at a reasonably 'early' point in time. Just as Jonathan Swift's *A Modest Proposal* satirically recommends that the poor sacrifice their young, *Early Exit* sardonically suggests a commercial form of euthanasia. By opting for an early exit and pledging to die at age 70, the citizen will receive funds to "invest in life" and will be able to avoid the costly and difficult processes of old age. Although *Early Exit* suggests a perverse transaction, there are mutually economic benefits such as decreased health care costs for the elderly and an increase in income for the signee.

The *Supertask* is a series of collaborations between Ginsberg and Sascha Pohflepp that explore the computational modeling of physical interactions. The *Supertask* includes *Yesterday's Today*, an exhibition at the LJMU Gallery in Liverpool, which allowed visitors to experience the temperature that was predicted by the Weather Channel yesterday for today. *Yesterday's Today* serves as a homeostatic example of our ability to manipulate the environment and blurs the boundaries between the virtual and the physical.

Yesterday's Today, **Supertask** series, 2011.
The air conditioning system ensures that today's temperature will always be whatever was forecasted yesterday, and the graph plots the difference.

Early Exit, 2008

Christian Giroux & Daniel Young

http://cgdy.com

Christian Giroux born 1971 in Kingston, Canada
BFA University of Victoria, MFA Nova Scotia College of Art and Design.

Daniel Young born 1981 in Toronto, Canada
interdisciplinary degree in Urban Geography, University of Toronto.

DANIEL YOUNG AND CHRISTIAN GIROUX are Canadian artists who have been collaborating since 2002. Their work spans sculpture, film installations and public art. Their work has been exhibited internationally and in 2011 they won the prestigious Sobey Art Award. Their sculptural objects often utilize mass consumer goods that are transformed into architectural prototypes.

Christian Giroux teaches at the University of Guelph, Ontario, and Daniel Young is currently an artist in residence at Kunstlerhaus Bethanien, Berlin. Their artistic collaborations strike a fine balance as they are able to tackle academically diverse concepts, but also present and package their ideas as both aesthetic and legible art pieces for anyone to enjoy.

In *Access* (2004) Young and Giroux created a sculpture out of galvanized steel ductwork, which fused a series of ventilation ducts into one cube-like structure with no entry or exit. Constructed out of HVAC ducting, which is normally used to ventilate office spaces, its closed circuit formation subverts traditional notions of flow and movement. As a self-contained and self-reflexive sculpture, *Access* becomes a parody of a post modern membrane.

Mr. Smith (2011) is a stunning sculptural work made out of triangular plywood struts and cast aluminium joints; *Mr. Smith* refers to architect and art theorist Tony Smith, a pioneer of American minimalist sculpture. In *Kermit* (2008) Giroux and Young transformed Ikea furniture into an abstract sculpture inspired by Boolean algebra. Utilizing Boolean operations such as subtraction via CNC controlled cuts, and the additive folding of powder-coated aluminium boxes, *Kermit* is the product of a chance permutation within a modernist grammar.

***Kermit*, 2008**
Powder coated aluminium, Ikea & components,
54.6 x 54.6 x 99 cm/ 21.5 x 21.5 x 39 in

***Mr. Smith*, 2011**
Cast aluminium, plywood & components,
height: 4 m/13 ft, dimensions variable

Antony Gormley

www.antonygormley.com

Born 1950 in London, UK
Archaeology, Anthropology and the History of Art,
Trinity College, Cambridge, UK, 1971
Sculpture, Slade School of Fine Art, University College,
London, UK, 1979.

"To use an archaic device of elevation (both of value and physical height) for the display of contemporary sculpture in the context of a collectively occupied and politically charged square at the centre of London is a wonderfully risky business, but one well worth the biscuit." Antony Gormley, *The Independent* (July 2010)

ANTONY GORMLEY is a contemporary artist best known for his sculptures. However, he is much more than a sculptor, and his artistic practice includes architecture, performance art, set design for theatre and film, and drawings. Gormley's list of accolades is extensive: He won the Turner Prize in 1994, was knighted as an Officer of the British Empire in 1997, became a Royal Academician in 2003, and won the 2011 Laurence Oliver Award for Outstanding Achievement in Dance for designing the set for Sadler's Wells' *Babel* (Words). Gormley is also is an Honorary Fellow of the Royal Institute of British Architects, and trustee of the British Museum.

Gormley's body-work sculptures are often modelled after his own body's shape and form. Even *Horizon* (2007 in London; 2010 in New York) featured 31 life-size sculptures spread throughout the city-space and installed on major sites. *Angel of the North* (1998) is a 66-foot tall winged statue in northern England, which is considered to be a national icon. A man-sized maquette of *Angel of the North* was auctioned in 2008 for £2 million.

Gormley's projects often explore the sensation of memory, the void of the body, and emergent forms. For his Fourth Plinth Commission for Trafalgar Square in 2009, he created a 100-day public art project, *One & Other*, which enabled 2,400 members of the public to each occupy the plinth for one hour and do anything they wanted. *One & Other* democratised performance art and ran 24 hours a day as well as being streamed online.

OPPOSITE *Spleen II*, **2002.**
Mild steel blocks, 25 x 25 x 50 mm 160 x 53 x 73 cm. Private Collection.

***Event horizon*, 2007.**
27 fibreglass and 4 cast iron figures
Each element: 189 x 53 x 29 cm. Installation
view, Rotterdam,
The Netherlands.
A Hayward Gallery Commission.

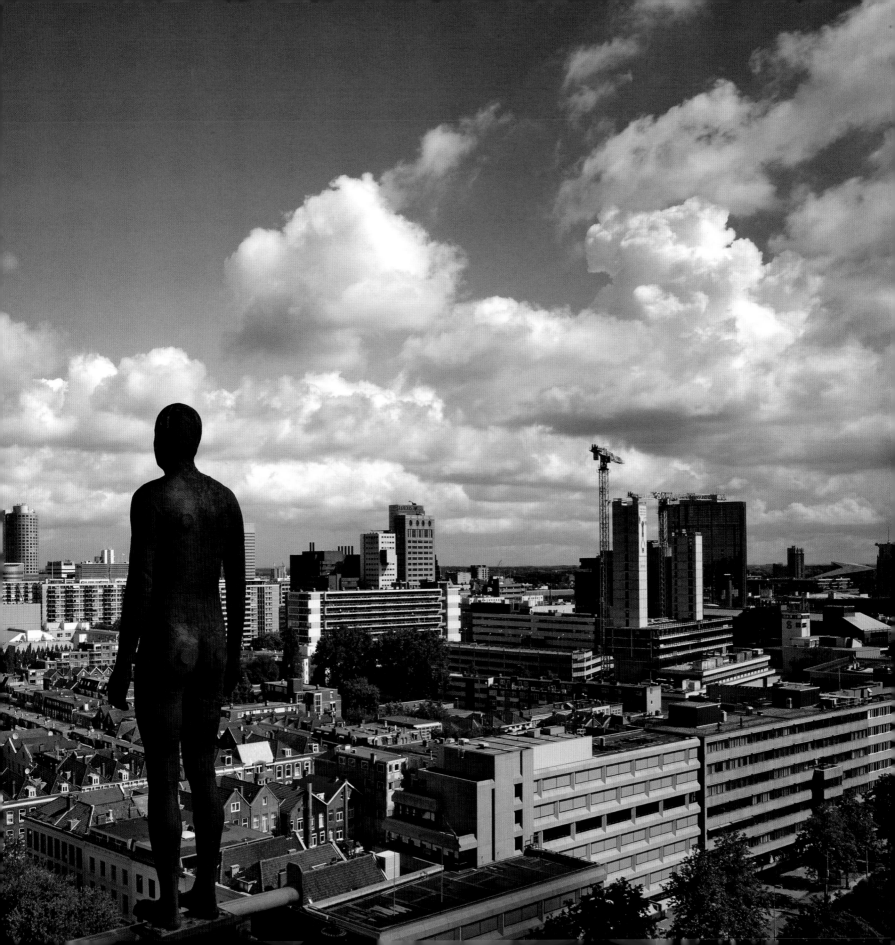

Usman Haque

www.haque.co.uk

Born 1971 in Washington DC, USA
Architecture, the Bartlett School of Architecture, London, UK, 1996
Lives and works in London.

"Traditionally, architecture has been thought of as hardware: the static walls, roofs and floors that enclose us. An alternative approach is to think of architecture as software: the dynamic and ephemeral sounds, smells, temperatures even radio waves that surround us. One might also consider the social infrastructures that underpin our designed spaces. Pushing this analogy even further, we can think of architecture as a whole as an "operating system", within which people create their own programmes for spatial interaction." Usman Haque, March 2007

USMAN HAQUE is a multidisciplinary researcher, artist, designer and architect. His work has won numerous accolades including the London Design Museum's Interactive Design of the Year award, the Swiss Creation Prize, and the Wellcome Trust's Sciart award. Haque's work has been exhibited internationally, including shows at the Institute of Contemporary Arts in London, Transmediale, Ars Electronica and at the National Art Museum in Beijing, China.

Haque studied at the Bartlett School of Architecture in the 90s and has been combining practice with theory as he develops and designs interactive architecture. His articles and essays explore issues such as the design of participatory systems, augmented reality and open source architecture. Haque has integrated his theory into many of his projects. *Primal Source* was an art installation at the Glow 08 festival, composed of a projection onto a screen of water and mist which responded to the sounds and movements of the festival visitors. *Primal Source* was built with open source software tools *Processing* and *Pure Data*, which received and processed incoming live signals from eight different microphones.

Remote, Still image from Second Life, 2008

Remote (2008) interconnected a physical room in Boston with a virtual room in Second Life. The items in each space were designed to match such that the movement of any item in either place initiated a symmetrical movement in the other. This coupling formed a single meta-environment, which blurred the boundaries of the physical and virtual. In *Open Burble* (2008), Haque created an interactive floating structure with balloons filled with LED lights, which would light up in response to text messages. Most impressively, the assembly of *Burble* involved voluntary participation, which enabled the public to contribute to the creation of its design.

In *Haunt* (2004), he built an environment that was most likely to induce visitors to view a ghost. The space was constructed according to his research of the types of places that are associated with a haunted sensation; the humidity level, temperature, electromagnetic and sonic frequencies were optimized; for example, haunted places tend to have an infrasound frequency around 19Hz, which is also a resonant frequency for causing the eye's cornea to oscillate. Similarly, a sudden temperature shift can make the hair stand on end. *Haunted* (2004) doesn't attempt to explain the paranormal nor mock it, but rather to explore the psychology of human perception and its relation to its architectural surrounding.

OPPOSITE *Burble London*, Holland Park, 2007

Primal Source, Santa Monica, California, 2008

Damien Hirst

www.damienhirst.com

Born 1965 in Bristol, UK.
BA in Fine Art, Goldsmiths, University of London, UK 1989
Lives and works in London and Devon, UK, and in Baja, Mexico.

"Art is about magic, so something like the shark, I imagined it was one thing and what actually appeared when I made it was beyond that." Damien Hirst, *The Guardian* (April, 2012)

DAMIEN HIRST might just be the most influential living artist today, and no serious contemporary art museum collection would be complete without one of his pieces. Hirst's oeuvre defies categorization. An avid collector and philanthropist, his creative endeavors have encompassed countless media including film, music video, conceptual artwork, painting, and sculpture. In addition to being one of the best selling artists in history, he is also a successful entrepreneur, collector and visionary.

Hirst emerged from obscurity as one of the Young British Artists in the 1990s, and won the Turner Prize in 1995. His artworks are often provocative and transgressive and feature death as a motif. For example, *Two Fucking and Two Watching* included a rotting bull and cow and was banned by New York health officials. Similarly, Hirst's 2003 exhibition, *Romance in the Age of Uncertainty*, at the White Cube gallery in London, alluded to Jesus and his 12 disciples with a set of gory vitrines and included a dead cow's head jammed with scissors.

In 2008, Hirst bypassed the traditional 'White Cube' show literally and figuratively by having an exhibition, *Beautiful Inside My Head Forever*, auctioned directly at Sotheby's. The show fetched the largest sum in history for a one-artist auction (over $190 million), and included *The Golden Calf*, a calf preserved in formaldehyde with gold plated horns and hooves, which sold for $18 million. Hirst's blockbuster retrospective at Tate Modern in 2012 featured over 70 works, ranging from a two-room installation with hatching butterflies to his spot paintings and student works from the 1980s. The big question is what will be the new additions to Hirst's retrospectives 30 years from now.

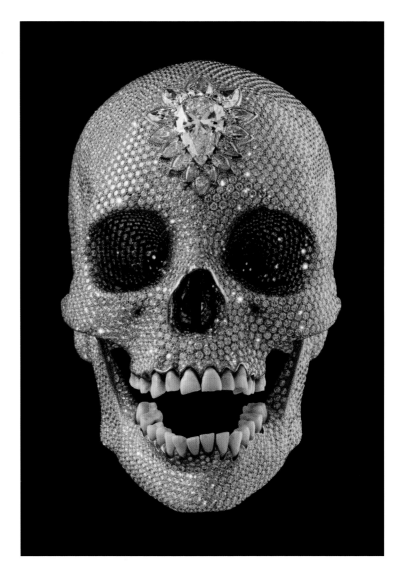

ABOVE *For the Love of God*, 2007

OPPOSITE *Psalm 27: Dominus illuminatio*, 2008

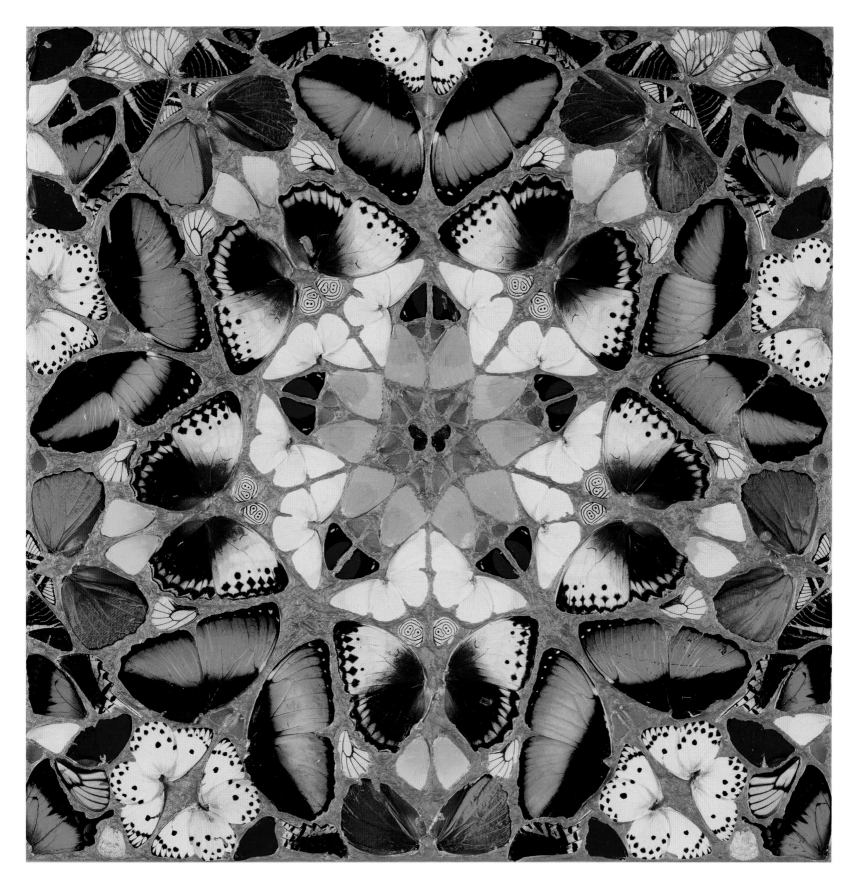

Carsten Höller

Born 1961 in Brussels, Belgium.
PhD in Agricultural Entomology, University of Kiel, 1988
Lives and works in Ghana and Stockholm, Sweden.

"The surprise of the slide is that it is a repeatable surprise."
Carsten Höller, *Frieze* magazine, Issue 85, 2004

CARSTEN HÖLLER is a contemporary German artist best known for his interdisciplinary projects that combine science, philosophy, art and architecture, and challenge the boundaries of contemporary art. His major exhibition venues include the Turbine Hall at Tate Modern in London, the Garage Center for Contemporary Art in Moscow, and the New Museum in New York City. Höller and his Swedish wife, Miriam Bäckström, represented Sweden at the 2009 Venice Biennale.

Höller initially trained as a scientist before becoming an artist. He holds a doctorate in agricultural science and was a research entomologist. Like his interests, Höller's projects are incredibly diverse. His artworks actualize his thought experiments and resemble a science laboratory, and often utilize performances, slides, mirrors, animals and games. *Frisbee House* (2000) featured an inundated room of Frisbees while *Sliding Doors* (2003) enabled visitors to walk through a set of five mirrored, automatic sliding doors and experience a pseudo-infinite hallway. Similarly, Höller's gigantic slide installation, *Test Site* (2006), was part of the Tate's Unilever Series and

created a playfully interactive structure that transformed the Turbine Hall into a mega-playground. These corkscrew slides are part of an ongoing project which began at the Berlin Biennale in 1998 and has included installing a slide in the office of Miuccia Prada in Milan in 2002; Höller asserts that various studies indicate that using slides can reduce stress and combat depression while increasing happiness levels.

His oeuvre expands the boundaries of contemporary art while radically experimenting with the integration of identity and perception. *Mirror Carousel* (2005) consisted of an unconventional merry-go-round filled with illuminated mirrors, and *Upside Down Goggles* (1994/2001) literally flipped the user's vision. Höller's training as an entomologist may have led him to wonder what differentiates humans from insects, and he has also created a series of structures intended for interactions between humans, pigs, birds, reindeer and mice.

Sliding Doors, **2003**
Installation view: Carsten Höller, Une exposition à Marseille, mac musée d'art contemporain, Marseille, 2004

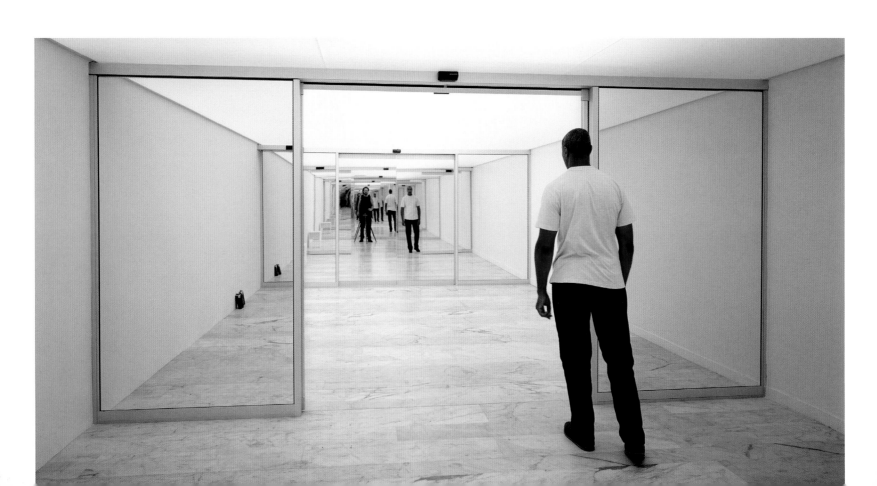

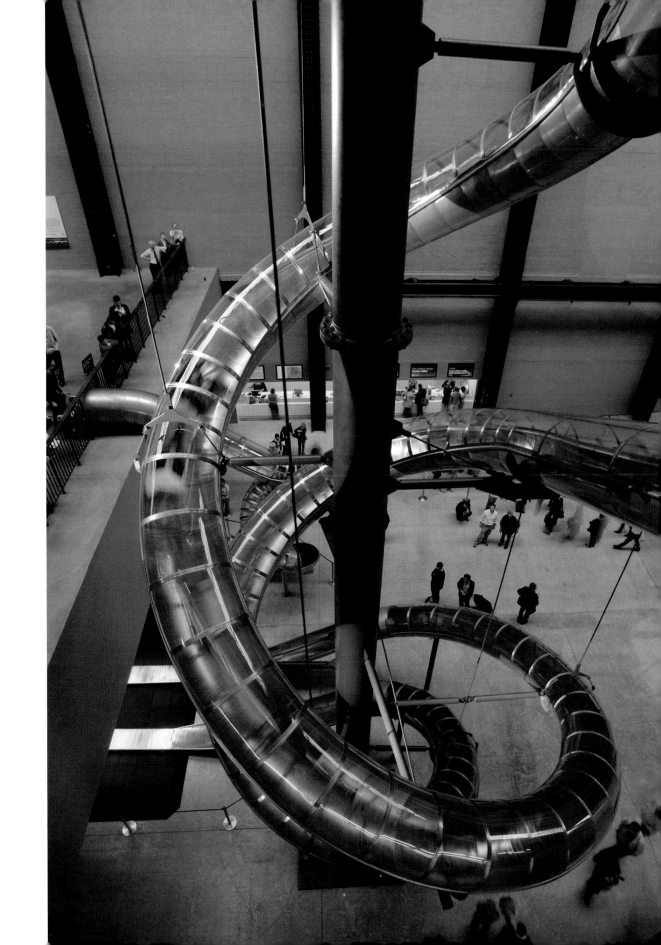

Test Site, 2006
Installation view: Unilever Series : Carsten Höller,
Turbine Hall, Tate Modern, London 2006

Jang-Oh Hong

Born 1974 in South Korea
MFA Goldsmiths, University of London, 2009
Lives and works in Seoul, Korea.

JANG-OH HONG, like many international artists, came to London in 2007 to pursue an MFA degree at Goldsmiths. In addition to obtaining his Masters degree, Hong was able to develop a deep range of conceptually rich and aesthetically stunning work. Skilled in many crafts, his work encompasses a diverse range of materials, from found objects, such as broken glass, to light installations. Hong creates stunning multi-media work that has been shown internationally, including exhibitions throughout the UK and Korea.

In *Blackout*, a solo exhibition, Jang-Oh Hong explores the multiple manifestations of light as a professional implementation, conceptual tool and physical phenomenon; Hong experiments with the transformation of an art-object when it becomes 'over-exposed' through a reverse-method of lighting, resulting in the subversive disappearance of the art-object. Hong generates a destructive interference where light blurs his drawings' colors and shapes. The exhibition's centerpiece is *Lucy in Black*, a large black diamond on the wall, which is distorted by lights

Untitled, 2007

shone not on the image but into the eyes of the viewers. Through the reversed relationship between light and object, Hong's contrary atmosphere encourages viewers to rethink notions of conventional perception and contemporary enlightenment. Traditionally, light symbolises spiritual awakenings, transcendental experiences, and a positivist framework with Renaissance rationality and liberty. Similarly, within an art context, lighting is aimed at highlighting rather than interrupting. However, in *Blackout*, Hong's interest is in light's ability to distort its target, in this case his paintings, by blinding the spectator.

In *Hong's Dysfunction Jewelry* series, he created a series of sculptures out of recycled broken glass, which were mounted onto rings and brooches. These meticulous creations involved great skill and dexterity, and are extremely fragile; the jewelry is only aesthetically functional as it would shatter all too easily if worn. As a result, Hong's work questions the boundaries between expectation and opposition, practicality and beauty.

Colourless, 2007

Lucy in Black, 2010

Pierre Huyghe

Born 1962 in Paris, France
École Nationale Supérieure des Arts Décoratifs, Paris, France, 1985
Lives and works in New York City.

"Technology allows us to use all sorts of things, to quote, to sample. There's a stronger output of images and stories as well as a stronger need to understand what one is being supplied with. But nobody wants to be just a continually fed terminal. One would like to be able to inhabit one's own culture, to participate in it." Pierre Huyghe, *Artforum* (June 2010)

PIERRE HUYGHE is a polymath who exemplifies the increasingly hybridized creative output of contemporary art. Huyghe is a filmmaker, installation artist and conceptual artist. He has also lectured on aesthetics and visual media, as well as working on several books. Huyghe's works have been shown at the Sundance Film Festival, Documenta, Kunstmuseum Basel, and at the Guggenheim Museum in New York. He represented France in the 2001 Venice Biennale where he won a jury prize for *Le Château de Turing*. Other accolades include winning the Guggenheim's Hugo Boss Prize in 2002 and the Smithsonian American Museum's Contemporary Artist Award in 2010.

Huyghe's works expand the boundaries of traditional genres and render environments in which fact and fiction coalesce – suggesting that the everyday is indistinguishable from the surreal. The *Host and the Cloud* (2009–2010) was a site-specific installation in Paris' abandoned National Museum of Art and Popular Traditions; the museum was populated by performance artists, who lurked about in different rooms and enacted a range of roles (museum staff, a couple having sex in a corner, a re-enactment of a terrorist trial, etc...) and would occasionally improvise in response to a visitor. Like many of Huyghe's other projects, *The Host and the Cloud* was also made into a stunning and engaging film. For *A Journey that Wasn't* (2006) he searched for albino penguins in Antarctica and then recreated his journey with a musical performance in Central Park, and a video installation at the Whitney Biennial.

The Third Memory (1999) is a two channel video that Huyghe created by juxtaposing footage from Sidney Lumet's film *A Dog Day Afternoon* (1975) with a reconstruction of the 'true' events based on John Stanley Wojtowicz' present-day recollection of the infamous bank robbery. Like Roland Barthes' 'third meaning', which suggests that every image has its own 'accidental' meaning, Huyghe's *The Third Memory* illustrates the fragility of memory and perception, and the impossibility of seamless communication. In *This is Not A Time for Dreaming* (2004) Huyghe produced a film with a puppet show that tells the story of Le Corbusier's commission to design the Carpenter Center at Harvard alongside Huyghe's commission for the building's 40th anniversary.

No Ghost Just a Shell (1999) is a series of collaborations initiated by Huyghe and Philippe Parreno where they bought the intellectual property rights to a manga figure, which they named 'Annlee'. Huyghe and Parreno commissioned several artists to create artworks with Annlee's character, which resulted in animations, posters, drawings, paintings, and sculptures. Finally, they assigned the copyright for Annlee to herself – thereby preventing other artists from modifying her. Other innovative conceptual projects include planting a garden with trees from different holidays (e.g. evergreens for Christmas, pumpkins for Halloween and roses for Valentine's Day) and letting them compete for space resources.

Two Minutes Out of Time, 2000.
Beta digital, 4 minutes.

A Journey That Wasn't, 2005
Super 16mm film and HD video transferred to HD video,
color, sound; 21 min, 41 sec.

Ryoji Ikeda

www.ryojiikeda.com

Born 1966 in Gifu, Japan
Lives and works in Paris, France.

"Mathematicians are so free, they are like poets."
Ryoji Ikeda, 2012

RYOJI IKEDA has achieved notoriety as both a visual
artist and electronic composer. He has produced
several critically acclaimed albums including *Matrix*,
which won the Golden Nica Award at Prix Ars
Electronica in 2001. Ikeda's art installations have been
exhibited at the Centre Pompidou in Paris, Tate Modern
in London and the Museum of Contemporary Art Tokyo
to name but a few of the international venues where
his work has either been displayed or performed.

 Datamatics is a series of new media works that
Ikeda has created that experiment with abstract codes
and their digital representation. *Datamatics* includes
the *Transfinite* installation at the Armory's Wade
Thompson Drill Hall in New York, a large-scale
installation that enabled participants to be fully
immersed in the world of binary data. Although the
pulsating black and white stripes and electronic
ambient sounds resemble the movie *Tron*, *Transfinite* is
more than a CGI intensive movie - it is a physical
manifestation of virtual data, which alters and
challenges the viewer's perception of reality. The
mathematical definition of transfinite is a number
that is not quite infinite but is larger than finite -
Ikeda's *Transfinite* installation encompasses a raw
amount of data that is both finite and yet mind-
boggling to the imagination. *Transfinite* features a
range of digital data from coordinates of solar systems
and human DNA to white noise and arbitrary data.

 Ikeda is inspired by mathematicians and is
enchanted by the concept of infinity and the sublime.
He employs minimalist aesthetics with cutting-edge
technology, and often constructs rhythmic patterns

out of corrupt data such as hard-drive errors. Ikeda's
radical sonic works are occasionally at the threshold
of human hearing. His albums include *+/- [the infinite
between 0 and 1]*, *0°C*, *Dataplex*, *Test Pattern* and *Op*.
Ikeda possesses an elusive and enigmatic persona
and although he is extremely prolific, and exhibits
internationally, he is unwilling to be photographed
and only gives interviews on rare occasions.

Transcendental (π) (n°1-a), **2008**
Stainless steel etching, wooden plinth.

Datamatics [prototype-ver.2.0] 2006–2008
Audiovisual concert

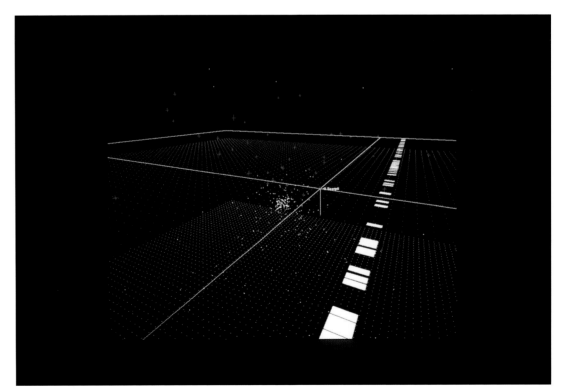

INK Illustration

www.inkillustration.com

RACHEL GANNON
Born 1983 in London
Illustration, Norwich School of Art and Design, UK, 2005
MA, Communication, Art and Design, Royal College of Art, London, UK, 2007.
Rachel's prolific projects include a book about 1950s fashion inspired by visiting the older adult wards at the Royal London Hospital. She also lectures at Norwich University College of the Arts and the University of Bedfordshire, and has been a visiting lecturer at the University of the West of England, University of Westminster and Camberwell College of the Arts.

CHLOÉ REGAN
Born 1982 in Birmingham, UK
BA, Visual Communication, University of Central England, 2005
MA, Communication Art and Design, Royal College of Art, London, UK, 2007.
As well as being a founding member of INK Illustration, Chloe both practices individually and runs an illustration department as a Senior Lecturer.

FUMIE KAMIJO
Born 1980 in Tokyo, Japan
BA, Illustration, Camberwell College of the Arts, 2005
MA, Communication Art and Design, Royal College of Art, London, UK, 2007.
In addition to her work with INK Illustration, Kamijo is also a successful entrepreneur and co-founder of Bobby Dazzler dolls. Bobby Dazzlers are a series of unique and hand-made dolls that are sold in the UK and Japan. Kamijo's work has surreal qualities and captures the dark and slightly sinister aspect of human behavior.

INK Illustration is a collaborative of Fumie Kamijo, Rachel Gannon and Chloé Regan founded by the three artists when they met at the Royal College of Art. The illustration collective work individually as well as collaboratively on a wide range of commercial and personal projects including curating, editorial work, retail, museum installations, craftwork and exhibitions. They have worked with a diverse range of clients such as Somerset House, Natural History Museum, Victoria and Albert Museum, *Varoom Magazine*, and the ICA. INK Illustration continually investigate drawing in its broadest sense through their illustration and design practice, and through academic research.

INK Illustration's *Invisible Library* exhibition at Tenderpixel gallery involved the creation of imaginary books. Part meta-fictional exercise, part postmodern experiment, INK materialized a series of imaginary books (whose only previous existence was through being mentioned in other books) by illustrating the hardcovers for these books and leaving the internal pages blank. *Invisible Library* transformed the contemporary art gallery into an interactive space. Gallery visitors were invited to explore any of the texts and add their own narratives. This open-source art exhibit was a tremendous success and visitors wrote stories, drew sketches and illustrations, and added their own point of view to each of the works; a sort of localized Wikipedia, the show exemplifies the potential of audience participation and engages a wider audience than traditional fine art exhibits.

The *Invisible Library* exhibit was praised by *The Guardian*, *Varoom Magazine*, and heralded by *Utne Reader* as "a successful attempt to enliven our culture's relationship with stories, remind readers of the importance of books, real or not, and reinforce their place in our collective imagination".

Invisible Library, 2009.
Imaginary books are books that are only mentioned in books, which this exhibition brought to life.

The pen should, as it were, walk slowly over the ground, you should be able at any moment to stop it, or to turn it in any other direction, like a well managed horse.

JOHN RUSKIN

The Wondering Line, 2011

Invader

www.space-invaders.com

Born 1969 in France

INVADER is a French artist whose work incorporates a retro-graffiti aesthetic inspired by the *Space Invader* video game. In addition to his street art, Invader's work has been exhibited internationally in art galleries and museums including the 6th Lyon Contemporary Art Biennale, the Mama Gallery in Rotterdam, the Brouson Center for Culture and Arts in Istanbul, and MOCA in Los Angeles, California.

Since Invader's street interventions often involve trespassing and illegal activity, he keeps his identity secret. He even signs 'legal' documents with the Space Invader logo. It is publicly acknowledged that he is male, was born in France in 1969, and that he is a cousin of street artist Thierry Guetta. Invader has had several run-ins with the law, including getting caught with buckets of grout and tile pieces while he was tagging an historic building in Los Angeles as part of his preparation for MOCA's 'Art in the Streets' exhibit.

Invader's interventions are meticulously planned ahead. In Montpellier, France, his tags when viewed on a map reveal a meta-tag as the locations of the mosaics combine to form one giant space invader. The popularity of his mosaic tagging has led to copycat art in other metropolises; his space-invaders.com site showcases an interactive map of all of the cities that he has 'invaded', and the number of tags that he has installed (e.g. for Bern, Switzerland, the site says "Invasion of Bern > Successful, [Space Invader] x 29, Score = 540"), along with images of his mosaics.

Invader's prolific body of work includes a series of sculptures entitled *Rubikcubism*, which are made out of Rubik's Cubes. *Rubikcubism* maintains Invader's pixel-aesthetics while re-creating iconic images such as Warhol's *Campbell's Soup Tins*, the *Mona Lisa*, Bonnie & Clyde, Mario Brothers, Pac Man, or, of course, Space Invaders.

Rubik space one, 2004
Rubik's cubes
16.5 x 16.5 x 5.5 cm/ 6.5 x 6.5 x 2.2 in

***Target*, 2006**
Mosaic tiles on board
52 x 46 cm/ 20.5 x 18.1 in

Natalie Jeremijenko

Born 1966 in Australia
Ph.D, Information Environments, School of Computer Science and Electrical Engineering, University of Queensland, 2008
BS, Neuroscience Biochemistry, Griffith University, 1993
BFA, Sculpture, Digital Information with Honors, Royal Melbourne Institute of Technology, 1992.

NATALIE JEREMIJENKO is an artist, engineer, activist, educator and inventor. In 2011, she was ranked as one of the most influential women in technology. Her diverse projects continue to bridge technology and innovation with art and science. She is currently an associate professor of Visual Art at NYU's Steinhardt School of Culture, Education, and Human Development. Jeremijenko has previously been on the Visual Arts faculty of UCSD, and at Yale's Faculty of Engineering.

Jeremijenko projects tend to have a subversive edge. Part revolutionary, and part mad-scientist, Jeremijenko is constantly challenging and questioning what it means to be human and part of the technological and biological ecosystems that surround us. Despite being an environmental activist, she is highly critical of jumping to conclusions that demonize technology. Jeremijenko has pointed out that extreme environmentalism can lead to a sort of ideological environmental suicide, since the only way to ensure that we don't damage our surroundings is to refrain from any action – death being the ultimate stasis.

Jeremijenko's prolific experimental platforms include an infrastructure on the roof of the Postmasters Gallery in New York that allows birds to communicate with their human companions via interactive sound installations that the birds can control. She has also created a 'fish interface' of motion sensitive buoys on the Hudson River. Jeremijenko has encouraged New Yorkers to feed fish food treated with chelating agents to the fish in the Hudson, in order to cleanse the toxins that they have consumed from GE's local pollution. She has also established a legal corporation, entitled Ooz (Zoo backwards) Inc, on which she has registered the fish as shareholders. *Flightpath* is a collaboration with Usman Haque, which allowed humans to feel what it is like to actually have wings and fly: "inviting citizens to rediscover the possibilities and wonder of urban flight."

Jeremijenko has distributed robotic chemical sensing dogs and tadpole walkers as artistic performances, and also in order to measure neighborhood pollution. She directs the xDesign Environmental Health Clinic, which is a space for anyone to come and report their environmental concerns and get advice on how to create positive social change, and improve 'environmental health.'

From guerrilla gardening in Manhattan to motion-activated videotaping of suicides on the Golden Gate Bridge in San Francisco, Jeremijenko is a creative and destructive force of nature that mirrors the complexity of contemporary society.

NoPark Project, **Environmental Health Clinic intervention, New York**
"The project takes a no parking area, like those in the vicinity of fire hydrants, and removes the asphalt to create an engineered micro-landscape that allows infiltration of the storm water and road run-off. This replenishes the hydration of the entire block, supporting trees and other vegetation. The area remains as emergency vehicle parking, but now it's also treating a different kind of emergency – an environmental health emergency." Natalie Jeremijenko

The Fish Interface can sense the movements of fish and convey
their presence to humans via colored LED lights. Amphibious
architecture is meant to foster interspecies communication

ABOVE AND OPPOSITE *Flightpath Toronto* was a mass-participatory spectacle designed by Usman Haque and Natalie Jeremijenko. This urban flight school enabled locals to experience what it's like to be a bird in an urban environment. Toronto, 2011

Michael Johansson

www.michaeljohansson.com

Born 1975 in Trollhättan, Sweden
MFA Malmö Art Academy, Sweden, 2005
BFA Art Academy in Trondheim, Norway, 2003.

"I am intrigued by irregularities in daily life. Not those that appear when something extraordinary occurs, but those that are created by an exaggerated form of regularity. Colours or patterns from two separate objects or environments concur, like when two people pass each other dressed in the exact same outfit. Or when you are switching channels on your TV and realize that the same actor is playing two different roles on two different channels at the same time. Or that one day the parking lot contained only red cars." Michael Johansson

MICHAEL JOHANSSON is a contemporary Scandinavian artist whose practice focuses on visual coincidences. Johansson likes to search for objects in flea markets and is especially excited to discover 'duplicates,' objects that closely resemble one another either in form, color or function. By recycling these found objects into playful sculptures, his amplified doppelgänger-installations evoke a sense of the extraordinary within the ordinary - or what he refers to as an "exaggerated form of regularity.".

Johansson's work has that sort of obsessive and compulsive perfectionism that is reminiscent of a computer programmer or engineer. Indeed, works of his such as *Dagar och Namn* (2010), *Han hade packat hela natten* (2005), and *Monochrome Anachron* (2008) exemplify his ability to assimilate and stack a surprising number of objects into a Tetris-like configuration. Like Borge's 1:1 map in *On Exactitude*

in *Science* (1964), Johansson's *TOYS'R'US – Dinghy scale 1:1* (2006) transforms the components of a 'real' boat into a Lego-like toy. Whether it's a corner full of white objects in *Ghost II* (2009) or an inundated caravan with as many objects as it can fit in *At least the weather was nice* (2006), Johansson's juxtapositions heuristically and humorously defy the laws of entropy.

ABOVE AND OPPOSITE *TOYS'R'US – Dinghy scale 1:1,* **2006**
Mixed media: dinghy, boat equipment, welded metal frame, spraypaint. Dimensions: 2 x 2.6 m. Installation view: *Besökarna*, Västra Hamnen, Malmö, Sweden

Miranda July

www.mirandajuly.com

Born 1974 in Vermont, USA
July was raised in Berkeley, California, and lives in
Los Angeles with her husband, a filmmaker Mike Mills.

MIRANDA JULY is a unique contemporary artist in that she is able to constantly reinvent herself and produce work in almost any creative mode. She is a successful singer, actor, author, director, screenwriter, sculptor and much more. While it's true that many successful artists have cashed in on some immense talent in one field to crossover to a mediocre career in another field (e.g. models or musicians attempting to become actors), July has proven that she really can shine brightly in any solar system.

At the 2009 Venice Biennale July exhibited a series of sculptures entitled *Eleven Heavy Things*. Her 'heavy' pieces consisted of cast fiberglass and steel-lined pieces, which were meant for viewer participation. Several are pedestals which visitors are invited to stand on together, (*We don't know each other, we're just hugging for the picture*), or to stand on alone, (*The Guiltiest One*). July's existential playfulness is illustrated in a tall and slender piece with a small hole that reads: "*This is not the first hole that my finger has been in; nor will it be the last*".

July's directorial debut, *Me and You and Everyone We Know* (2005), won the Caméra d'Or award at the Cannes Film Festival. In addition to directing the film, July wrote the screenplay and performed the role of the female protagonist, a likable aspiring artist who is filled with self-doubt (self-doubt is a recurring motif in July's work). This quirky romantic comedy parodies the contemporary art market by featuring an unlikable and aloof contemporary art museum curator. July's character struggles to get an exhibition, and finally succeeds by humiliating herself rather than by convincing the curator of her artistic merit. July also directed, starred and wrote *The Future* (2011), an independent low budget film about a couple who radically alter their lives after adopting a stray cat.

From Eleven Heavy Things,
Venice Biennale, 2009

In addition to proving her screenwriting ability, July is also an acclaimed author. Her fiction has been published in *Harper's Magazine* and the *New Yorker*. Her collection of short stories *No One Belongs Here More Than You* combines her trademark deadpan humor and emotionally isolated characters; *No One Belongs Here More Than You* is as sweet as cotton candy and tenderly portrays the extraordinary humanity that is obscured by the facade of ordinariness.

Promotional poster for *Me and You and Everyone We Know*, 2005

Brian Jungen

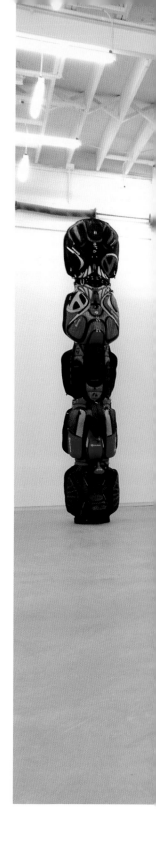

Born 1970 in Fort St. John, British Columbia, Canada
Diploma of Visual Art, Emily Carr Institute of Art and Design, 1992
Lives and works in Vancouver, Canada.

BEST KNOWN for his sculptures, Brian Jungen uses mass manufactured objects (plastic chairs, sports shoes, baseball bats, etc.) and reassembles them into incongruent artefacts. His work has been shown at Tate Modern, the Vancouver Art Gallery and the Smithsonian Museum of the American Indian among other international venues. Jungen won the Sobey Art Award in 2002 and the Gershon Iskowitz Prize in 2010.

Jungen's residency at the Banff Centre for the Arts in 1998 inspired him to create *Prototypes for New Understanding* (1998–2005) in which he took apart and reconfigured Nike Air Jordan sneakers into a series of objects that are reminiscent of aboriginal masks. This sculptural process echoes Duchamp's readymades, transforming it into a 21st century re-readymade akin to a digital product that was created by copying and pasting. Jungen created a series of totem poles out of golf bags, which were widely exhibited including being showcased at the Barbican's Martian Museum of Terrestrial Art. In *Cetology* (2002), the artist created a stunning sculpture of a skeleton of a whale using plastic chairs – juxtaposing an endangered species with a non-biodegradable product while using his thematic de-familiarized aesthetic.

Jungen's works have also tackled various political issues. In *Isolated Depiction of the Passage of Time*, he created an installation that explores the skewed jail sentences of First Nation people in Canadian prisons; food trays are arranged by colors that represent the jail sentence statistics while within the sculpture a concealed monitor plays the film *The Great Escape*.

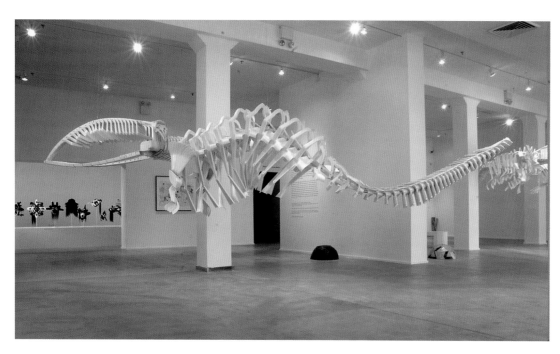

Shapeshifter, 2000
Plastic chairs. 276 x 84 x 60 inches (701 x 213 x 152.5 cm)

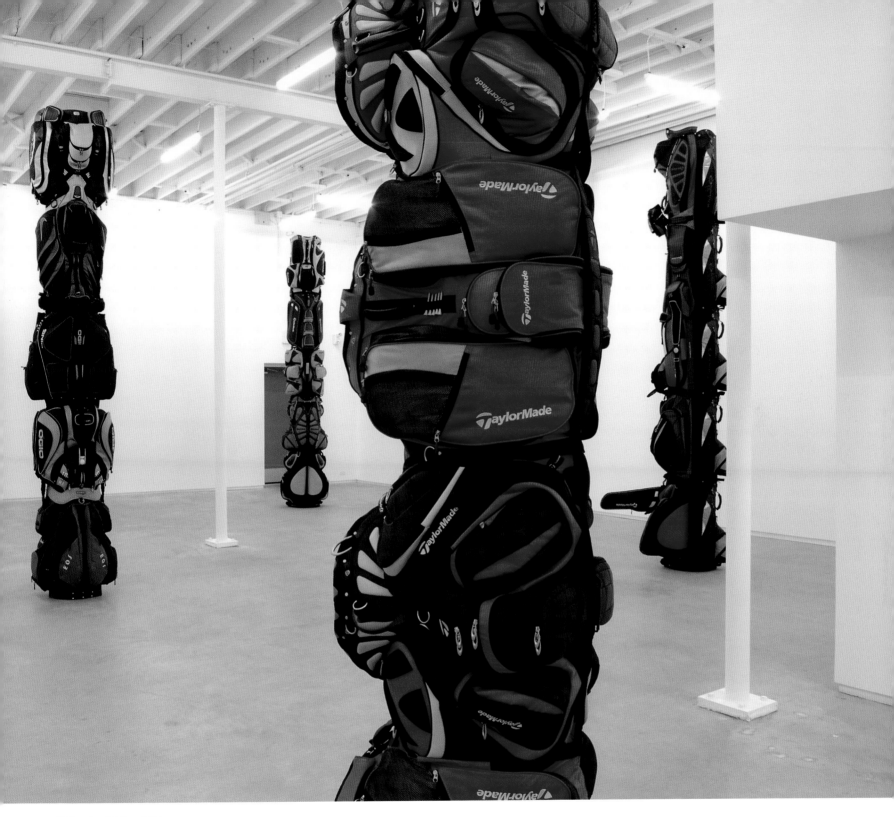

Installation view, Catriona Jeffries, 2007

Eduardo Kac

www.ekac.org

Born 1962 in Rio de Janeiro, Brazil
Lives and works in Chicago, Illinois, USA.

EDUARDO KAC is an American contemporary artist who has pioneered biotechnological and transgenic art. His practice is both cutting-edge and subversive, and highlights the bio-ethical ramifications of new technologies. Kac's oeuvre reads like a Bio-Art *Guinness Book of World Records*. During his prolific career, he has been the first to do many things including being the first person to have a microchip implanted into his body.

Kac's most controversial work is *Alba*. Kac hired a French research laboratory to genetically engineer a rabbit with the green fluorescent protein of a jellyfish. *Alba* was the result of this experiment and would turn green when exposed to blue light. However, a series of journalistic articles about Alba led to a public relations storm, which ultimately caused the French lab to hush the story up and to keep Alba. It is not known what happened to Alba after the lab's media blackout. Nevertheless, Kac began an extensive campaign aimed at returning Alba to Kac's family, including designing a flag dedicated to freeing Alba, which he would fly outside his house.

In *Genesis*, Kac encoded verse 26 from the first book of *Genesis*, – "And God said, Let us make man in our image, after our likeness: and let them have dominion over the fish of the sea, and over the fowl of the air, and over the cattle, and over all the earth, and over every creeping thing that creepeth upon the earth" – into Morse Code that was genetically sequenced as bacterium grown in a petri dish. The petri dish was broadcast over the Internet via a webcam, and web-visitors could turn on and off an ultraviolet light which would cause the bacteria to mutate.

Aromapoetry is the first poetry book written exclusively with smell. It consists of twelve poems and explores the potential grammar and semantics of olfactory stimuli. Nanotechnology was required to produce *Aromapoetry*, which has a substantial shelf life as the book has been designed to prevent the scents from rapidly fading.

In *Natural History of the Enigma*, Kac created a series of 'plantimals'. These new life forms intertwine plant and animal DNA. *Edunia* is a genetically engineered plant that combines Eduardo Kac's genes with with a Petunia. Kac's DNA is represented in the plants red veins.

OPPOSITE *Natural History of the Enigma*,
transgenic work, 2003/08
Edunia, a plantimal with the artist's DNA
expressed only in the red veins of the flower

Dialogue Lagomorphe, 2002,
Pencil on watercolor paper, 40.6 x 50.8 cm/ 16 x 20 in

***Aromapoetry*, 2011**
Artist's book with box and slipcase, 12 custom-made aromas enmeshed
in a nanolayer of mesoporous glass, letterpress text and graphics, 16 2ml
vials with engraved titles, 29.7 x 21 x 5.1 cm/ 11.7 x 8.3 x 2 in an edition of
ten signed and numbered by the artist

Anish Kapoor

www.anishkapoor.com

Born 1954 in Mumbai, India
Hornsey College of Art
Chelsea School of Art and Design
Lives and works in London, UK.

"Quickly I realised that when you make an object and place pigment on it, the pigment falls to the ground like a halo around the object. And the implication is that it's like an iceberg: that most of the object is hidden, is invisible."
Anish Kapoor, *The Guardian* (November 2008)

"I'm thinking about the mythical wonders of the world, the Hanging Gardens of Babylon and the Tower of Babel. It's as if the collective will comes up with something that has resonance on an individual level and so becomes mythic. I can claim to take that as a model for a way of thinking."
Anish Kapoor, *Mr. Big Stuff*, Sarah Kent (December/January 2008)

ANISH KAPOOR is one of the most acclaimed contemporary artists. He has had solo shows at the Tate and Hayward Gallery in London, at the Reina Sofia in Madrid, the Guggenheim in Bilbao, and the National Gallery of Modern Art in New Delhi. His body of work transcends traditional art-spheres and often ventures into architecture. He has received numerous honours and awards including the Turner Prize (1991),

the Japanese Praemium Imperiale (2011), and India's highest civilian honour, the Padma Bhushan (2012). In 1999 he became a Royal Academician; in 2003 he was knighted as a Commander of the British Empire and France elected him a Commander in the French Order of Arts and Letters.

Kapoor represented Britain at the Venice Biennale in 1990 where he won the Premio Duemila Prize. During that period, he was best known for his monochromatic sculptures that explored the perception of a void or curved space, which were often constructed of granite, marble, pigment or plaster. In the mid 90s, he began producing mirror-like sculptures formed of polished stainless steel, which distort the environment that they reflect. *Cloud Gate* (aka "The Bean", 2004) is one of his best-known public commissions and is the centerpiece of the AT&T Plaza in Chicago's Millennium Park. If architecture is frozen music, then *Cloud Gate* is a melodic and hyper-resonating frequency embodying the emergence of space from the Big Bang and vacuum energy to modernity's globalization of contemporary culture.

Cloud Gate has become a symbol of Chicago's resurgence and is often featured on postcards and in films including *Source Code*, *The Break-Up* and *The Vow*.

Kapoor's artworks employ a wide range of artistic practices. *Svayambh* (2007) consisted of a large block of red wax that continually moves on a set of rails. *Svayambh* means 'self-generated' in Sanskrit and the piece evokes a sense of the bloody and corporeal, and of the emergence of biological structures. *Shooting into the Corner* (2009), exhibited at the Royal Academy of Art, was a cannon that fired wax pellets into a corner of the gallery and which enabled the wax to produce a spontaneous and transient form.

Kapoor's *Orbit* (2012) was commissioned for the 2012 Olympic Games by the Greater London Authority and is the tallest sculpture in the UK – reaching a height of 115 meters. Kapoor has also designed theatre and opera sets, and collaborated with numerous writers and architects. His *Ark Nova* project is a collaboration with Arata Isozaki and involves an inflatable concert hall that will travel through Japan's earthquake damaged regions.

OPPOSITE ***Double Hexagon*, 2007-2008**
Stainless steel, 227.5 x 385.3 x 44 cm
Photo: David Regen © Anish Kapoor

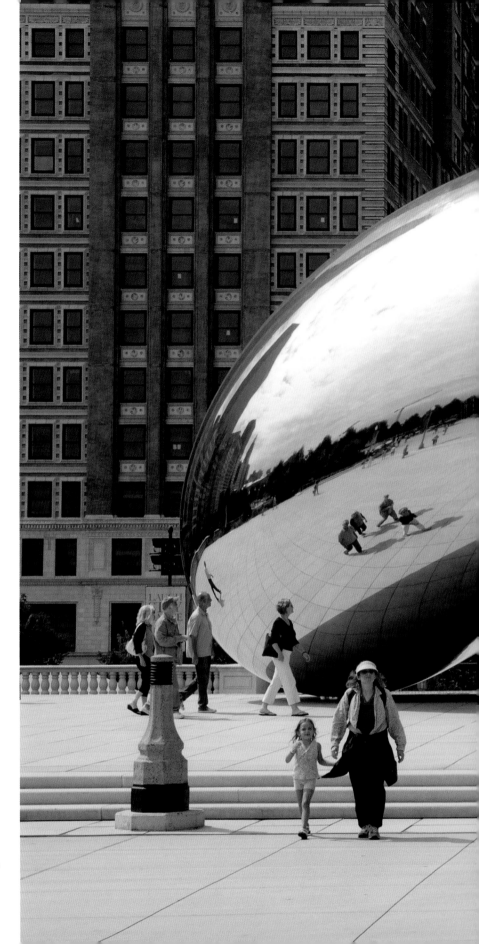

***Cloud Gate**, 2004*
Stainless steel, 10 x 20.1 x 12.8 m, Millenium Park, Chicago
© Anish Kapoor

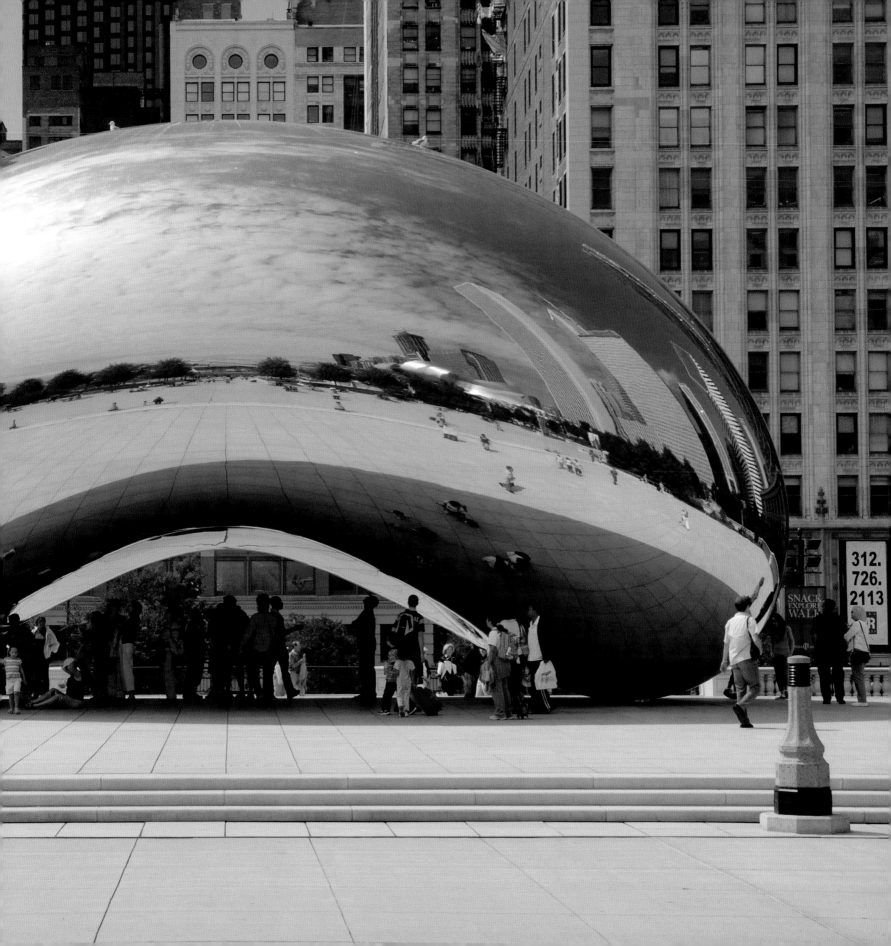

Marina Kassianidou

www.marinaek.com

Born 1979 in Limassol, Cyprus
Double Bachelors in Computer Science and Studio Art,
Stanford University, California, 2002
MFA, Central St. Martins, London, UK, 2005
Lives and works in Limassol, Cyprus, and London, UK.

"Kassianidou is moving away from art that is about other art and towards processes such as aging and weathering that eventually give a surface its character [...] The artist's marks make more evident the traces left on the wall from people's movements through space, such as fingerprints or smudges."
Andrew Smaldone

MARINA KASSIANIDOU is an artist, curator and researcher based both in Limassol, Cyprus, and London, UK. After graduating from Stanford University with a BS in Computer Science and a BA in Studio Art in 2002, she received an MFA from Central St. Martins in 2005, and is currently doing a PhD in Fine Art at Chelsea College of Art and Design. Her research has been published in academic journals in Europe and the USA, and her accolades include a Fulbright scholarship and the Arthur Giese Memorial Award for Excellence in Painting.

Marina Kassianidou's practice blurs traditional boundaries and illustrates that the arts and sciences overlap and continuously develop one other. Kassianidou's practice invites the viewer to do a double-take and seek beyond that which first meets the eye. Her interests are as diverse as her artistic practice and her creative aspirations have continued to synthesize bodies of knowledge that might appear to be diametrically opposed.

Kassianidou has created a series of camouflaged interventions, ranging in medium from pencil marks on cardboard to the application of acrylic onto linoleum such that a drawing can only be discerned by a most astute observer. She often applies materials that are similar in appearance to the surface onto which they are juxtaposed. Oscillating between presence and absence, her work illuminates palimpsests and envisages a destabilization of rigid categories.

Untitled, 2009
Acrylic on found linoleum 34 x 46 cm

Untitled 2008
Pencil and watercolour pencils
on cardboard 28 x 36 cm

Untitled 2009
Acrylic on found linoleum 62 x 48 cm

Aaron Koblin

www.aaronkoblin.com

Born 1982 in Santa Monica, California, USA
MFA, Design Media Arts, UCLA

AARON KOBLIN is the creative director of the Data Arts Team at Google. His data visualization works are part of the permanent collections at MoMA, New York and
the Centre Pompidou Centre, Paris, and his projects often incorporate innovative uses of technology. During his masters degree at UCLA, Koblin's professors included Casey Reas who created Processing, a programming language designed for visual artists. In *Flight Patterns*, using Processing to plot FAA flight data, Koblin created a series of videos and images that visualize the flights of over 200,000 aircrafts that were monitored in a 24-hour period, August 12, 2008. The colors of the patterns were determined by the altitude of the aircraft (e.g. white for low altitude and blue for high altitude) and the aircraft model.

In *Ten Thousand Cents*, he collaborated with Takashi Kawashima. Using Amazon's Mechanical Turk, they posted 10,000 partial images of a 100 dollar bill, and paid anyone one cent to redraw the image. The website through which users were asked to draw each image, recorded the drawing, ultimately leading to 10,000 videos, each of which re-traced a different section of the 100 dollar bill. In addition, the precise cost for this crowd sourcing was 10,000 cents = 100 US Dollars. *Ten Thousand Cents* was displayed as a grid of 10,000 videos. It's interesting to note that each drawing was created in isolation and the users did not know what they were contributing to, highlighting the fact that new technologies can be harnessed for both cooperation and/or exploitation.

Koblin has also developed several music videos. For Radiohead, he used laser scanners to generate 3D animations of the band members performing. Koblin has also developed several platforms that enabled web visitors to interface and contribute to music videos. In *The Johnny Cash Project* participants are able to select a frame from the video and draw their own version of it. The most popular drawings are then used

Ten Thousand Cents, 2008
Drawn by 10,000 anonymous artists via Amazon's Mechanical Turk website

The Sheep Market

TheSheepMarket.com features 10,000 sheep drawn by anonymous workers, each of whom was paid two cents to "draw a sheep facing the left"

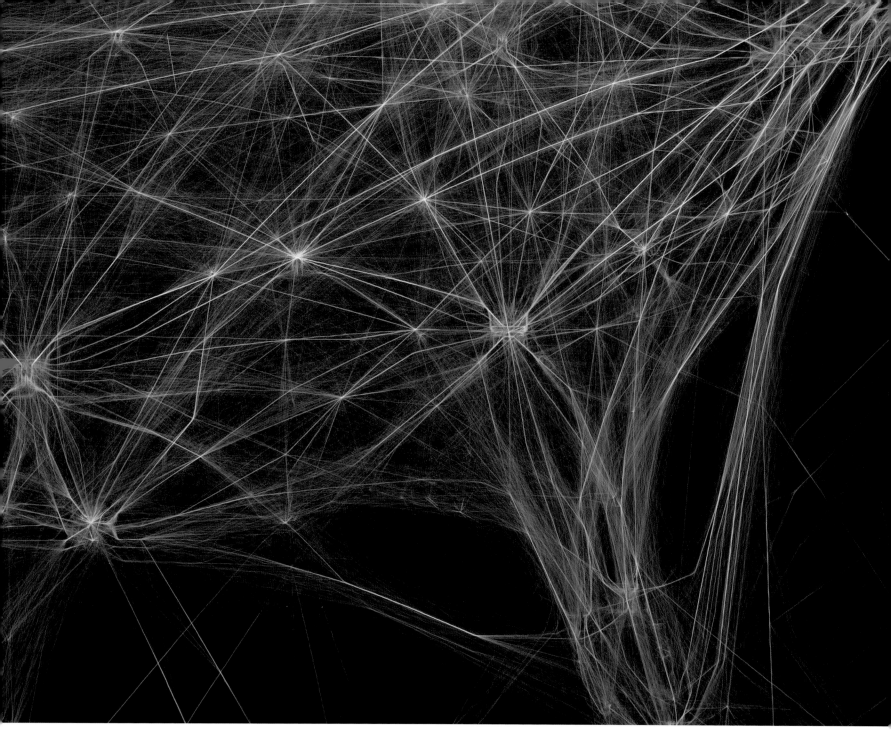

ABOVE AND OPPOSITE *Flight Patterns*, 2008.
Stunning visualizations of flight data over a 24-hour period with color and
form determined by the planes' altitudes, models, and manufacturers

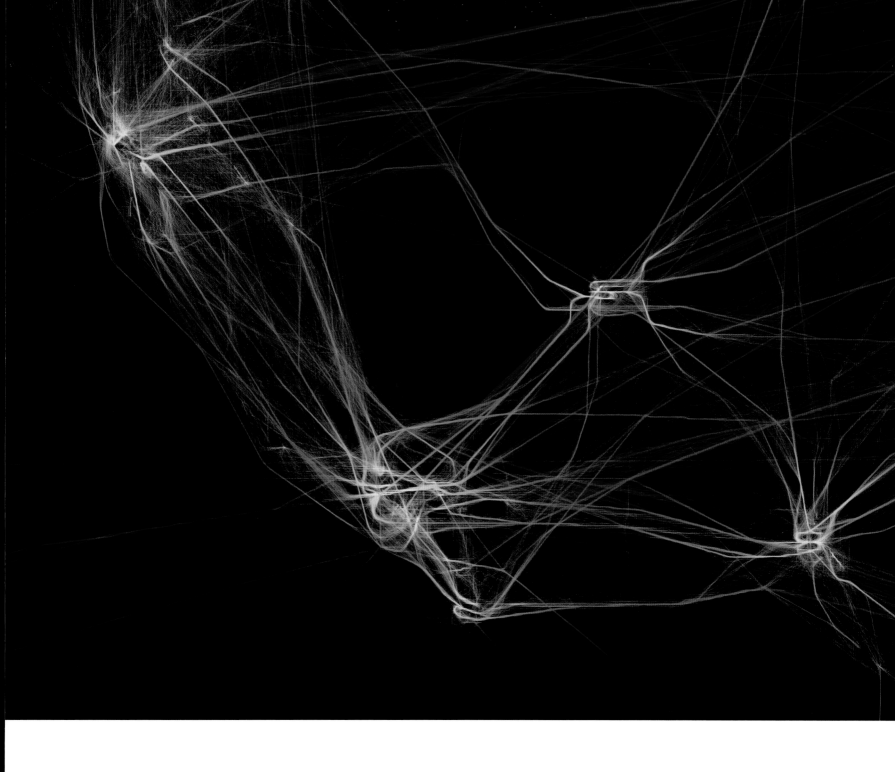

Alicja Kwade

www.alicjakwade.com

Born 1979 in Poland
Universität der Künst, Berlin, Germany, 2005
Lives and works in Berlin.

ALICJA KWADE won the Piepenbrock Sculpture prize in 2008. Her practice often questions the value systems of common objects.

Kwade's sculptures and installations continue the discourse of Minimalism from the 1960s but with a contemporary and post-Soviet feel. In *Berliner Bordsteinjuwelen*, she collected stones from the pavements across Berlin and then polished them so that they resemble gemstones. Similarly, *412 Empty Litres Until the Start* was made out of 555 kilograms of empty champagne bottles broken into shards of glass and scattered into a diamond shaped heap.

Kwade has also created a series of works in which she sculpted coal into the shape of a diamond (*Lucy*, 2004) or into bricks resembling gold bars (*Union 666*, 2008). Curiously, in certain contexts a block of coal that is coated in gold leaf may be more valuable than an actual block of gold; for example, during a cold winter, the coal could be used as fuel for a fire and heat, whereas pure gold lacks functionality and is usually appraised by its aesthetic value. Similarly, diamond and coal are both composed of carbon, but their distinct values are based on scarcity, aesthetics and irrational human wants rather than actual utility.

In *Parallelwelt*, mirrors are placed between Kaiser Dell desk lamps, creating the illusion that the mirrors are transparent. The light's reflection creates a mysterious and surreal ambiance, and the lamps are imbued with an anthropomorphic aura. Akin to the scientific axiom that the observer always becomes observable while influencing the system that he/she observes, *Parallelwelt* illustrates that light both creates and distorts vision. Furthermore, the mirrors actually flip right and left while creating the illusion of re-creating 'reality'.

Parallelwelt (schwarz/rot), 2009
Kaiser-Idell lamps, two mirrors
83 x 45 x 45 cm / 32 3/4 x 17 3/4 x 17 3/4
in ohne Rahmen / not framed
Unique

Der Tag ohne Gestern (Dimension 1-11), **2009**
Steel, extra shiny black varnish, speakers, mixer, microphone, neon tubes, 11 parts
Format variabel / format variable ohne Rahmen / not framed unique
Installation view "Grenzfälle fundamentaler Theorien", Johann König, Berlin, 2009

Namhee Kwon

Born 1971 in Korea.
BFA, Gangnung National University, South Korea, 1994
MFA, Hongik University, South Korea, 1997
MFA, Goldsmiths University of London, UK, 2002
Lives and works in Seoul.

NAMHEE KWON is a conceptual Korean artist. Her work often echoes the minimalist movements of the 1960s, or the surrealists of the 1930s, evoking a poetic impression of the banality of everyday life.

Quiet World is an ongoing project involving a sign that Kwon designed that depicts two ellipses separated by a single space. The Quiet World sign has been installed in numerous public spaces. An ellipsis can indicate an omission, silence, or an undeveloped idea. As a sign, Quiet World procures a range of interpretations ranging from parodying propaganda to a self-reflexive reminder that a street sign is just a sign. Quiet World has also become a sort of trademark, manifesting in multiple forms.

During her 2010 solo exhibition at Tenderpixel, Kwon transformed the gallery walls into a series of blank pages, mounting a numbered neon sign onto each wall. The neon read clockwise - 1 -, - 2 -, and - 3 -. like John Cage's 4'33. The audience and the environment became a major component of the installation/performance as the artificial light, transient daylight, and the visitors' shadows altered the visual grammar of the gallery space.

Quiet World Sweets, 2009

Quiet World, 2001 to Present

- 3 - , 2011

Are you dreaming or are you speaking, 2004

Michael Leyton

www.rci.rutgers.edu/~mleyton/homepage.htm

Born 1959
Living and working in New York.

"Aesthetics is the theory of memory storage."
"Artworks are maximal memory stores."
"Geometry=Computation=Aesthetics."
Leyton, quoted from pages 89-90 of *Shape As Memory:
A Geometric Theory of Architecture* (2006)

MICHAEL LEYTON is a true renaissance man. His creative endeavors span musical composition, sculpture, paintings, architecture and much more. He is the author of *A Generative Theory of Shape*, *The Structure of Paintings and Symmetry, Casuality, Mind*. His artwork and research into visual perception and memory have redefined contemporary aesthetics and contributed to a gamut of diverse disciplines ranging from robotics and mathematics to psychology and art history.

Leyton's aesthetics are based on the maximization of 'memory storage'. He also advocates asymmetry. This is in direct opposition to the theories of aesthetics that have dominated Western culture for the last 3,000 years and that emphasized regularity, symmetry and the minimization of process and information. Leyton's formalism highlights the importance of process and history. In a nutshell, symmetry is the absence of history, and the breaking of symmetry creates memory. For example, with a flat piece of paper, you have no additional information; however, if you see a crumpled piece of paper, you realize that it has undergone a process of being crumpled and are able to recognize/perceive its history. Whether it's an exploding building, a two-dimensional circle being stretched into an ellipse, or a scratched car door, processes create a recognizable past for an object.

The *Administration Building* series combine photography, painting and computational aesthetics. In this series, Leyton applied the process-grammar that he developed, to the composition of his works. Without getting too technical, Leyton offers a range of geometrical and Boolean processes, which are exemplified in the *Administration Buildings*. The *Second Administration Building* misaligns, unfolds, and breaks the symmetry of the cubes, cylinders and spheres, and creates a process of anomalization. Similarly, the *Fourth Administration* utilizes what Leyton terms 'Double-Bay Scenarios' on the horizontal reflection frame, which destabilize the viewer's sense of equilibrium. Ultimately, process, memory and history are intertwined and form the basis of a new theory of art.

Second Administration Building

Further Development of Fourth Administration Building

Hrvoje Majer

www.hrvojemajer.co.uk

Born 1975 in Croatia
BA, Painting and Art History, University of Zagreb,
Academy of Fine Arts, Zagreb, Croatia, 2003
MA, Fine Arts, University of Arts, Central St. Martins,
London, 2005
Lives and works in London.

HRVOJE MAJER is a celebrated Croatian artist whose practice contemporises traditional oil painting and emphasises the fragile and transient nature of human awareness. Majer's *Diana and Actaeon* is a contemporary interpretation of this illustrious myth and is inspired by Titian's *masterworks*. Majer's adaptation substitutes Diana-Artemis with 20th century celebrity goddess Marilyn Monroe while retaining Diana's virginity in the pure whiteness of Marilyn's iconic dress. Similarly, Diana's nymphs become chickens signifying the herd mentality celebrity culture represents as their star-struck fans follow their 'role-models' mindlessly. In Majer's painting, Actaeon is surprisingly relaxed as he has relinquished his fears and shifted into a mode of spiritual awareness: His antlers point to the heavens as he enjoys the tranquillity of the forest. Similarly, his hounds are calm, and respectively portray a Freudian super-ego and unconscious as they sit harmoniously above and below Actaeon.

The ancient myth of Actaeon and Diana is infused with a multiplicity of meanings, versions and interpretations. The Roman goddess Diana was known to the Greeks as Artemis, and was the protector of wild animals, the wilderness, women's virginity and fertility. In Ovid's *Metamorphoses*, Actaeon is in the forest with his hunting dogs when he accidentally stumbles upon Diana-Artemis as she bathes naked in a stream. Diana turns Actaeon into a stag and his own dogs ruthlessly tear him apart. Titian's *Diana and Actaeon* (1556–9) and The *Death of Actaeon* (1565–76) render Ovid's narratives into a masterful retelling of the ironic downfall of Actaeon, the hunter who becomes the hunted.

Majer's interpretation continues this ancient discourse while combining traditional and contemporary imagery and retelling and re-contextualizing the story of Diana and Actaeon. Majer visited the National Gallery and researched Titian's works extensively while adding his own images to this classic tale. His

nymphs-turned-chickens represent cheap entertainment, blind ideology, and fast and genetically modified food; Majer's radical transformation of Actaeon draws upon Mayan iconography where a stag head represents wisdom and higher knowledge. In the background of Majer's work, a faint trio of bathers are present, symbolizing change and the unknown: The future remains uncertain and yet there is nothing to fear.

Equinox Encounter, 2011

All Demons Are Beautiful, 2008

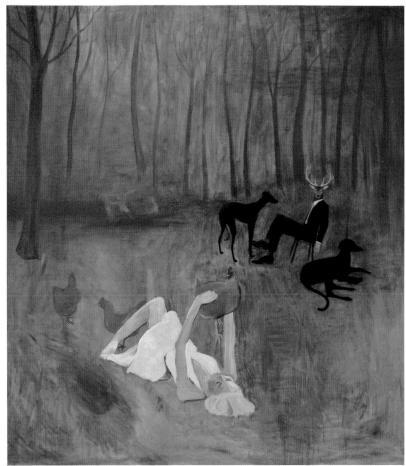

Diana and Actaeon, 2010

David McCandless

www.davidmccandless.com

Born 1970 in UK
Lives and works in London, UK.

"I'm interested in how designed information can help us understand the world, cut through BS and reveal the hidden connections, patterns and stories underneath. Or, failing that, it can just look cool!" David McCandless

DAVID MCCANDLESS is a designer, artist, author, computer programmer, and journalist. He refers to himself as a 'data detective' who is passionate about visualizing statistics and ideas with the minimum usage of words. He's a whiz at discovering overlooked facts and making them visually accessible. He has spoken at TED, and written for publications such as *Wired* and *The Guardian*. His blog and book, *Information is Beautiful*, have both been critically acclaimed, and illustrate a wide range of topics including the different emotions with which colors are associated in accordance to culture, and the evolution of marriages in the West.

McCandless' work is inspired by Hans Rosling's innovative use of data to educate and convey large data sets involving socioeconomic, global health and literacy information. McCandless' infographics range from analyzing Facebook profiles to figuring out probabilities, such as when people are least likely to break up (Xmas day), to studying medical databases in order to identify which health supplements have the highest efficacy ratings (green tea, fish oil and vitamin D), or illustrating the lamest heated debates on Wikipedia pages (Spelling: Brazil vs. Brasil, Kyiv or Kiev, sulfur or sulphur, etc...). McCandless' uncanny ability to clearly communicate abstract or complex ideas has led to a growing fan base and he is sure to keep contributing to our visual and non-visual data-scape.

The Hierarchy of Digital Distractions, infographic, **2009**

OPPOSITE *Colours in Culture, infographic*, **2009**

Colours and Culture

The meanings of colours around the world

Legend (colours):
- Rojo
- Naranji
- 黄色
- Okotshani
- синий
- Purple
- ピンク
- кафяв
- ضيبأ
- Gris
- Kala
- Silver
- Gold

Cultures (A–J):

A American
B Japanese
C Hindu
D Native American
E Chinese
F Asian
G Eastern European
H Muslim
I African
J South American

Meanings (1–85):

1 Anger
2 Art / Creativity
3 Authority
4 Bad Luck
5 Balance
6 Beauty
7 Calm
8 Celebration
9 Children
10 Cold
11 Compassion
12 Courage
13 Cowardice
14 Cruelty
15 Danger
16 Death
17 Decadence
18 Deceit
19 Desire
20 Earthy
21 Energy
22 Erotic
23 Eternity
24 Evil
25 Excitement
26 Family
27 Femininity
28 Fertility
29 Flamboyance
30 Freedom
31 Friendly
32 Fun
33 God
34 Gods
35 Good Luck
36 Gratitude
37 Growth
38 Happiness
39 Healing
40 Healthy
41 Heat
42 Heaven
43 Holy
44 Illness
45 Insight
46 Intelligence
47 Intuition
48 Religion
49 Jealousy
50 Joy
51 Learning
52 Life
53 Love
54 Loyalty
55 Luxury
56 Marriage
57 Modesty
58 Money
59 Mourning
60 Mystery
61 Nature
62 Passion
63 Peace
64 Penance
65 Power
66 Power (personal)
67 Purity
68 Radicalism
69 Rational
70 Reliable
71 Repels Evil
72 Respect
73 Royalty
74 Self-cultivation
75 Strength
76 Style
77 Success
78 Trouble
79 Truce
80 Trust
81 Unhappiness
82 Virtue
83 Warmth
84 Wisdom
85 Youth

Steve McQueen

Born 1969 in London, UK
Chelsea School of Art, London, UK, 1990
Goldsmiths, University of London, UK, 1993
Tisch School of Arts, New York University, USA, 1994
Lives and works in Amsterdam and London.

STEVE MCQUEEN is an artist who often works within the medium of film. He won the Turner Prize in 1999. In addition to working within the contemporary art sphere, McQueen has also written and directed two commercially successful films, *Hunger* and *Shame*. *Hunger* is about the 1981 Irish hunger strike and won McQueen the Camera d'Or at Cannes in 2008.

Shame revolves around a New York yuppie who is unable to manage his sexual urges. The protagonist is played by Michael Fassbender, who is addicted to sex, but seems incapable of becoming aroused by someone with whom he has an emotional attachment. The protagonist's sister is played by Carey Mulligan, who is as dysfunctional as her brother. *Shame*'s plot is quite minimal; while it is heavily loaded with sexual content, there are very few references to why the protagonist and his sister are emotionally damaged. While the plot leaves many details for the viewer to imagine and interpret, the film is visually stunning and imbued with moments of suspenseful silence. *Shame* exemplifies the concept of director as auteur, as the visual rhythm and conceptual richness of the film is amplified by the directorial choices made by McQueen.

In 2009, McQueen represented England at the Venice Biennale, where he screened a 40-minute film, *Giardini*. *Giardini* was filmed at the gardens where the Biennale takes place, but during February, a time when the gardens are peaceful and quiet. The Biennale visitors watching McQueen's film were able to see how their location radically transforms via a slight temporal shift. In contrast to the fair's flamboyant ambiance, *Giardini* presents an alternative space where stray dogs explore the empty park and rain romantically pours down forming a reflective puddle. Like many of his other works, *Giardini* is filled with melancholy and beauty.

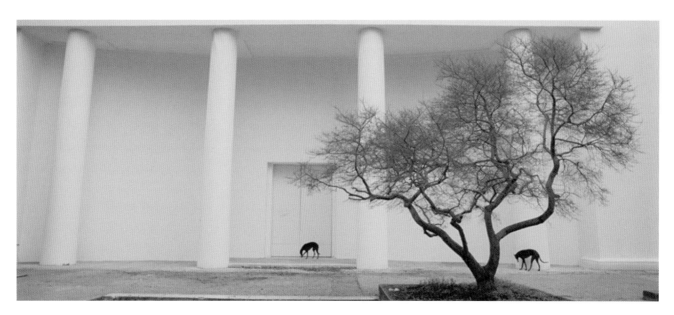

Image from *Giardini*, Venice Biennale, 2009

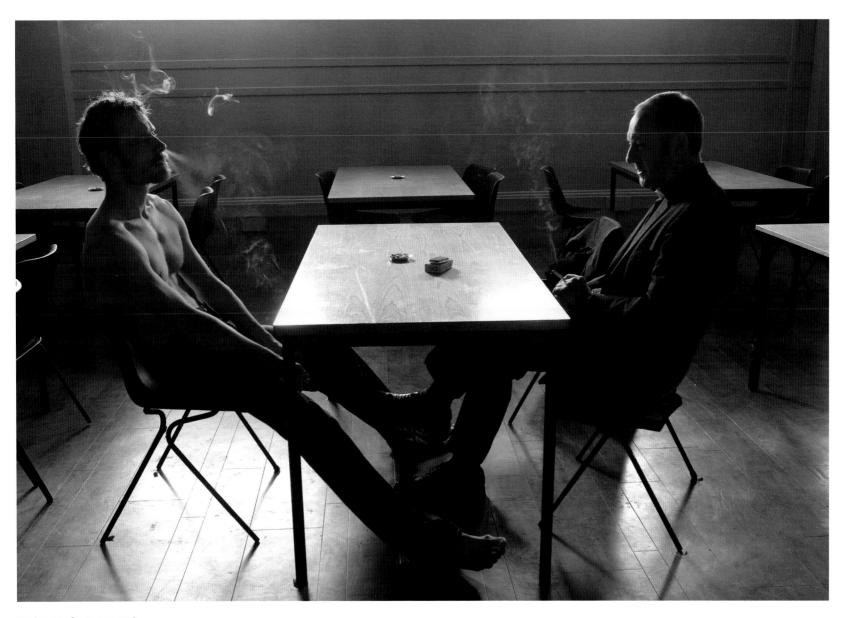

Movie poster for *Hunger*, 2008

Mike Mills

www.mikemillsweb.com

**Born 1966 in Berkeley, California, USA
Married to Miranda July.**

MIKE MILLS is a visual artist with a diverse body of work. He is a polymath; Mills plays guitar and performed background vocals for an indie rock band, and is a successful graphic designer, acclaimed filmmaker and photographer.

Mills directed music videos for artists such as Yoko Ono, Air, and Moby. He created the graphic design for the albums of the Beastie Boys, Beck, Sonic Youth, and Ol' Dirty Bastard, and drew the graphics on various X-Girl and Marc Jacobs campaigns. Mills continues to produce his own line of posters and design products entitled *Humans by Mike Mills*. According to his webshop the "*Humans* project imbeds highly personal themes into mass produced items such as posters, scarves, ribbons, fabric patterns, T-shirts and bags. *Humans* operates in between the art world and popular culture, in between graphic design and an art practice."

In addition to music videos, Mills has directed commercials, documentaries and feature films. His commercials encompass a range of industries and clients such as Levis, Volkswagen, Nike and Adidas. Even in his commercials, Mills maintains an almost spiritual and post-materialist sensibility. Mills claims that ads have been a fertile ground for him to experiment with and to develop his aesthetics and artistic vision. His films include a documentary on the theory of jazz developed by Ornette Coleman, a documentary on depression in Japan, and a short film, *The Architecture of Reassurance*, which was screened at the 1999 Sundance Film Festival. His first feature film, *Thumbsucker* (2005), starring Tilda Swinton and Lou Pucci, won acting awards at Sundance and the Berlin International Film Festival. *Beginners* (2010) which starred Ewan McGregor, was based on the story of Mills' father coming 'out of the closet' after becoming a widower.

Mills has also published photographic art books. Mills draws inspiration from Bauhaus pioneer Laszlo Moholy-Nagy who advocated the integration of diverse media and industries such as design, fine art, technology and architecture. So far, Mills' career trajectory remains unpredictable. Only time will tell what other media Mills will successfully explore.

OPPOSITE **Promotional poster for *Thumbsucker* the movie, 2005**
Mills also designed all of the posters for the film's ad campaign

144

M/M (Paris)

www.mmparis.com

MATHIAS AUGUSTYNIAK
Born 1967 in Cavallion, France
Royal College of Art, London, 1991.

MICHAEL AMZALAG
Born 1968 in Paris, France
École Nationale Supérieure des Arts Décoratifs, Paris, 1991.

M/M (Paris) was established in 1992 by Mathias Augustyniak and Michael Amzalag. They had initially met in 1988 when they were both students at the École Nationale Supérieure des Arts Décoratifs in Paris. Augustyniak moved to London in 1990 and graduated at the Royal College of Art in 1991, after which he returned to Paris to collaborate with Amzalag.

Initially, M/M (Paris) focused on designing record sleeves for the music industry, but they kept an open mind while experimenting with numerous media. This dynamic duo collaborated with artists ranging from musicians (Björk and Madonna) and fashion designers (Yohji Yamamoto and Jil Sander) to contemporary artists (Liam Gillick, Sarah Morris, and Pierre Huyghe), and acted as artistic directors for several magazines such as *Les Inrockuptibles*, *Purple Fashion*, and *Vogue Paris*. M/M (Paris) also designed sets for the opera *Antigona* by Tommaso Traetta in 2004.

M/M (Paris) have a post-punk aesthetic, which often incorporates a DIY and hand-drawn look. With projects ranging from interior design to graphic design and contemporary art, M/M (Paris) have been able to freely oscillate between the contemporary art market and their advertising and mass-driven clients. As such, M/M (Paris) exemplify the idea that visual art is a common language and rebuff the notion of 'high art' as
distinct. In 2006, they exhibited an installation of their wallpaper at the renowned gallery, Haunch of Venison. In 2008, the Centre Pompidou exhibited a retrospective of M/M (Paris)'s series of art posters. Their work is included in many museum collections such as Tate Modern, the Centre Pompidou, Miami Museum of Contemporary Art, and London's Design Museum.

M/M (Paris), Wallpaper Posters, 2001
Four color silkscreen poster 120 x176 approx.
Unlimited edition

M/M (Paris), Double Hobnob [Commemorative Mirror], 2006
Six color silkscreen on cut-to-shape 6mm mirror with wall
mounting system at the back, 120 x180cm, edition of 4 + 2 AP

Takashi Murakami

www.kaikaikiki.co.jp

Born 1962 in Tokyo, Japan
BFA (1986), MFA (1988) and PhD (1993) from Tokyo University of the Arts, Japan.

"Japanese people accept that art and commerce will be blended; and in fact, they are surprised by the rigid and pretentious Western hierarchy of 'high art.'"
Takashi Murakami, *ARTINFO*, June 2006

TAKASHI MURAKAMI is much more than a visual artist, he is a cultural producer who intertwines notions of 'high' and 'low' art, and the underground with the über-commercial. Not surprisingly, in 2008 he was the only artist included in *Time* magazine's list of the '100 Most Influential People'. Murakami curates a network of galleries that he established in Japan, which showcase emerging and established contemporary artists. He also founded the GEISAI art festival and constructed several ateliers which produce his artworks and merchandise, while cultivating and training a new generation of artists.

His works tend to combine Japanese 'kawaii' figurines in radiant colors, in both flat and highly glossy finishes. Recurrent psychedelic themes include mushrooms, Buddhist icons, beaming flowers, and hyper-sexualized manga characters. Murakami's media include videos, paintings, prints, giant balloons, wallpaper and sculpture. His 2011 *Google Doodle* celebrated summer solstice and incorporated smiling flowers with his signature manga-characters Kaikai and Kiki.

The flattening and blurring of cultural boundaries in Murakami's works is exemplified in the production and re-production of manga and anime symbols as they mutate back and forth from the elitist contemporary art market to the mainstream. He collaborated with Louis Vuitton, redesigning the brand's monogram and creating series of handbags. The popularity of the bags soared and even spawned a secondary market supporting a wide range of counterfeit handbags – in certain cliques, every teenage girl absolutely had to have one of these super-flat and super-cute handbags.

No serious contemporary art museum collection would be complete with a Murakami sculpture or painting, and his works fetch record values in auction houses. In 2008, Sotheby's sold *My Lonesome Cowboy* (1998), a cartoon-like sculpture of a masturbating boy ejaculating a spiral of sperm, for $15.2 million. If you don't happen to have millions of dollars in your savings account, you can buy an eco-friendly Murakami cotton shopping bag on Amazon for only $16...

My Lonesome Cowboy (1998)

Ivan Navarro

www.ivan-navarro.com

Born 1972 in Santiago, Chile
BFA Pontifical Catholic University of Chile, Santiago, Chile
Lives and works in New York City.

CHILEAN ARTIST Ivan Navarro is based in Brooklyn, New York. His work is included in the permanent collections of Saatchi Gallery in London, the Hirshhorn Museum in Washington DC and the Centro Galego de Arte Contemporanea in Spain, and he also exhibits internationally. Recurring motifs in his work include light, death, minimalism, and de Stijl aesthetics. Navarro is inspired by conceptual and minimalist artists such as Dan Flavin and Dan Graham, and his works have also alluded to designers such as Gerrit Rietveld. Navarro is best known for his series of neon and fluorescent mirror-sculptures that often amplify ironic one-word messages such as 'surrender', 'abandon', 'try,' or 'die'.

Navarro's critically acclaimed exhibition at the Chilean Pavilion in the 2009 Venice Biennale was entitled *Threshold* and consisted of three artworks: *Resistance*, *Death Row* and *Bed*. *Death Row* is a colorful row of thirteen reflective aluminum doors, which mirror their own neon-light frames to create an infinity of columns. Whereas *Death Row* is an autopsy of the color spectrum, *Resistance* is a perpetual motion machine that lights up every time a visitor rides a bicycle that is wired to a fluorescent cart. *Bed* is a cylindrically mirrored sculpture that resembles a bottomless well as it repeatedly mirrors the neon lit word 'Bed' beyond the depths of perception. *Threshold* invites you to look beyond the looking-glass towards the transcendental and sublime.

Echo, 2008

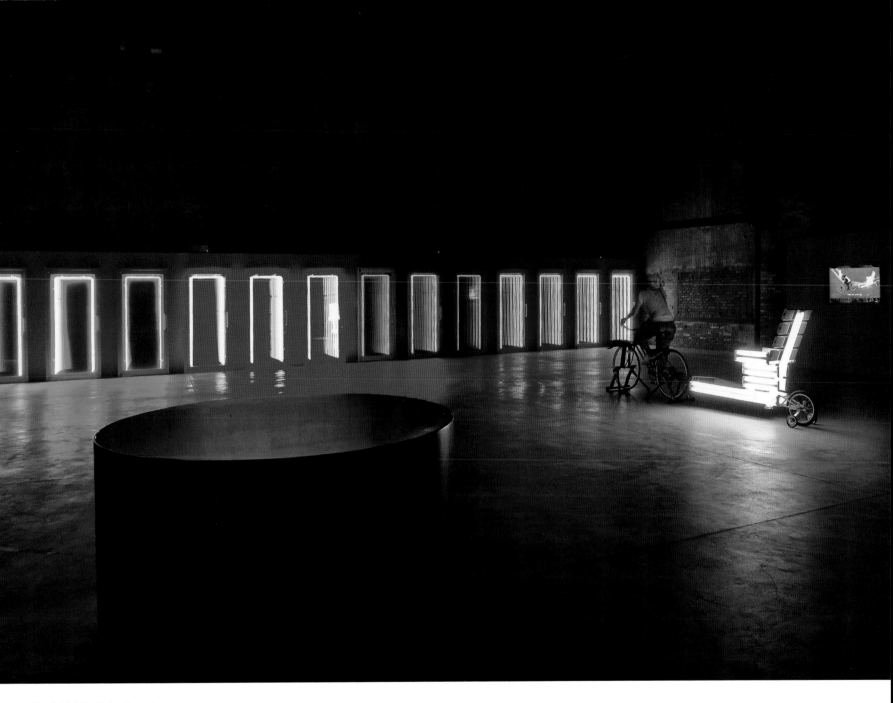

Threshold at the Venice Biennale, 2009

Roman Ondák

Born 1966 in Zilina, Slovakia
Lives and works in Bratislava, Slovakia.

ROMAN ONDÁK is a neo-conceptual artist whose works often involve audience participation. Ondák has exhibited internationally and was awarded the Frieze Art Fair's Artist of the Year in 2011. The interactive nature of Ondák's work empowers its viewers and challenges traditional distinctions between art production and consumption. In *Measuring the Universe*, Ondák instructed gallery invigilators to mark the height, name and date of each gallery visitor. *Measuring the Universe* exemplifies the organic aesthetic in Ondák's projects, which fosters emergent patterns and avoids being predetermined. Similarly, *I'm just acting in it* is a series of 24 drawings of Ondák created by people who had never met him but who had received a verbal description of his physical characteristics.

During the 2009 Venice Biennale, Ondák converted the Slovakian Pavilion into a landscape filled with trees and bushes – enabling the public gardens that host the Biennale to reassert themselves into the viewer's awareness, and obliterating the internal and external boundaries of the fair. This horticultural intervention – appropriately entitled *Loop* – pushes the boundaries of the white cube and alludes to the symbiotic perception/experience of the spectator with his environment.

Ondák's exhibition at Modern Art Oxford was also critically acclaimed. *Stampede* is a film of people who agreed to be squeezed into a darkened room. The film utilizes night-vision technology and was exhibited alongside Ondák's *Time Capsule*, a replica of the Fenix 2 capsule that was used to rescue the 33 Chilean miners who were trapped underground for 69 days.

Loop, Venice Biennale, 2009

Measuring the Universe, MoMA, 2009

Damián Ortega

Born 1965 in Mexico City, Mexico.
Lives and works in Berlin, Germany.

"Who made who? If the individual can change the context or the context made can change the individual. This [is a] mix of inside and outside, individual and group of society, open and closed." Damián Ortega, *The New England Journal of Aesthetic Research* (October 2009)

DAMIÁN ORTEGA is one of the most innovative and influential contemporary sculptors. He has had major solo shows at the Centre Pompidou, ICA Boston, and at Tate Modern, and was nominated for the Hugo Boss prize in 2005, and the Preis Der Nationalgalerie in 2007.

Prior to his career as a contemporary artist, Ortega was a political cartoonist, which he credits for combining elements of incongruity, transformation and dysfunctionality. His playful sculptures include *Cosmic Thing* (2002), for which he took apart a Volkswagen Beetle and created an installation from its components. In another one of his 'Beetle' works, he buried a Volkswagen Beetle outside a Volkswagen factory. For *120 Days* (2002) he created 120 versions of Coca-Cola bottles, which were crafted by a Tuscan glass studio. Alluding to the Marquis de Sade novel *120 Days*, Ortega's bottles were formed in various lewd and perverse shapes.

A major source of inspiration for Ortega was his teacher, Gabriel Orozco. Ortega's sculptures also have a uniquely visual and conceptual framework, which blur the boundaries of art, sculpture and architecture. Ortega's projects tend to deconstruct systems varying from the mechanical to the social, but rather than scientifically searching for meaning and/or function, Ortega's works isolate and re-contextualize their subjects in order to stimulate the viewer's imagination and inspire an alternative visual vocabulary.

Escarabajo, 2005
16 mm film. 16 minutes.

OPPOSITE *Cosmic thing*, 2002.
Stainless steel, wire, Beetle 83' and plexiglass. Variable dimensions.

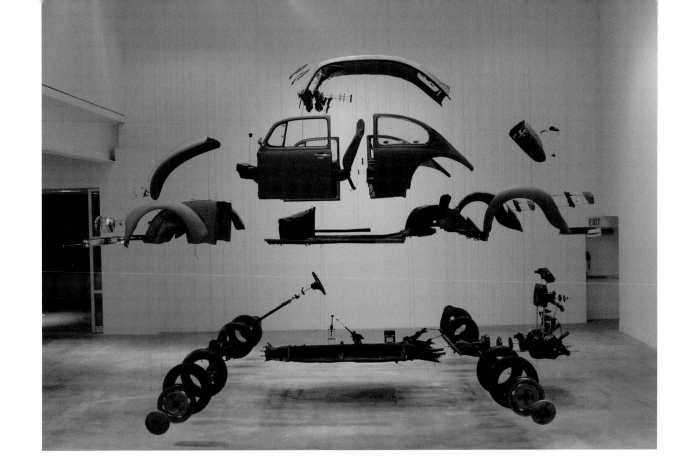

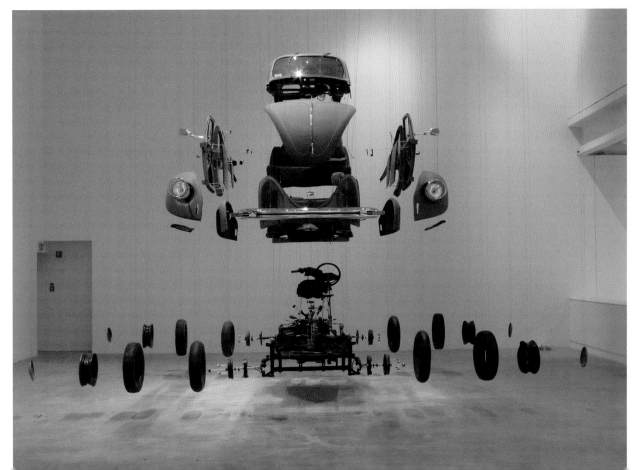

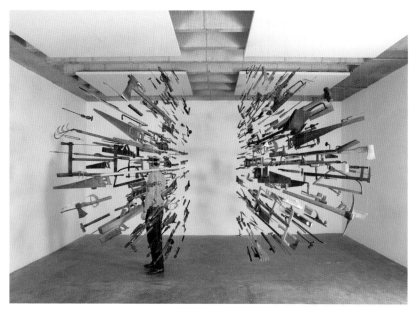

Controller of the Universe, 2007
Found tools and wire 285 x 405 x 455 cm
(112.2 x 159.45 x 179.13 inches)

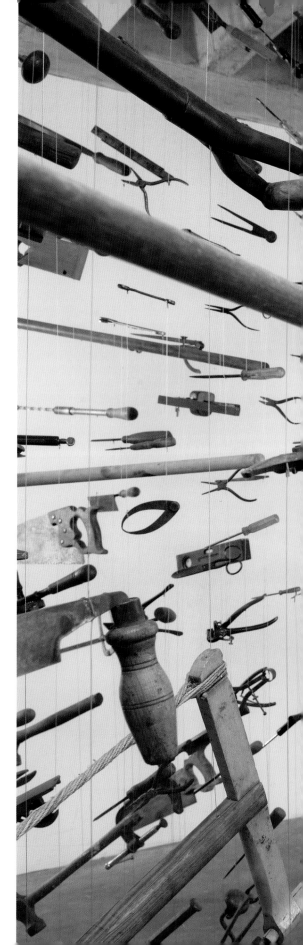

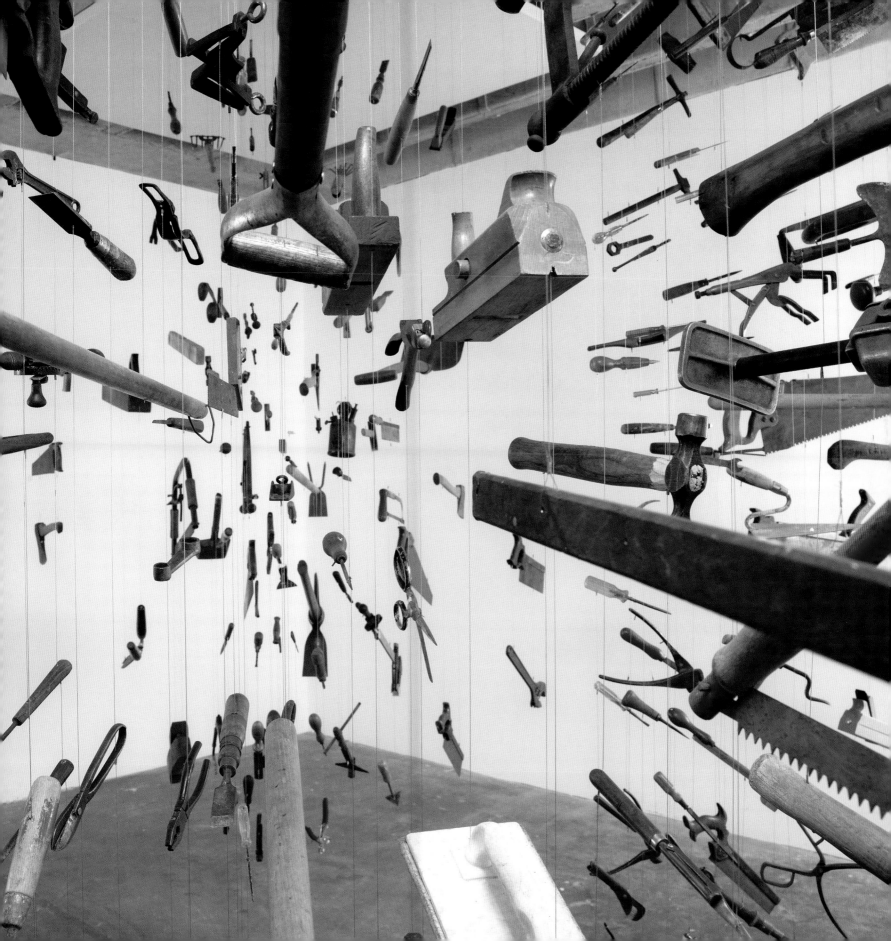

Miguel Palma

www.miguel-palma.com

Born 1964 in Lisbon, Portugal
Lives and works in Lisbon.

MIGUEL PALMA is a Portuguese artist whose work spans a range of media such as video, drawing, kinetic installations, art books and performances. He has been exhibited internationally, including at MUDAM in Luxembourg, Bloomberg SPACE in London, Prospect New Orleans, Chelsea Art Museum in New York and VOLTA 5 in Lisbon. He has also had a retrospective exhibition of his work with over 100 pieces at Gulbenkian Modern Art Center, Lisbon.

Palma's work often explores issues such as the development of technology, the environment, cybernetics and the fragility of life. Palma explains that when his father passed away, he became obsessed with building life-like artworks that were both delicate and self-sustaining. He often creates large-scale installations, mechanically engineered with various gadgets and toys such as models of cars and planes.

Pleura and *Deep Breath* are a transparent pair of room-sized mechanical lungs that repeatedly inflate and deflate. *Osmosis* comprises three aquariums, one of which contains a live fish in salt water, the other a live freshwater fish, and the third aquarium is a desalination unit. The water is continually recycled via the desalination point, as a delicate state of equilibrium enables both fish to 'share' the same water.

Autofocus involves a video camera and monitor powered by a propeller along a set of rails. The monitor displays the view of the camera, which points to a globe of the Earth. When the fan powers off, gravity pulls the unit away from the globe, whereas when the fan is turned on, the camera/monitor shift towards the globe, causing the image on the monitor to zoom in. *Autofocus* playfully explores homeostasis, vision and movement.

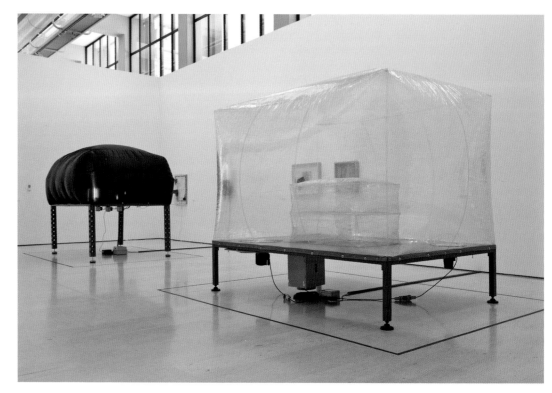

Pleura, **2009**
Iron workbench, MDF, three ventilators, electronic system, acrylic pouch. 300 x 200 x 270 cm/ 118 x 79 x 106 in

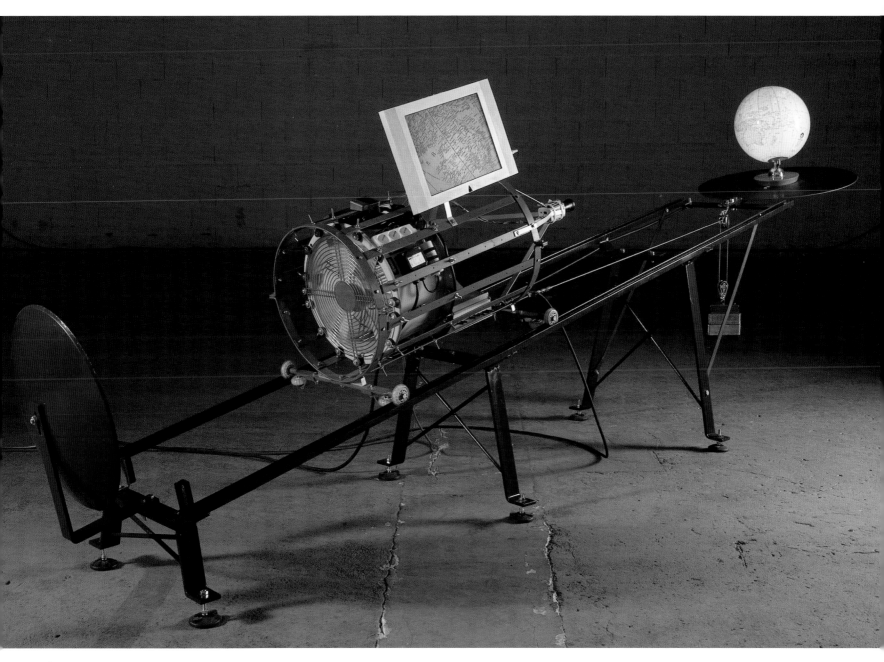

Autofocus, 2006
Metal structure, video camera, LCD, fan, earth globe,
electric and electronic devices, cables, mechanical devices
150 x 300 x 100 cm/ 59 x 118 x 39 in
Property of MUDAM, Luxembourg

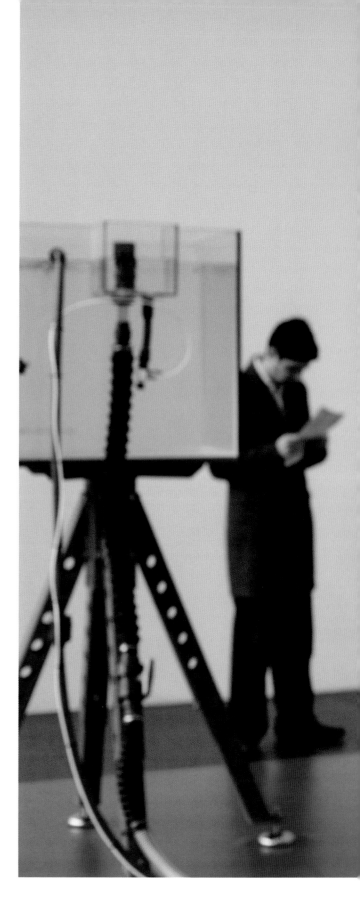

Osmosis, **2009**
3 aquariums, 3 iron tripods, osmosis system, digital
thermostat, water pumps, 1 salt water fish, 1 fresh water
fish, filters, timer 350 x 250 x 200 cm/ 138 x 98 x 79 in

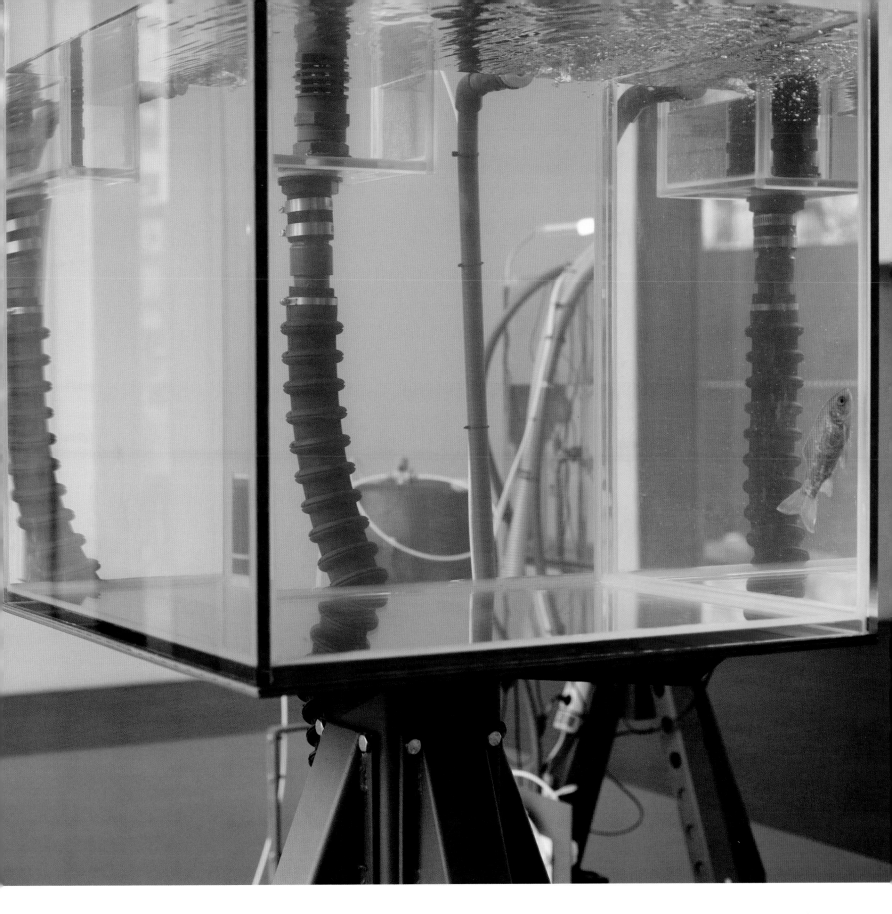

Bona Park

www.bonapark.co.uk

Born 1977 in Seoul, Korea
MFA Art Practice, Goldsmiths, University of London, UK , 2008
BA Fine Art, Korea National University of Arts, Seoul, Korea, 2004

BONA PARK'S performance art often establishes a participatory platform. Park's recipes are reminiscent of John Cage's performances, which often enabled the audience to become a component of the work. In *Jesus is Coming, Look Busy!* Park invited anyone who believed that they look like Jesus to attend a private view in which they were asked to serve free red wine. Anyone could claim to be Jesus regardless of gender or race and without resorting to growing a beard.

In *Bona Park*, Park hired an actress to pretend to be her and discuss her work at her own private view. Just as Cage's 4'33 created a sound piece based on the noise generated from the spectators' response to Cage's 'silent' four minutes and thirty-three seconds, Park's *Bona Park* created a structure in which the exhibition visitors were able unknowingly to respond and perform. Much like a reality TV show, this reflexive performance juxtaposes actors with 'real' people and mirrors popular culture right back at itself.

In *Sea of Love*, Park advertised in *The Guardian*'s *Soul Mate* section: "Wouldn't it be nice to sit & talk? Slim and attractive Asian Artist, long -black hair, F, 29 seeks somebody to share fun and zest." This generic solicitation resulted in a series of dates with Park, all of which involved walking along the Thames between the London Eye and Tate Modern. Her dates were asked to photograph whatever they wanted, and the photos from her series of courtships were displayed at a London art gallery.

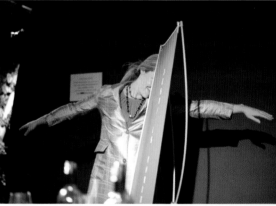

Jesus is coming, look busy!, 2009

Bona Park, 2009
Performed by Yeun Ahn

C., British, 33
Maintainer for
a residence

16. 06. 2007

R., British, 34
Classic guitar-
 ist

18. 06. 2007

S., British, 36
Instructor for
self-defense &
poet
24. 06. 2007

H., British, 60
Engineer

19. 06. 2007

A., British, 34
Artist & social
worker

29. 06. 2007

Sea of Love, 2007

165

Cornelia Parker

Born 1956 in Cheshire, UK
Gloucestershire College of Art & Design, Gloucestershire, UK, 1975
BA, Wolverhampton Polytechnic, UK, 1978
MFA, Reading University, UK, 1982
Awarded O.B.E. and elected to the Royal Academy, 2010
Lives and works in London.

"Humanity may be on the brink of disaster, but this could
be an exciting, creative period, with everyone -- philosophers,
artists, politicians, bus drivers – doing everything they can
to avert it." Cornelia Parker, *The Guardian*, February 12, 2008

CORNELIA PARKER is a renowned installation and
sculpture artist. She was shortlisted for the Turner Prize
in 1997 and her works are held in most contemporary
art museums including MoMA, the Tate Gallery and
Boston's ICA. Parker's works often employ
unconventional materials that are charged with
meaning, such as a feather from Sigmund Freud's
pillow, or the charred remains of a Texan church that
was hit by lightning. In *Cold Dark Matter: An Exploded
View*, Parker commissioned the British Army to blow
up a garden shed, and later suspended the surviving
fragments as an installation. For *Pornographic
Drawings*, Parker dissolved pornographic videotapes
that were confiscated by H.M. Customs and Excise,
and reused the melted liquid as ink to create a series
of drawings.

In *Thirty Pieces of Silver*, Parker had a steamroller
flatten a set of silver artefacts, and then suspended
them from thin wires. This process resulted in a
surrealist installation that exemplifies the transformation
of a ordinary object into a non-functional art object.
In *Alter Ego* silver-plated kitchen wares are suspended
along with their flattened doppelgänger – creating
a shadow, like effect, and suggesting that form and
meaning are fluid and intertwined.

Alter Ego, 2004

Thirty Pieces of Silver, 1988–9

Katie Paterson

www.katiepaterson.org

Born 1981 in Glasgow, Scotland
BA in Fine Art, Edinburgh College of Art, Scotland, 2004
MFA Slade School of Fine Art, UCL, London, UK, 2007
Lives and works in Berlin, Germany.

KATIE PATERSON'S practice is a perfect marriage of art and science, and technology. She was the first resident artist at UCL's physics and astronomy department, and her work has been exhibited internationally, including recent solo shows at Haunch of Venison in London, PKM in Seoul, and the James Cohen Gallery in New York.

Paterson's work often interprets and re-creates invisible forces. During her master's degree at Slade, Paterson recorded a melting glacier and set up a phone line so that anyone could call and listen in. This sound piece was entitled *Vatnajokull* (The Sound of), and is meant to inspire listeners to visualize and imagine this disappearing Icelandic glacier. In *Earth-Moon-Earth*, Paterson encoded Beethoven's *Moonlight Sonata* into Morse code, broadcast the transmission onto the surface of the moon, and finally recaptured the patchy returning transmission and had it played on an automated grand piano.

For *All the Dead Stars*, Paterson produced a laser-etched print of all of the 27,000 dead stars known. Of course, this list suggests its own incompleteness as mankind is only aware of stars that we've empirically extrapolated to have died, ranging from white dwarfs to supernovae, but the complete history of the cosmos includes many events that are unknown to us.

Throughout the 54th Venice Biennale, Paterson used a hand-held confetti cannon, which was fired 100 times in locations varying from piazzas to hidden back streets. Paterson's *100 Billion Suns* is meant to both condense and convey all of the cosmic gamma-ray bursts (GRBs) into a series of confetti cannon explosions. Just as there are 3,216 known GRBs, each of Paterson's confetti cannons contains 3,216 pieces of confetti, condensing each confetti explosion into a sort of super-supernova. GRBs are the most luminous events in the universe, and although they usually span less than 40 seconds, they emit more energy than the sun will in its entire ten billion year lifetime. The initial burst involves gamma rays and is usually followed by a lower energy 'afterglow' of x-ray, ultraviolet, infrared, and radio waves. Paterson's *10 Billion Suns* also leave an afterglow of confetti and the hint that even the unimaginable can be rendered within a human scale.

All the Dead Stars, 2009
Laser etched anodised aluminium, 200 x 300
cm/ 79 x 118 in

OPPOSITE *100 Billion Suns*, 2011
Confetti cannon, 3,261 pieces of paper

Grayson Perry

Born 1960 in Chelmsford, England
BA in Fine Art, Portsmouth Polytechnic, 1992
Lives and works in London, England.

GRAYSON PERRY is a contemporary artist whose trademark medium, oddly enough, is the ancient craft of ceramics. He is the only ceramic artist to have won the Turner Prize (2003). While his practice draws on folk art and Greek pottery, his work is innovative, edgy and intellectually subversive. His ceramics have been exhibited internationally, including solo shows at the Barbican Art Gallery, the Kanazawa 21st Century Museum of Contemporary Art, and the Stedelijk Museum in Amsterdam.

Perry constantly experiments with various media. He authored and illustrated a graphic novel, and has also worked with embroidery, printmaking, tapestry and film. He curated a blockbuster show at the British Museum in 2011; *Tomb of the Unknown Craftsman*, which juxtaposed his own work with artefacts from the museum's permanent collection. *Tomb of the Unknown Craftsman* blurs time and space while seamlessly integrating ancient items produced by unknown artisans with Perry's contemporary creations.

An avid cross-dresser with a female alter ego by the name of Claire, Perry often appears at private views and public events as his alias. Perry's artwork is often autobiographical, and characters such as Claire's/Perry's favorite teddy bear, Alan Measles, are often embedded into his work. His aesthetics gravitate towards bright colors such as pink, light blue and yellow, and his illustrations depict topics ranging from sex and motorcycles to war and holy relics.

World Leaders Attend the Marriage of Alan Measles and Claire Perry, 2009
Glazed ceramic. 52 cm x 32 cm (GP 277).

The Walthamstow Tapestry, 2009
Tapestry. 1.4 meters x 7 meters, 55.1 x 275.5 inches. Edition of 12 plus 2 APs (GP 280)

Stefanie Posavec

www.itsbeenreal.co.uk
www.twitter.com/stefpos

Born Colorado, USA
BFA, Colorado State University in Fort Collins, Colorado, USA, 2002
MA, Communication Design, Central St. Martins, London, UK, 2006
Lives and works in London, UK.

STEFANIE POSAVEC specializes in data visualization and information design. Her artwork ranges from designing books, albums and iPhone apps to infographics, posters and limited edition art books. Posavec exemplifies the hybrid and prolific nature of a 21st century artist and designer, and her curiosity seems to be boundless. She's designed an artist-theme for the Google Chrome browser that anyone can download for free. Other digital creations include her visual index embedded in Stephen Fry's *MyFry* iPhone app; the index is both ravishing and functional as it enables users to read *The Fry Chronicles* in a non-linear fashion by scrolling through a color wheel that highlights various motifs and themes in the book.

Posavec's *Writing Without Words* projects are a series of works that color code, visualize and represent text from various sources of literature; In *Literary Organism*, she transformed Jack Kerouac's *On the Road* into a stunning two-dimensional tree that divides the book's paragraphs and sentences into bifurcating visual elements. Her *Sentence Drawings, Sentence Length* and *Rhythm Textures* all provide unique and engaging visual interfaces, which provide alternative modes of 'reading' literature. Posavec has also experimented with various visual patterns that emerge by multiplying numbers and her *11 x* series are a striking series of rainbows of pixels and geometric shapes.

Posavec has created her own artist books and also designed limited edition posters and book covers for various authors. She created the artwork for 111 signed and numbered limited-editions of Haruki Murakami's *1Q84*, for a new edition of Oscar Wilde's *The Picture of Dorian Gray*, and the UK edition cover for Levitt and Dubner's best-selling *Super Freakonomics*. Posavec also designed an album cover for the American rock band

Ok Go, and has teamed up with various researchers and designers such as Microsoft's Greg McInerny (visually analyzing Darwin's *Origin of Species*) and David McCandless (*Left vs. Right* infographic of the American political system).

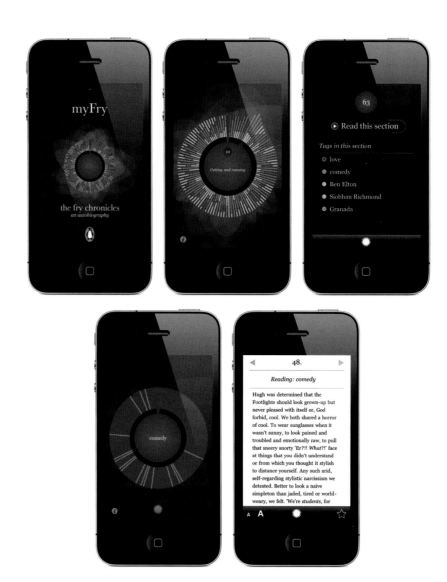

ABOVE **MyFry, an interactive biography of Stephen Fry, 2011**

OPPOSITE **Analysis of Jack Kerouac's *On the Road* from Posavec's *Literary Organism* series. Other visualizations in this series include Walter Benjamin's seminal essay *The Work of Art in the Age of Mechanical Reproduction***

LITERARY
ORGANISM

A visualization of Part One of
On the Road, by Jack Kerouac

BASIC STRUCTURE

Each literary component can be subdivided into even smaller parts. We visualized in this diagram using words. The diagram is read clockwise, starting from the first chapter, paragraph, or sentence.

NOTATION

3.5
chapter
paragraph

COLORS

WORD COUNT CHART

Gerhard Richter

www.gerhard-richter.com

Born 1932 in Dresden, Germany
Lives and works in Cologne, Germany.

GERHARD RICHTER's diverse body of work includes abstract painting, photo-realistic painting, printmaking, and glass sculpture. Richter is one of the most influential artists alive, and continually innovates and reinvents himself. He first represented Germany in the Venice Biennale in 1972, and returned in 1980, 1984, 1997 and 2007. In 2010, his works sold at auction totaled more than $70 million, and in 2011, his 1982 *Candle* sold for $16.5 million.

Along with Lueg and Polke, Richter originated the anti-art style Capitalistic Realism, which appropriates images from advertising and consumer-driven materialism. Richter's black and white paintings from the 1960s often re-created images from print media such as newspapers and books. Richter would project the photo onto a canvas, trace the image precisely, and then blur the final image. The blurring of the image became part of his trademark and exemplified the transient nature of memory and physical reality.

In the 1980s, Richter painted a series of memento mori still lives. Death and destruction are recurring themes in his works. In 1988, he produced 15 paintings about the three Red Army Faction members, a radical-leftist German terrorist organization. During this period, Richter also produced a series of colorful large-scale abstract paintings.

Richter can also be credited with creating pixel art over a decade before the introduction of the personal computer. *256 Colours* is a randomly arranged color chart, which was organized by chance procedures developed by Richter. Richter's stained glass installed in Cologne Cathedral combines 11,500 squares from 72 colors, indiscriminately arranged.

Richter's diverse body of work has often engaged with, challenged, and developed contemporary art theory. Several of his pieces echoed previous artists' works, such as *Ema (Nude on a Staircase)*, in response to Duchamp's *Nude Descending a Staircase*, and *Panes of Glass* as a critique of *Bride Stripped Bare By Her Bachelors, also by Duchamp*. From conceptual art and architecture to painting and sculpture, Richter remains prolific and potent.

Cologne Cathedral, 2007

Strip 1568, 2011

Mika Rottenberg

Born 1976 in Buenos Aires, Argentina
Hamidrasha, Bait Berl College of Arts, Israel, 1998
BFA, School of Visual Arts, New York, USA, 2000
MFA, Columbia University, New York, USA, 2004
Lives and works in New York, USA.

"When you're making creative work, you in some ways commodify your soul and your emotions. Raqui, the star of *Dough*, is beautiful. She has so much pride in the way she carries herself and it is very inspiring to me. She is a size-acceptance activist, and she wrote about my 2006 video *Dough* on her website. People accuse me of basically hiring women's bodies, but I don't. These women own their own means of production." Mika Rottenberg, *Artforum*, (July 2010)

MIKA ROTTENBERG is an acclaimed contemporary artist best known for her video and photography projects. She has exhibited at De Appel Arts Centre in Amsterdam, the Guggenheim Museums in Bilbao and New York, MoMA in New York, and the KW Institute of Contemporary Art in Berlin.

Rottenberg's fantastical videos often involve the female form and the harvesting of bodily fluids via mechanical human labor (pumping, pedaling, squeezing, etc.) *Cheese* (shown at the Whitney Biennial in 2008) consists of six longhaired women in white dresses working on a farm and converting their hair and goat's milk into cheese. *Mary's Cherries* (2003) also employed a similar surrealist logic as a group of women formed a production line where red fingernails were transformed into cherries. The recurring women in her films often have bodies with uniquely exaggerated characteristics. Whether it's fingernails, sweat, hair or tears, Rottenberg's films tend to explore the notion that value can be extracted from nature in the most unusual ways.

In addition to her videos and photography, Rottenberg also produces drawings and installations. She has an immaculate sense of composition of sculptural forms, and her works have a self-referential quality that suggests that any alternative world highlights the absurdist nature of our own reality.

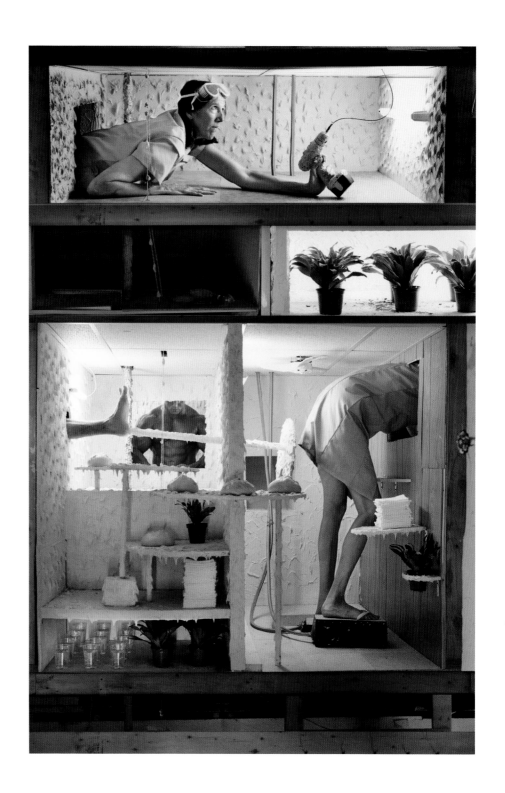

Kat Legs & Torso (performance still), 2008
C-print 67.75 x 44 inches 172.1 x 111.8
centimeters. Edition of three.

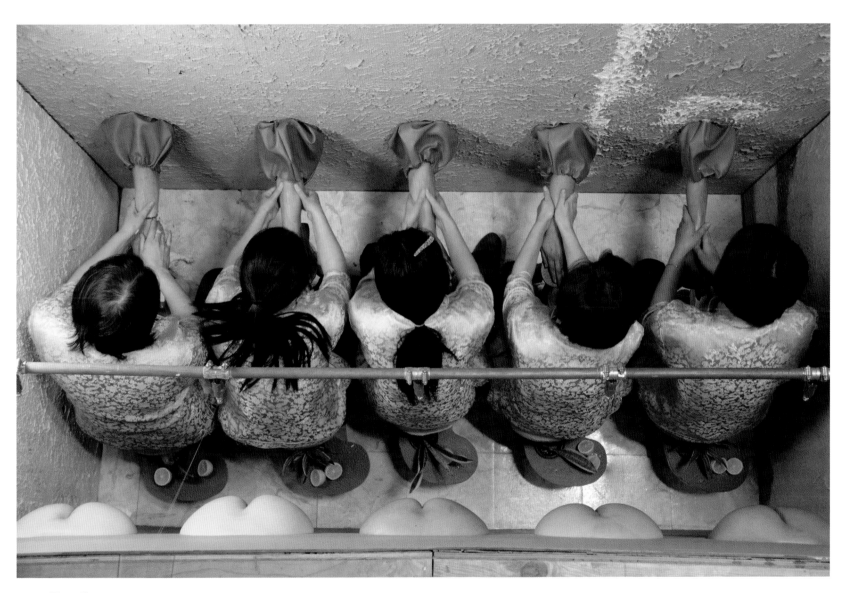

Squeeze (film still), 2010
Single channel video installation. Duration: 20 min. Dimensions variable. Edition of six.

Michal Rovner

www.michalrovner.com

Born in 1957 in Tel Aviv, Israel
Cinema, Television and Philosophy, Tel Aviv University, 1979–81
BFA in Photography and Art, Bezalel Academy, 1985
Lives and works in New York and Israel.

"The text is a sub-text of my work, has been for, for a while."
Michal Rovner on BBC Radio 3, November 2003

MICHAL ROVNER is a contemporary Israeli artist.
Rovner is a co-founder of the Camera Obscura School
of Art in Tel Aviv. She represented Israel at the 2003
Venice Biennale. She has been exhibited at the
Whitney Museum, MoMA, the Stedelijk Museum, and
Tate Modern. Her works often explore perceptions of
identity, death and memory, and retain an ambiguity
that elicits various interpretations.

Rovner's innovative digital art incorporates
photography with video. She has collaborated with
filmmakers such as Robert Frank and Philip Glass.
A recurring theme in her films is the portrayal of a
herd of animals or people in an unconventional setting.
Against Order? Against Disorder? was exhibited at the
Venice Biennale and included *Time Left*, a room lit
only by wall projections of a cluster of human figures
shuffling about repetitively, and *Data Zone*, which
embedded these humanoid silhouettes into Petri
dishes. *Time Left* and *Data Zone* highlight the
similarities between laboratory cultures and human
civilization, and suggest that swarm-like behavior
can manifest at any scale.

Data Zone, Culture Plate #4, 2003

Time Left, the Israeli Pavilion at the 50th Venice Biennale, 2003

Wu Shanzhuan

Born 1960 in Zhoushan, China
The University of Fine Arts of Hamburg, Germany, 1995
Normal Department of the Zhejiang Art Academy, China, 1986
Lives and works in Hamburg, Germany, and Beijing, China.

"I mean logos are in a way very nice, but in a way, also limit what we buy. I think they said that formerly in Hamburg, you could buy five hundred kinds of potatoes. But today you can only have five." Wu Shanzhuan interviewed by Hans Ulrich Obrist (May 2006)

WU SHANZHUAN is a conceptual Chinese artist. His works have been shown at the Frieze Art Fair and at the Shanghai Biennale in 2011, among other international venues. *Artforum* referred to his exhibition at the Guangdong Museum of Art as one of the best shows in Asia of 2008. Wu has produced artworks in a diverse range of media such as drawing, installation, painting, and photography.

Mathematics and logic play an inspirational role in Wu's graffiti-like and expressionistic works. Wu was one of the first Chinese pop artists, and his canvases often combine diagrams with symbols and text. His work *d=m·r·r ?d: destiny m::...* (2010) combines schematics and the production of a set of circular hieroglyphs designating a dozen attributes such as reason, consciousness, democracy, ignorance and energy. His hybridized and globalized zodiac systems were constructed out of wood and painted with a glossy finish, resulting in a stunning sculptural array of destinies.

Wu's *Red Humor* (1986) installation consisted of an entire room covered with popular and eclectic textual references such as Buddhist scripture, Maoist slogans, and classic Western art history. His conceptual performances have often parodied Chinese cultural icons - setting up stalls to sell shrimp or toy pandas at art exhibitions. Wu also collaborates with his romantic and creative partner Inga Svala Thorsdottir; their *Paradise* (1993) performance and photograph exemplifies their thought-provoking artworks, and is a contemporary reinterpretation of original sin as a naked Thorsdottir hands Wu an apple in the produce section of a supermarket.

Yellow Flyng, 1995/2008
Mixed Media, 500 x 350 x 1600 cm

OPPOSITE *d=m·r·r (d: destiny; m: mass; r: random)*, 2010
Steel frame construction and wood. Dimensions vary according to installation

Conrad Shawcross

www.conradshawcross.com

Born 1977 in London, UK
Foundation, Chelsea School of Art, London, 1996
BA, Fine Art, Honors, Ruskin School of Art, Oxford, 1999
MFA, Slade School of Art, University College, London, 2001
Lives and works in London.

CONRAD SHAWCROSS works primarily with mechanical sculptures. Shawcross often collaborates with scientists as he develops his machines and is inspired by the philosophical and historical implications of technology. He is currently an artist in residence at the Science Museum in London, and he has exhibited at the Frieze Art Fair in London, the Sculpture Garden at 590 Madison Avenue in New York, and at Galleria Tucci Russo in Turin, Italy. His projects are critically acclaimed, and he won the Illy prize at Art Brussels in 2009.

His website classifies his bodies of work into ten categories: Axioms, Ropemakers, Harmonics, Lattices, Preretroscopes, Lightworks, Editions, Perimeter Studies, Continuums, and Commissions. For example, all works listed under Ropemakers are kinetic sculptures that actually produce ropes. *Paradigm (Ode to the Difference Engine)* was produced in homage to the invention of the computer (aka a Difference Engine) by Charles Babbage, and suggests that all algorithmic and repetitive machines – even ropemakers – are computational machines. *Nervous System (Inverted)* is a large-scale mechanical ropemaking system that intertwines strings to generate over 20,000 meters of rope each week.

Chord is another sculpture in Schawcross's Ropemaker series. According to Shawcross, his "original interest in it is to do with space and time and the linear perception of time – whether it's a line or a cycle. This rope being a linear structure formed from a rotational system, it has quite a good reference to that" (*The Arts Desk*, 2009). *Chord* was installed at an abandoned underground tunnel that is part of the Kingsway Tram Subway in Holborn, London. Two identical and large-scale rope-making machines were installed back to back and mechanically moved away from one another while weaving the rope that they leave behind and between them. Like giant and colorful spiders, these machines reanimate the forgotten tunnels and hint at a rediscovered sense of purpose.

Slow Arc Inside a Cube is part of Shawcross's Lightworks series, and was inspired by scientist Dorothy Hodgkin who developed protein crystallography and determined the chemical structure of insulin. *Slow Arc Inside a Cube* has a cube-shaped lattice that encapsulates a mechanical lamp. As the light moves about within the cube, the lattice's grid-formed shadows eerily shift alongside the neighboring walls. *Slow Arc Inside a Cube* is mesmerizing and proto-cinematic, and illustrates that science and art need not be distinct.

OPPOSITE **The Nervous Systems (Inverted), 2011**
Oak, glulam, metal, steel, string, mechanical system,
Dimensions variable

Slow Arc Inside a Cube IV, **2009**
Steel mesh, mechanical system, light, 1.2m x 1.2m x 1.8m

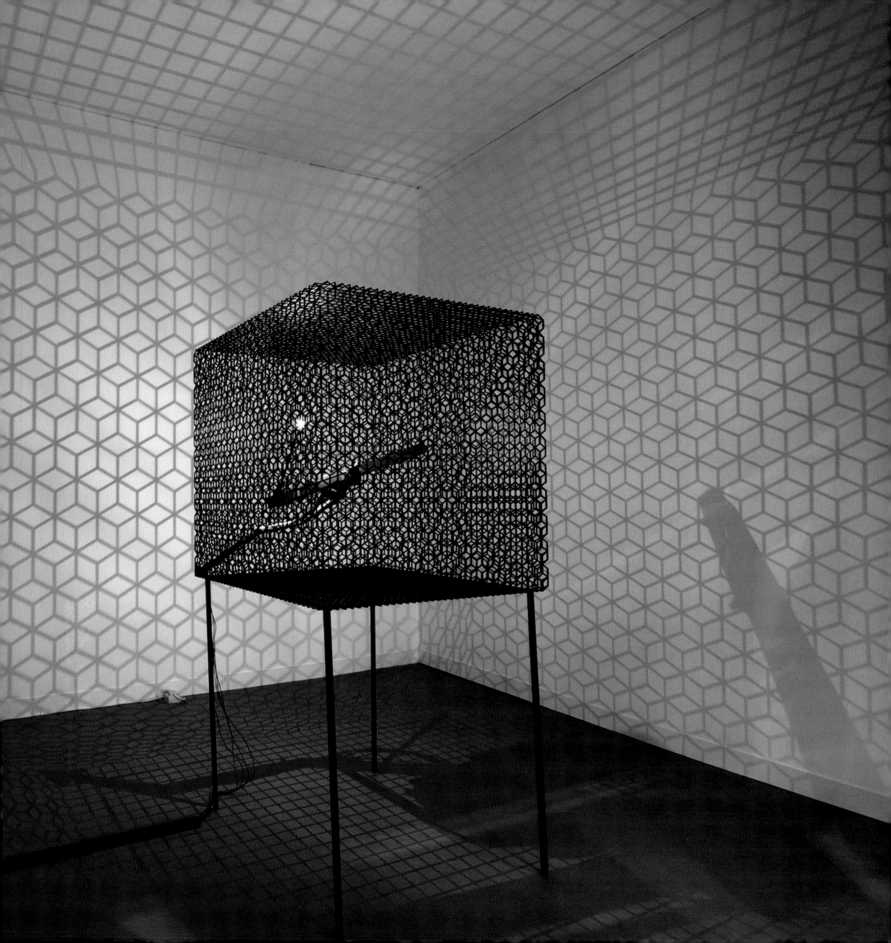

Lisa Slominski

www.lisaslominski.com

Born 1981 in Cincinnati, Ohio
Art Practice MFA, Goldsmiths, University of London, London, 2008
Visual and Critical Studies BA, School of the Art Institute of
Chicago, 2003
Living and working in London, UK.

SLOMINSKI'S artistic practice defies categorization and spans a range of media. Slominski has experimented with alternative forms of art making ranging from wallpaper to laser-cut acrylic glass. Regardless of the medium, she is a perfectionist and her work always displays a very polished and painstaking precision. Her laser-cut perspex sculptures integrate sublime and abstract shapes with iconic symbols such as emoticons, intimating the interplay between visual language and communication.

In *Pookie*, Slominski synthesizes her interests in patternmaking into an installation of over 100 laser-cut perspex symbols placed along a wall and spanning the floor to the ceiling. *Pookie*'s emoticon grammar alludes to both hi-tech ASCII art and perennially sacred mandala art. The resulting syntax is both sacred and profane, virtual and physical. The flocked screen prints of *Pookie* allude to Victorian velvet wallpaper, while the juxtaposition of ghostly monochromatic hues for the varying prints hint at the fallibility of mechanical reproduction.

In her Miami exhibition, *Dreamy Nomads, Baby*, Slominski juxtaposes laser-cut astro turf and linoleum with a fountain-like configuration of mirrors. Along the walls, two light boxes read "just passed our place. miss u xx." and "AMAZING!!!... where r u?" These asymmetric transmissions illustrate the representational capacity of visual literacy to communicate a tide of information such as geography/locality, shibboleths, and emotional mental states. *Dreamy Nomads, Baby* elevates DIY materials into the realm of fine art and exemplifies the transformative power that a contemporary artist may invoke by appropriating commodities and discernible visual arrangements. Context alters and re-creates content. Marshall McLuhan was right, the medium is the message, but even the medium shifts with time.

Pookie, **2011**
(installation view), Tenderpixel, London

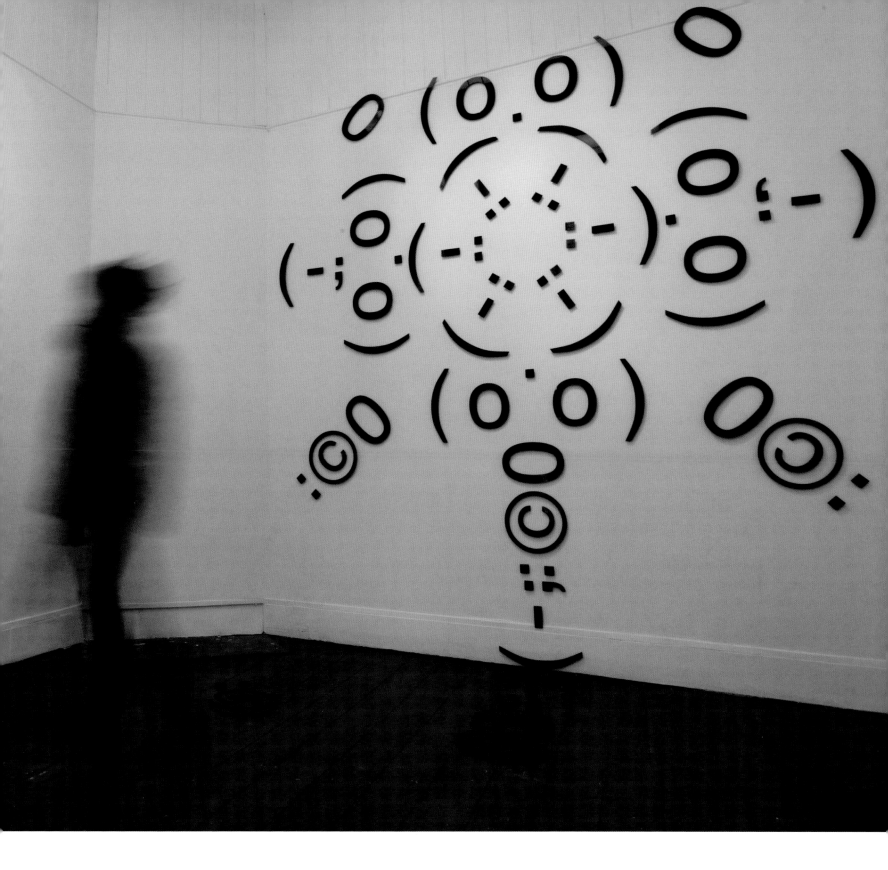

just pass our place u miss u xx

@miss@our.just
@miss@our.just

just passed our place..just
passedxx miss u xxpass

just pass our place u miss u xx

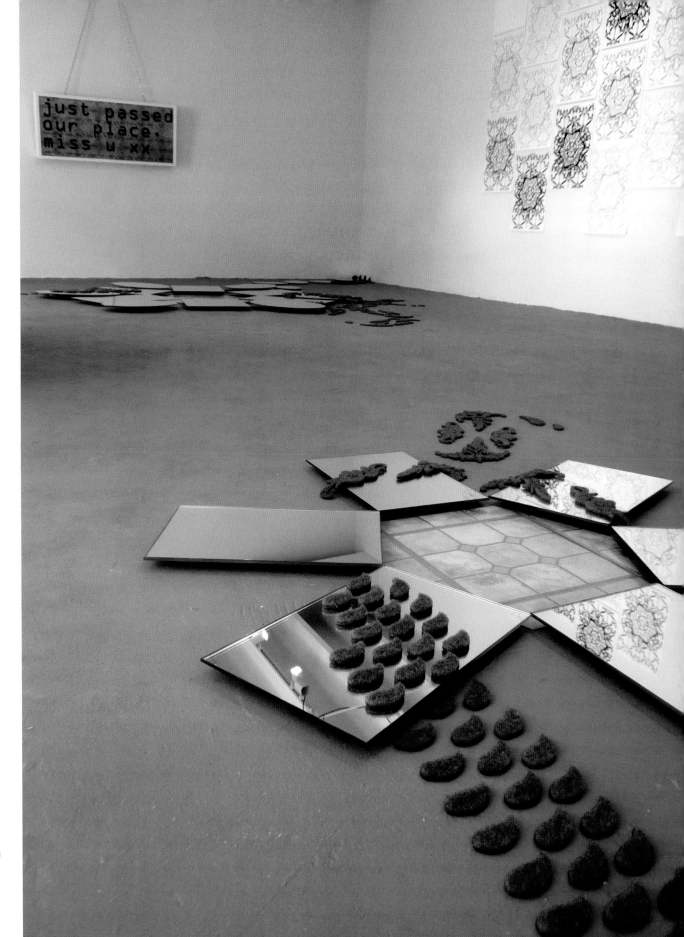

OPPOSITE AND RIGHT *Dreamy Nomads, Baby,* **2011** (installation detail), Dimensions Variable, Miami

Estela Sokol

www.estelasokol.com

Born 1979 in Sao Paulo, Brazil
Degree in Printmaking, Centro Universitário
Belas Artes, São Paulo, 2002
Lives and works in Brazil.

ESTELA SOKOL'S bright and colorful studio is always in a state of flux. Whether she's working with translucent plastic, industrial rubber, acrylic or synthetic varnish, Sokol's experimentation conveys a minimalist sensibility and a playful frame of mind. Her work resonates with the constructivist aesthetics that were popularized in Brazil in the 1950s. Sokol's paintings, sculptures and photos transcend their diverse media and transform the ordinary into the unexpected.

Sokol's sculptures tend to employ common industrial materials with which they create the illusion of luminosity without resorting to artificial lighting. This is done by juxtaposing bright and glossy objects with dark materials. The contrast results in the radiance of iridescent light, which reflects onto and illuminates its surroundings. For example, each monochromatic plastic in Sokol's studio is able to reflect light and tint the coloring of the white wall space around it; a large orange sheet of colored PVC hung on the wall can alter the form of the ground beneath it and cause it to appear orange as well. Furthermore, the combination of differently colored reflections can create a range of prism-like activities.

In her surreal photographs Sokol documents her optical research. Acrylic sheets placed along the snow during a sunny day shine as bright as a neon light. Similarly, colored latex balls hovering above or sunken into the snow become almost phosphorescent. Just as light is both a wave and a particle, Sokol's practice synthesizes form and content and illuminates its environment.

Polarlicht Series, C-Print, 2011

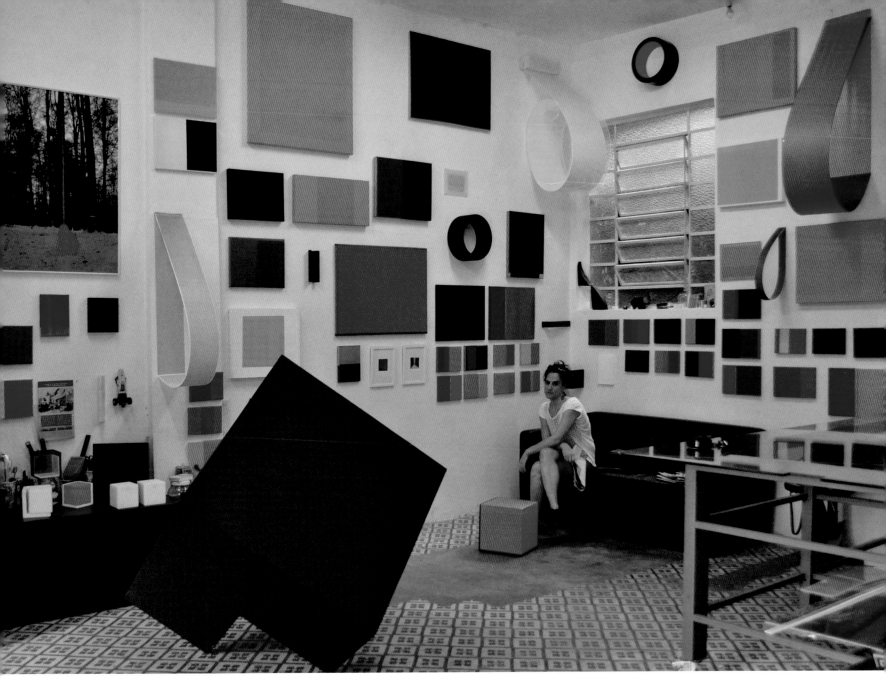

Estela Sokol in her studio, 2011

Mounira Al Solh

www.mouniraalsolh.com

Born 1978 in Beirut
Lebanese University, Beirut, LB, 1997-2001 (Painting)
Gerrit Rietveld Academie, Amsterdam, NL, 2003–2006
Lives and works in Beirut, Lebanon, and Amsterdam,
the Netherlands.

MOUNIRA AL SOLH is a multidisciplinary artist based in Amsterdam. She is the chief editor of *Not Only Arabic* magazine, and has also contributed articles to publications such as *Metropolis M*. Al Solh's work has been exhibited internationally, and was showcased at the first Lebanese Pavilion at the Venice Biennale (2007), at the Van Abbe Museum in the Netherlands (2008), and at Tate Modern in London (2011).

Al Solh's video *Rawane's Song* won the VideoBrasil jury prize. It juxtaposes witty subtitles with a video recording of Al Solh walking around her artist studio with her camera pointed at her feet. *Rawane's Song* attempts to avoid discussing the war in Lebanon, while ironically highlighting its indirect effect on her artistic practice: "I got JEALOUS of those artists who were able to do an artwork related to identity matters and I was particularly pissed off by the ones who came from a war background and knew how to talk about it."

The *Mute Tongue* is a series of 19 short videos performing nineteen Arab proverbs and sayings. Exploring processes of translation and performance, these videos are enacted by a Croatian artist who does not speak Arabic. Al Solh is fascinated with notions of social and political transformations.
The Sea is a Stereo is a series of works relating to a community of swimmers in Beirut, interrogating thresholds between emigration and immigration while alluding to Al Solh's migration to Amsterdam.

Paris Without A Sea, 2007–08
Video Nº 2, 13mns

Rawane's Song, 2006
Video, 7mns

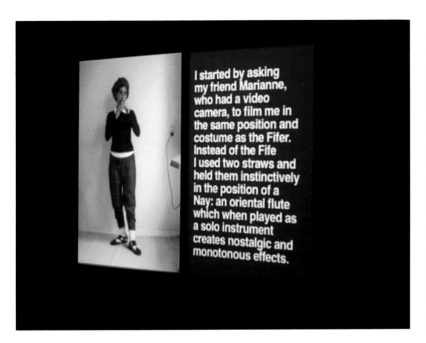
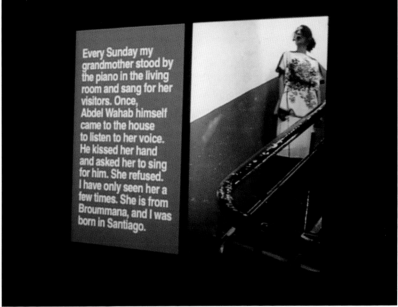

As If I Don't Fit There, 2006
Video installation with ambient sound, 12 minutes

Sputniko!

www.sputniko.com

Born 1985 in Tokyo, Japan
MA, Royal College of Art, Design Interactions, 2010
BS, Imperial College London, Mathematics and Computer
Science, 2006.

ALTHOUGH SPUTNIKO! is still in her 20s her career seems to have already launched into outer space, her work has been displayed at MoMA, the Tokyo Museum of Contemporary Art, and Ars Electronica. Sputniko!'s parents are mathematics professors and she completed her bachelor's degree in Computer Science and Mathematics. One might have expected her to be an engineer and perhaps take on a career in the aerospace industry. However, Sputniko! continued on to a master's in Design Interactions and currently engages in a range of creative endeavors.

Sputniko! is composed of a feminized 'Sputnik' (the first successful satellite), and 'ko', a typical ending for the naming of a Japanese girl (e.g. Yoko, Aiko, Yuko, etc...), tagged with an exclamation mark. The suffix 'ko' seems to emasculate the Russian Sputnik and its rocket. Perhaps, this persona aims to highlight the increased blurring of gender boundaries that is commonplace as new technologies re-contextualize the means of production and re-production.

Menstruation Machine is a prototype that also functions as a conceptual art piece. Like a chastity belt or empathy belt, it is worn around the waist and generates painful cramps - thereby enabling men to experience what it's like to have a period. *Menstruation Machine* even dispenses blood. Similarly, *Penis Cybernétique* is a prototype that Sputniko! designed to enable her to feel like she has "an extra body part (in this case - penis)". *Penis Cybernétique* features a motorized penis that oscillates from flaccidity to erection in correlation with her heart-rate. Inspired by the Open Prosthetics Project, Sputniko! has shared the code that she used to build *Penis Cybernétique*.

As a recording artist, she published *PARAKONPE 3000*, a DVD album featuring 15 of her songs and videos. Her songs often challenge pervasive technologies and popular culture. Tracks include: *Google Song, Child Producing Machine, Skype Song,* and *Sputniko! TV: Robot Duelling is Dangerous.*

OPPOSITE *Menstruation Machine, Takashi's Take*

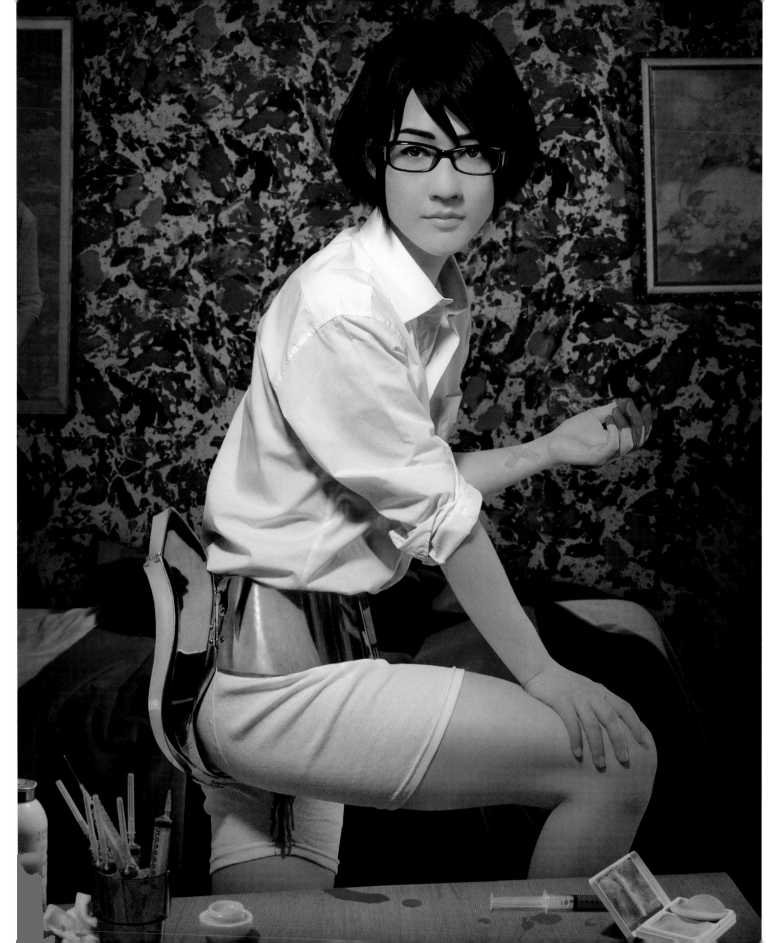

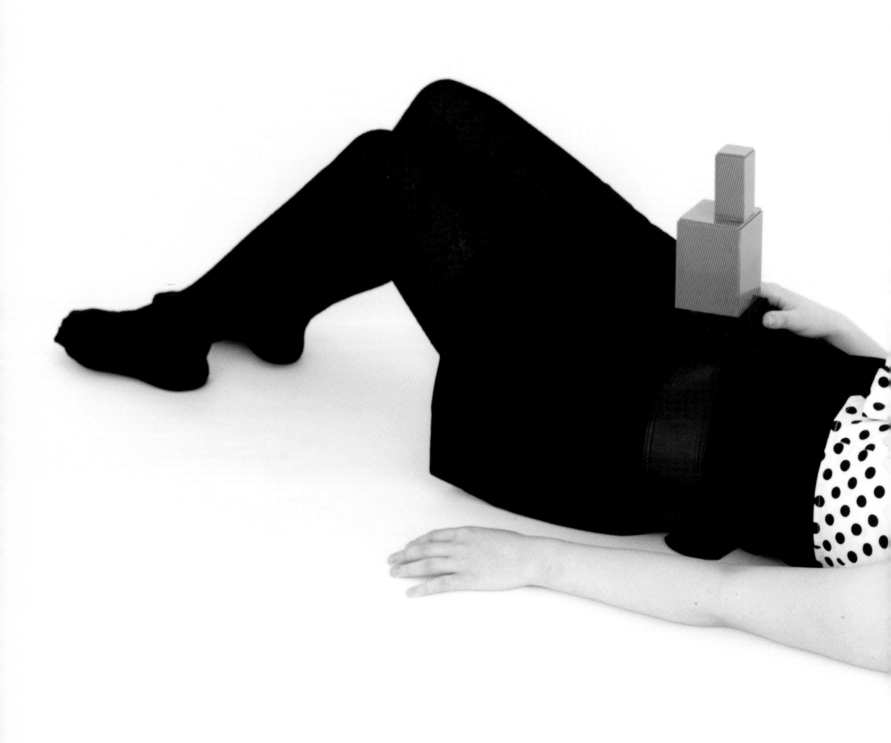

Penis Cybernétique

Simon Starling

Born 1967 in Epson, Surrey, England
Maidstone College of Art, 1987
BA, Nottingham Polytechnic, 1990
MFA, Glasgow School of Art, 1992
Lives and works primarily in Copenhagen, Berlin and Frankfurt.

"One of the things that I've been thinking about a lot over the last few years is this idea of a post-conceptual practice and how it's possible to take some of the very clear, hard-won models from conceptual work, you know, from the sixties, seventies, perhaps, and to try to re-deploy them in a way, to give them a new life." Simon Starling, *Art and Research*, Vol. 1, Number 1, Winter 2006/7

SIMON STARLING is a Turner Prize-winning artist whose conceptual art and practice often utilizes alternative modes of sculpture and performance. In *Shedboatshed*, Starling took apart a wooden shed and converted it into a boat, which he sailed along the Rhine, and then converted it back into a shed upon reaching his destination. Starling is also a professor of art at the Staatliche Hochschule für Bildende Künste in Frankfurt, Germany. His work has been exhibited widely including solo exhibitions at Tate Modern and the Guggenheim; he also represented Scotland at the Venice Bienniale in 2003.

The cyclical re-usage of materials is also exemplified in *Wilhelm Noack oHG*, which was exhibited in Berlin in 2007 and at the Venice Biennale in 2009. *Wilhelm Noack oHG* is a kinetic sculpture and a film that reflexively projects footage from the factory that built the projector. The film is looped continuously via a helix structure, which emphasizes the reflexive and introjective nature of the project. The monotonous hum of the projector generates a relaxing ambiance while the projected footage reincarnates the defunct factory. *Wilhelm Noack oHG* is masterful in both its craftsmanship and conceptual depth. Like a Zen koan, *Wilhelm Noack oHG* suggests that time is cyclical, and that reality is a subjective construct.

***Shedboatshed (Mobile Architecture No 2)*, 2005**
wooden shed and mixed media ca. 390 x 600 x 340 cm

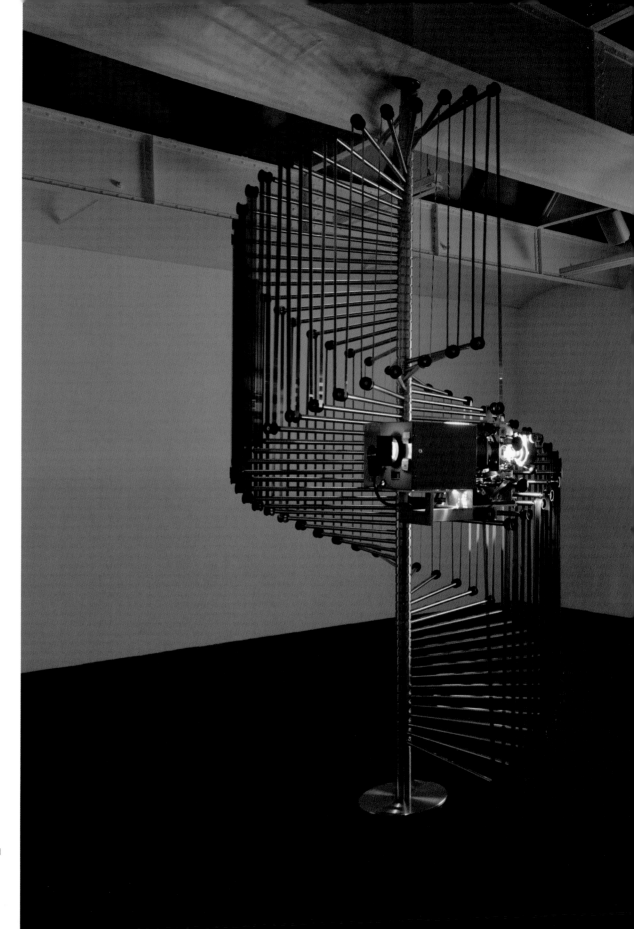

Wilhelm Noack oHG, 2006
Purpose built loop machine, 35 mm film projector, and
35 mm b/w film with sound. Duration: 4 min., 407 x
192 cm, projected dimensions variable

Do Ho Suh

Born 1962 in Seoul, Korea
MFA and BFA Oriental Painting,
Seoul National University, Seoul, Korea, 1987
BFA Painting, Rhode Island School of Design,
Providence, Rhode Island, USA, 1994
MFA Sculpture, Yale University School of Art,
New Haven, Connecticut, USA, 1997
Lives and works in London, Seoul and New York City.

DO HO SUH is an acclaimed Korean installation artist and sculptor whose projects often blur the boundaries of art and architecture. His work has been exhibited at MoMA in New York, MOCA in Los Angeles, Tate Modern and the Serpentine in London, the Mori Art Museum in Tokyo, and at the Venice Biennale (art fair) and Venice Biennale of Architecture.

One can already get the impression that memory, identity and collectivity are paramount just by browsing through the titles of some of Suh's works: *Who Am We?* (2000), *Some/One* (2003), *High School Uni-form* (1997), *Home within Home* (2009–2011), *Doormat: Welcome Back* (2003) and *Reflection* (2004). Indeed, Suh's works tend to explore the formation of identity at both the individual and social levels.

Suh's diverse body of biographical narratives includes a series of 'fabric architectures' that map and recreate his living spaces out of translucent fabrics. In *Staircase IV* (2004) he recreated the staircase from his former New York apartment on a 1:1 scale. The transparency of the installation's fabric emphasizes a sense of the infinity of space and time, and the fragility of memory.

Cause and Effect (2007) exemplifies the intricate nature of Suh's installations. *Cause and Effect* features thousand of plastic men piggybacking atop one another to create a giant vortex. The perception of this sculpture alters radically depending on the viewer's distance and suggests that the individual and the group and are always intertwined. Similarly, *Some/One* (2001) is made out of thousands of military dog tags, and amalgamates faceless soldiers into one large figure. *Some/One* has a hollow center filled with mirrors, which are meant to integrate the spectator's form and image. Like all Korean males, Suh had to serve in the Korean military where he was a sharpshooter. However, Suh explains that *Some/One* is open to interpretation and not meant to target any specific culture.

OPPOSITE **Staircase**
Polyester fabric, metal armature. Dimensions variable. Installation for Psycho Buildings: Artists take on Architecture (Hayward Gallery, London, May 28 – August 25, 2008), 2008.

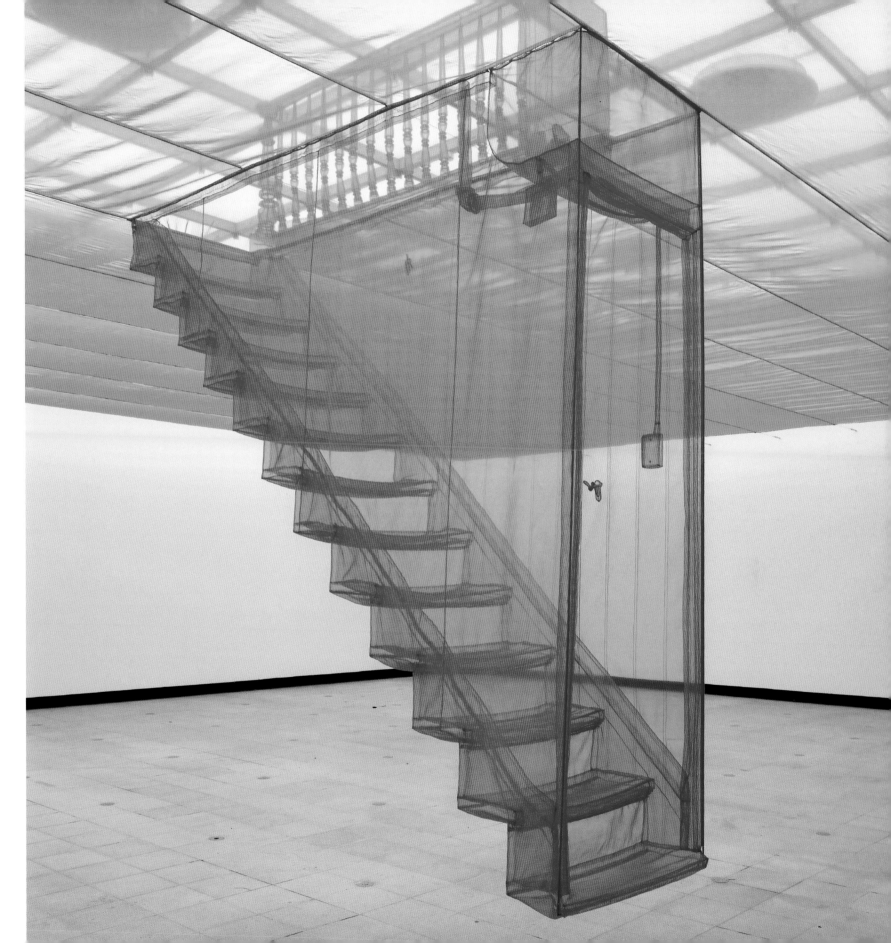

Cause & Effect
Acrylic and stainless steel and aluminum frame 941 x 1089 x 340cm

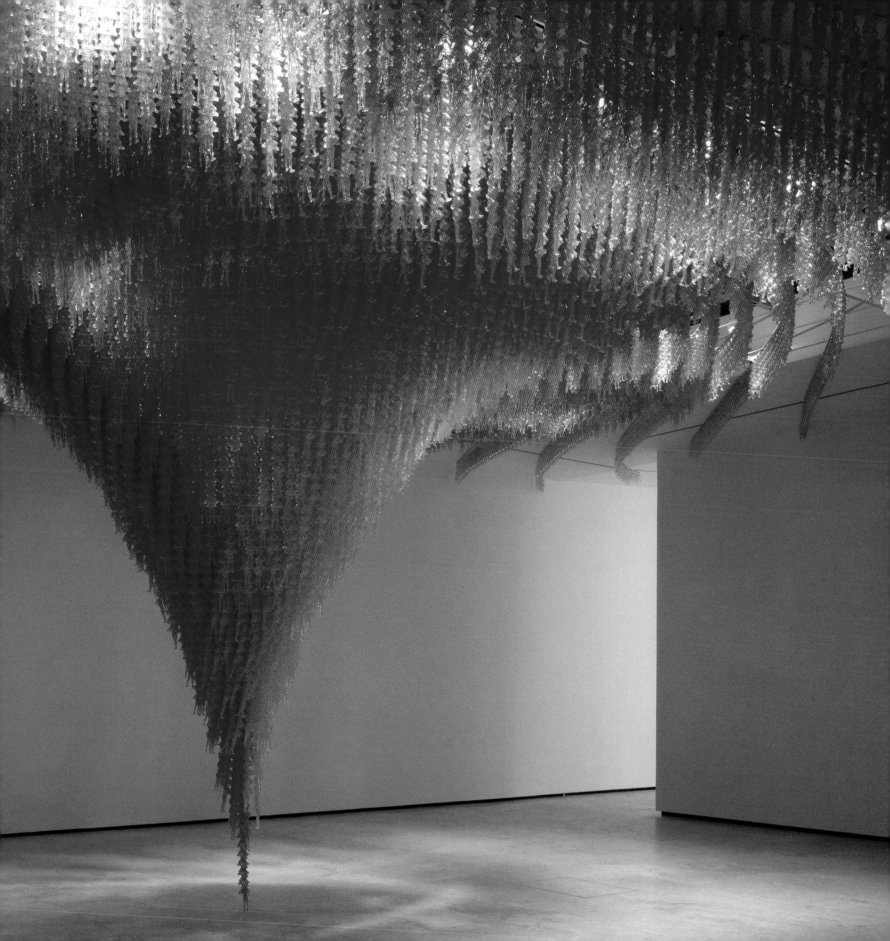

Benedetta Tagliabue

www.mirallestagliabue.com

Born 1963 in Milan, Italy
Architecture at Istituto Universitario di Architettura
di Venezia, Italy, 1989
Lives and works in Barcelona, Spain.

BENEDETTA TAGLIABUE is an architect and artist. She is the director of the Miralles-Tagliabue studio (EMBT) which creates innovative designs in a variety of media such as landscapes, building restorations and public installations. EMBT's projects include the Italian Pavilion at the Venice Biennale, a Camper shop in Seville, and the Vicky Sharpa Primary School in Nepal.

Tagliabue's EMBT designed and built the Spanish Pavilion at the 2010 Shanghai World Expo. The pavilion was constructed out of wicker and employed Chinese artisans in the production, attempting to highlight the link between east and west. The resulting installation is a stunning synthesis of form and function. The metallic grid provides a frame for the wicker, and has a cellular and membrane-like appearance - giving the structure a life of its own.

Tagliabue's aesthetics tend to employ curved forms and an organic and tactile feel. She became well-known following the critical success of the Scottish Parliament building, which won the 2005 RIBA Stirling Prize. The celebrated restoration/transformation of the Santa Caterina Market in Barcelona infused a fresh breath of life into its impoverished neighborhood and integrated a mosaic rooftop with the building's original 19th century structure. The Gas Natural Office Building in Barcelona also received critical acclaim and was a finalist in the WAF World Architecture Festival.

ABOVE AND OVERLEAF **Spanish Pavilion at Shanghai World Expo 2010**

OPPOSITE **Gas Natural Company Building, Barcelona, Spain, 2008**

Gas Natural Company Building, Barcelona, Spain, 2008

Patrick Tresset

www.patricktresset.com

Born France
MSc, Art Computing, Goldsmiths, University of London, UK, 2006
PhD, Arts and Computational Technologies, Goldsmiths,
University of London, 2013 (exp)
Lives and works in London, UK.

PATRICK TRESSET's unique art fuses robotics technology, mysticism and chaos. After moving to London over two decades ago, painting a tarot deck and developing his career as an artist, Tresset decided to pursue an academic career in robotics and computational art research at Goldsmiths' Department of Computing. Throughout his innovative work, he has been programming and constructing a series of drawing machines. The idea being that by teaching a machine to draw for him, Tresset would no longer need to draw himself.

By attempting to simulate the creative process that humans have developed during the 30,000 or more years we have been drawing, Tresset's robots shed light on the diverse features of human creativity. Understanding the process that the artist undergoes while sketching a portrait is an extremely complex and interdisciplinary process, which incorporates fields ranging through computational aesthetics, cognitive science, art history and the psychology of perception. Tresset refers to his playful Frankenstein creations as "post-human entities to imagine our reality."

Aikon, exhibited in London in 2011, enabled any gallery visitor to have his or her portrait drawn by the resident robot, Paul. Meanwhile, another robot in the gallery, referred to as Peter, would pass the time by scribbling random patterns on a whiteboard, erasing the message and re-scribbling. Peter's robotic hands would often collide with each other, giving them a human-like fallible quality. Tresset's clumsy robotics are also incorporated into the portraits drawn by *Aikon* [Paul], which features elements of unpredictability. It would appear that the ghost in the machine is very much alive and well.

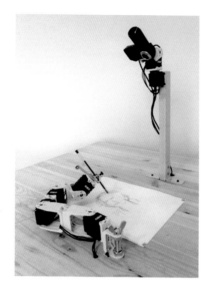

Image of *Aikon* in action, 2011

Patrick Tresset is currently a PhD researcher at Goldsmiths. After an interruption of almost seven years in his artistic practice, he has found his medium of expression by diverting the on-going academic research he conducts in collaboration with Professor Frederic Fol Leymarie from the Department of Computing. Their *Aikon-II* project investigates the sketching activity through computational modeling and robotics. *Aikon* has received notable media attention including from the BBC, *Wired*, *Blueprint*, *New Scientist*, and *El-Mundo*. YouTube features a selection of videos of *Aikon* as it sketches portrait of gallery visitors.

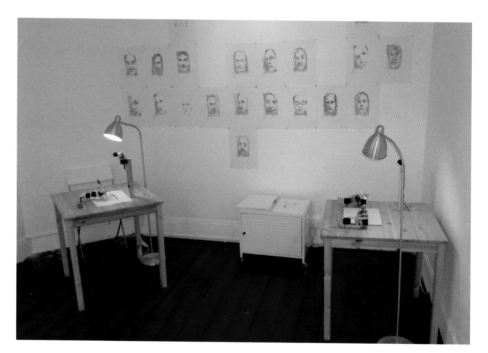

Portraits of *Aikon*'s drawings at Tenderpixel, 2011

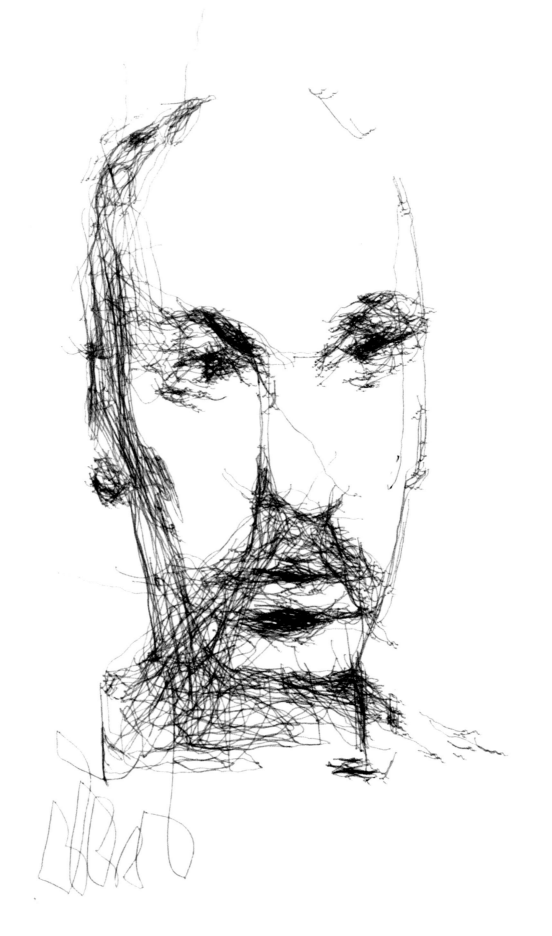

Tatiana Trouvé

Born 1968 in Cosenza, Italy
Lives and works in Paris, France.

"Memory is not at all precise. It's chaotic and as such very lively. The process of reminiscence or recollection allows us to change things and create new ones, new projects. I did a very simple experiment that anybody can do and which consists of memorizing someone's face a first time, a second time, and then a third time. If each time you have to draw the face, you obtain very different portraits. Memory works with clues that enable us to reconstruct things. Those clues are taken from present reality. They are more or less exaggerated and distorted. They bring what's absent towards the present and modify it as a result [...] I'd like to do sculptures of echoes, falling, emptiness, depressurization, magnetism..." Tatiana Trouvé, *Intermondes – Interworlds* interview with Elie During

TATIANA TROUVÉ is a contemporary artist who is best known for her installations and drawings. She participated in the 2007 Venice Biennale and has exhibited her work internationally. Trouvé's accolades including winning the Marcel Duchamp Prize in 2007, and the Paul Ricard Prize in 2001. Monographs on her work have been accompanied by texts from leading critics and theorists such as Hans Ulrich Obrist, Heike Munder, and Dieter Roelstraete.

After discovering how difficult it was to exhibit work as a relatively unknown artist, Trouvé began creating a fictional office to store her ideas and projects, which transformed into her ongoing *Bureau d'Activités Implicites* (BAI) project, and featuring a variety of architectural and conceptual 'modules'. In her *Administrative Module*, Trouvé began cataloguing all of the rejection letters that she received and rearranged them into an office cubicle along with office supplies and random certificates, slips and vouchers. Her *Reminiscence Module* includes cylindrical mirrors that archive various paper notes relating to her own memories; *Waiting Modules* consists of a vinyl seat and Perspex desk where a visitor can listen to Trouvé's sound recordings while waiting. Overall, BAI forms a "fictional autobiography" that documents the evolution of Trouvé's dreams and aspirations.

Trouvé draws inspiration from multi-dimensional thinkers such as Borges, Boetti, Wittgenstein and Perec. She often "freezes" time by producing surreal copper sculptures that defy Newtonian mechanics. Referring to her installations as "petrified narratives", Trouvé emphasizes the fluid nature of perception and memory.

OPPOSITE ***350 Points Towards Infinity*, 2009**
Installation view, Migros Museum, Zurich

214

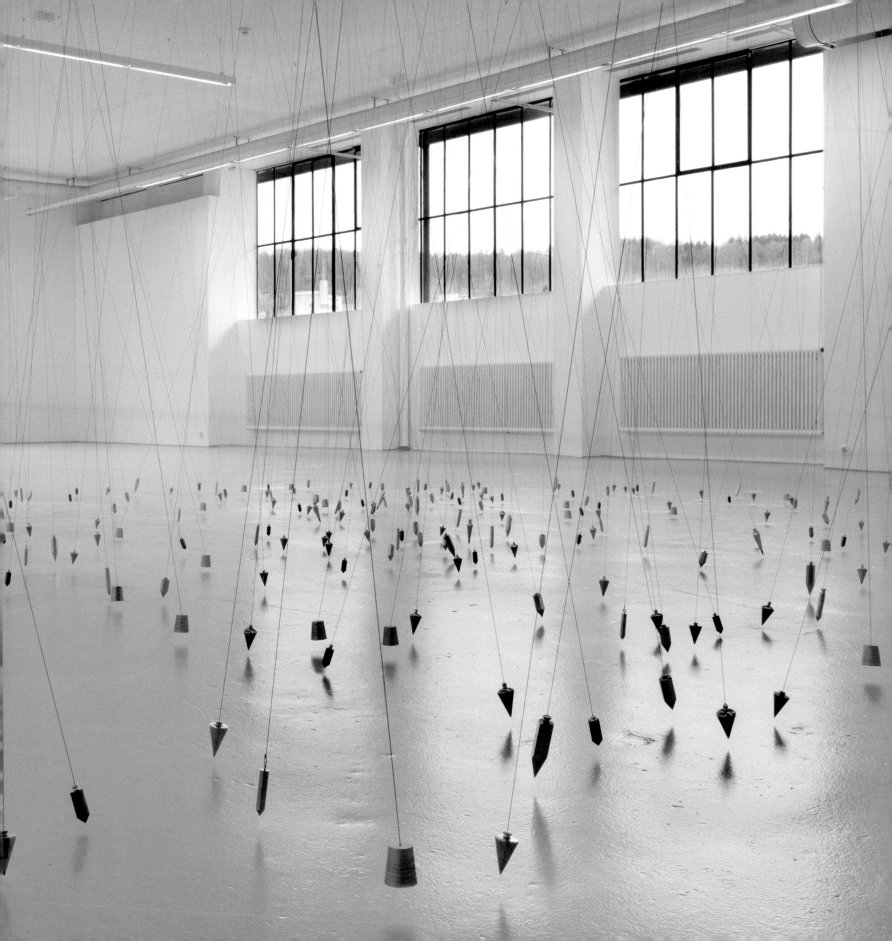

Envelopements, 2009
Installation view, Migros Museum, Zurich

Hannah Westwood

www.hannahwestwood.tumblr.com

Born 1983 in the United Kingdom
BA in Contemporary Textile Practices from Norwich School
of Art and Design, 2005
MFA in Fine Art Textiles from Goldsmiths, University of London, 2007
Lives and works in London.

HANNAH WESTWOOD'S work employs ordinary tools within extraordinary situations. For several years, she has been creating site-specific drawings using plain pencils. Her surrealist murals are the result of months of work and dozens of pencils. Although graphite pencils create marks that can be smudged away, the murals remain extremely durable and their transformation/decay compose a vital element of the evanescent nature of Westwood's practice.

For *Transient Territory*, Westwood occupied Tenderpixel gallery for three weeks, drawing for twelve hours a day with graphite pencils and the occasional use of chalk. The resulting mural resonated with - and was inspired by - the Victorian space of the gallery, and visually reinforced the structure of the Tenderpixel gallery with a range of arches and columns composed of highly detailed drawings. Ultimately, *Transient Territory* superimposed a temporary second skin onto the gallery's walls; cyborg-like images of technological icons juxtaposed with human genitalia, creating a seductive and yet disturbing ambiance. The sexually charged and manga-esque work utilizes transient materials such as graphite and chalk and highlights the impermanence of the perversity being played out, in a kind of artistic suicide.

Westwood's *Eye of the Storm* mural alludes to the increasingly complex character and pace of contemporary society and secular time. Particularly, the ever-changing facades of our physical and virtual

landscapes, and the types of fleeting interaction forged within. From the cataclysmic explosion at the center of the drawing where energy and guts convulse and splurge to the constant push and pull, the viewer sees a soft flow, but also a violent battle between forms, structures, matter and flesh. The outcome is abstract battlefields, apocalyptic scenes and dystopian visions of a space in chaos.

Eye of the Storm, Tenderpixel Gallery, 2011

Lines of Grey (2008)
Graphite onto Wall, E-raum, Cologne, Germany

Overhaul, 2007
Graphite onto the wall, Laurie Grove Slipper Baths,
New Cross, London

Richard Wilson

www.richardwilsonsculptor.com

Born 1953 in London, UK
Hornsey College of Art, London, UK, 1974
MFA, Reading University, Berkshire, UK, 1976.

"It's about turning things over, turning rules and regulations on their head, and if you take a building, it's all about rules and regulations. I'm breaking those rules." Richard Wilson, *Artist of the Week* by Jessica Lack, *The Guardian* (August 6, 2008)

BOTH AN ARTIST and a musician, Richard Wilson is best known for his sculptures and installations. Wilson has been nominated twice for the Turner Prize (in 1988 and 1998), and in 2006 he was elected as a member of the Royal Academy. His works are held in several major public collections including the British Museum, Ulster Museum in Belfast, the Museet for Samtidskunst in Oslo, and the Centre of Contemporary Art in Warsaw. Wilson has represented Britain in numerous festivals including the Venice Biennale, the Sao Paulo Biennial, and the Yokohama Triennial.

Wilson's projects often explore the perceptions of architectural spaces. In *Elbow Room* (1992), he replicates a Scandinavian chalet but then substitutes the interior of the exhibition space for part of the chalet at such an angle that the viewer's perception is significantly altered. One of Wilson's best known pieces is *20:50* (1987) and consists of a room that was half filled with 200 gallons of used sump oil, generating the illusion of an inverted room; *20:50* is now a permanent installation in the Saatchi Collection. *A Slice of Reality* (2000) was commissioned as a pubic sculpture that coincided with the opening of the Millennium Dome, and featured a cross-section of an exposed sand dredger lying on the bank of the nearby Greenwich Peninsula. *18 Holes* (2008) was commissioned for the Folkestone Triennial and appropriated the remains of a neglected crazy golf course into three beach huts composed of eighteen slabs of concrete (one from each hole).

18 Holes, Folkstone Triennial, Folkstone, 2008

OPPOSITE *Elbow Room*, Museet for Samtidskunst, Oslo, 1992

222

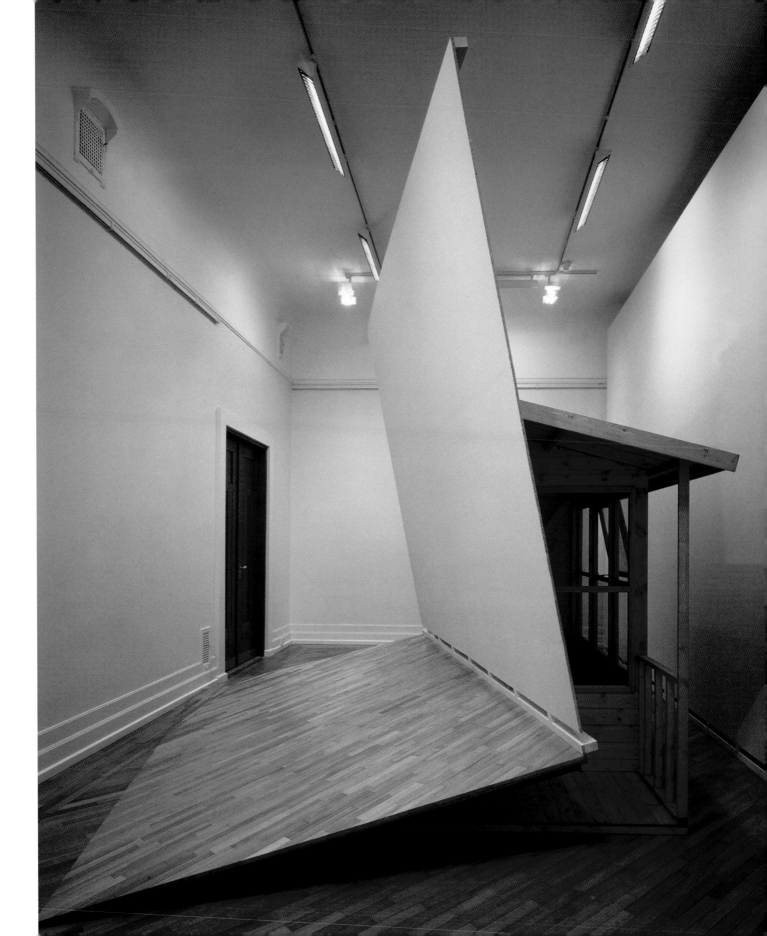

Jeremy Wood

www.jeremywood.net

Born 1976 in San Francisco, California
BFA, University of Derby, UK, 1999
MFA, Central St. Martins, London, UK, 2005
Lives and works in both the UK.

JEREMY WOOD is a cutting-edge artist. His work often appropriates technology in unexpected manners. His innovative use of Global Satellite Positioning has led to an ongoing series of GPS-drawings. For over a decade, Wood has been carrying a GPS receiver and recording all of his physical whereabouts; using his body as a geodesic pencil, he has created drawings of varying scales ranging from a giant pentagram drawn by flying across Europe, to spelling out literary quotes while walking his dogs in a park.

My Ghost illustrates Wood's movements throughout London over several years. Since he is constrained by physical objects such as buildings and rivers, *My Ghost* generates an alternative mapping of central London's infrastructure. In the middle left section, one can view a legend of the map, which provides a drawn scale of one mile, created by Wood walking back and forth, and spelling out "1 Mile". In the bottom right corner of the piece, Wood has quoted Moby Dick: "It is not down in any map, true places never are."

By always carrying his GPS receiver, Wood enables the emergence of unexpected and spontaneous patterns. Meanwhile, his work synthesizes time and space, and generates a continuous discourse between the physical and virtual. Wood's *Lawn Mower* series illustrates the oscillating frequencies with which he mows his own lawn throughout the seasons. He has also created a series of sculptural 'data glitches'. *Data Cloud* was inspired by the imprecision of GPS data, and how this technology often misinterprets the physical world. The benches that Wood constructed are based on the GPS data that was registered from two benches, and their imprecise and cloud-like positional uncertainty.

Wood has received praise from several sources, ranging from *The New York Times* and *Wired Magazine* to cutting-edge academic theory, including a November 2009 feature in the peer-reviewed *Cartographic Journal*. His work is exhibited internationally and is in the permanent collections of the University of the Arts, the London Transport Museum, and the Victoria and Albert Museum in London.

OPPOSITE *My Ghost*, London GPS Map 2009

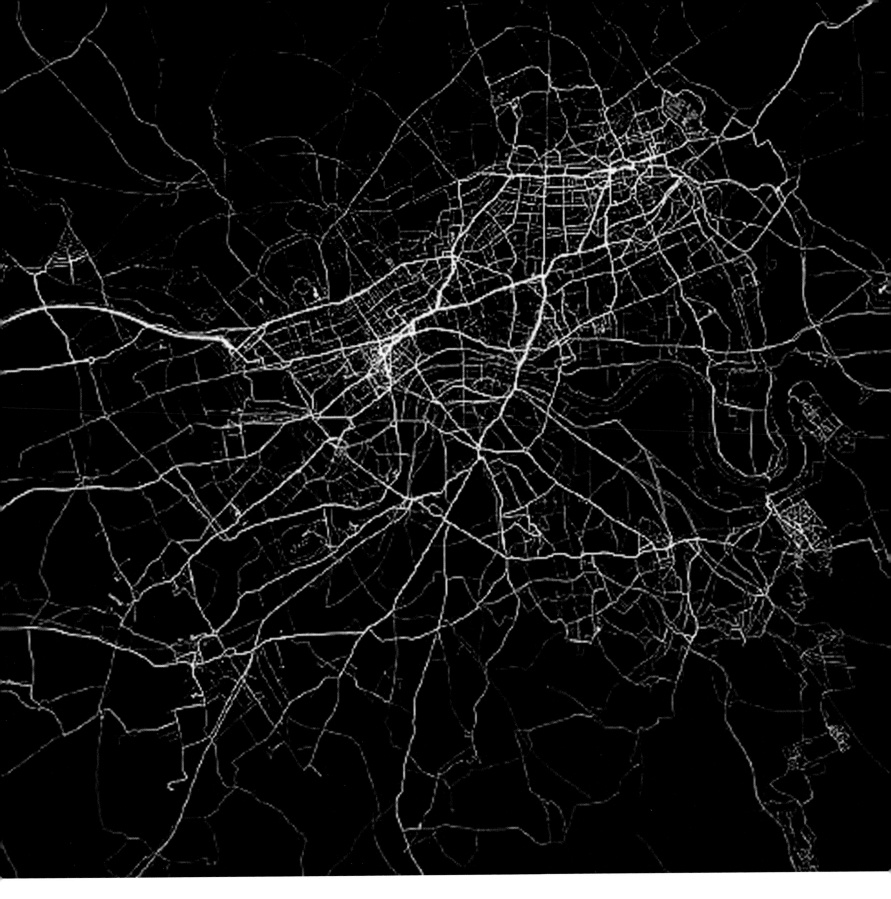

Data Cloud, Beatrixpark, Amsterdam, 2008

John Wynne

www.sensitivebrigade.com

Born 1957 in Zweibrücken, Germany
PhD in Sound Art from Goldsmiths,
University of London, 2007
Lives and works in London.

JOHN WYNNE is an artist and Reader in Sound Arts at University of the Arts London. His site-specific installation of 300 speakers, player piano and vacuum cleaner at Beaconsfield Gallery in London explored the gallery's architectural acoustic potential. As a sculptural and sonic assemblage, this piece was inspired by acoustic resonances and the colors of the space. The speakers were found on the streets and in recycling centers in Berlin and London. The pianola automatically plays *Gipsy Love* from Franz Lehar's operetta at a reduced tempo. Meanwhile, the speakers complement the pianola with a 32-channel composition consisting of sounds from the piano and sounds synthesized by the artist in situ.

During an artist residency at Harefield Hospital, Wynne collaborated with Tim Wainwright on Transplant as they recorded and interviewed patients who were awaiting or recovering from cardio-thoracic transplants. Many of the sitters awaiting a donor were reliant on life-support apparatus. Their monologues are interwoven with the sounds of the ward. The project resulted in a 24-channel installation, a piece for BBC radio, a book and DVD.

Wynne has also worked on several projects themed around endangered languages. *Anspayaxw* is a 12-channel installation based on his work with photographer Denise Hawrysio and linguist Tyler Peterson recording native Gitxsanimaax speakers in and around Kispiox reserve in British Columbia. The 12 sound channels juxtapose sounds from the reserve, such as passing vehicles and pedestrians walking through snow, with the intimate stories of the locals and large-scale photographs. *Ansapayxw* both encourages and illustrates the interplay of art and anthropology.

In addition to Wynne's socially engaged pieces, he has also created a diverse range of other works. *Hearing Loss* is an installation using his late father's hearing aids and a photograph taken by his father when the family crossed the Atlantic by ship to Canada. *Hearing Loss's* sound fields are created by the feedback from the hearing aids, placed in close proximity to each other, in a semi-enclosed space. *Hearing Loss* addresses the absence of the person whose ears the devices were made to fit.

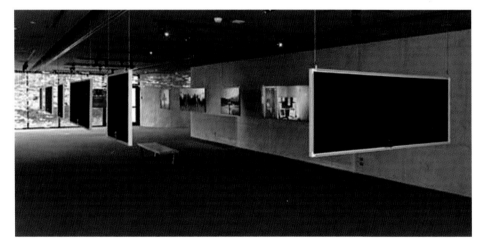

Anspayaxw, **12 channel installation**

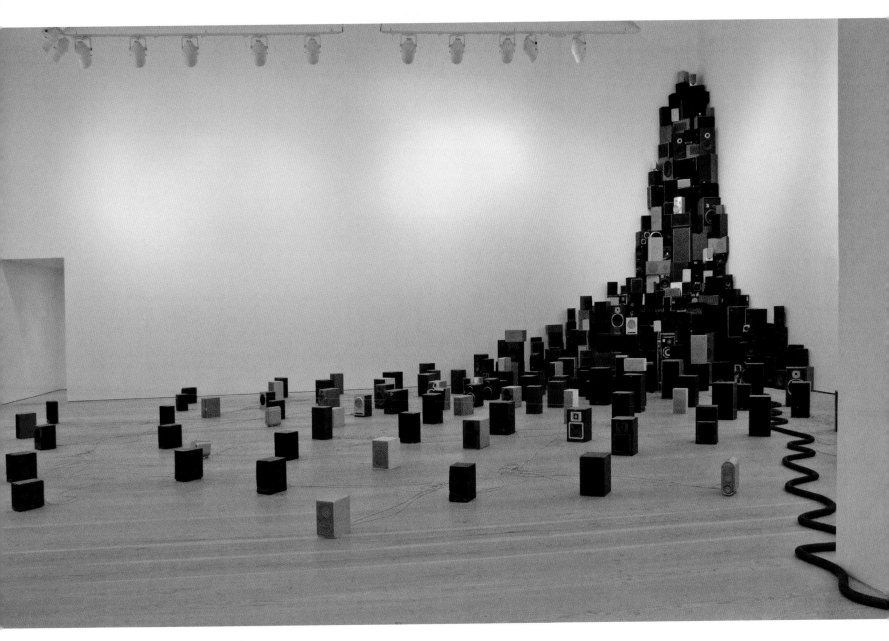

300 Speakers, Pianola and Vacuum Cleaner, Saatchi Gallery, 2010

Yarisal & Kublitz

www.yarisalkublitz.com

Ronnie Yarisal
Born 1981 in Geneva, Switzerland
Central St. Martins, London, UK, 2004
Chelsea College of Art, London, UK, 2001.

Katja Kublitz
Born 1978 in Copenhagen, Denmark
Central St. Martins, London, UK, 2004
Gerrit Ritveld Academy of Arts, London, UK, 2001.

Both Katja and Ronnie live and work in New York and Berlin.

"Things that seem useless can be made intriguing through time, by forcing people to wait for an outcome. Why are we compelled to see something we know will happen? Why are we compelled to see something break? These are some of the things we are interested in." Katja Kublitz, *Art Review* (Issue 32, May 2009)

YARISAL AND KUBLITZ are video and installation artists. They won the Diesel New Art Sculpture Prize in 2005 and have exhibited in venues including the Charlottenborg Museum of Art in Denmark, H10 Gallery in Chile, and Exit Art in New York City. Their installations often employ a surreal and comic approach. For example, *Lemon Incest* is a kinetic sculpture of theirs that was made out of a simple - albeit unusual - array of materials: a pierced paint can, yellow paint, a balloon, concrete, a needle and a rope. *Lemon Incest* transitions from tension towards release and mischievously suggests that destruction is an inevitable part of creation.

Yarisal and Kublitz's *Anger Release Machine* enables gallery visitors to do more than just interact with the installation – they can literally select which item of crockery to destroy. Like Jenny Pickett's and Sunshine Frère's *If I Can't Have You, No One Can* (see Frère and Pickett), *Anger Release Machine* places a value proposition upon the destruction of an object and suggests a radical – and yet playful – alternative to consumer capitalism. The mechanized and standardized usage of a vending machine for *Anger Release Machine* suggests that destruction itself is a commodity.

***Anger Release Machine**, 2006–08*
Vending machine, porcelain, crystal, plates, various items
100 x 90 x 190 cm, edition of 3 + 1AP

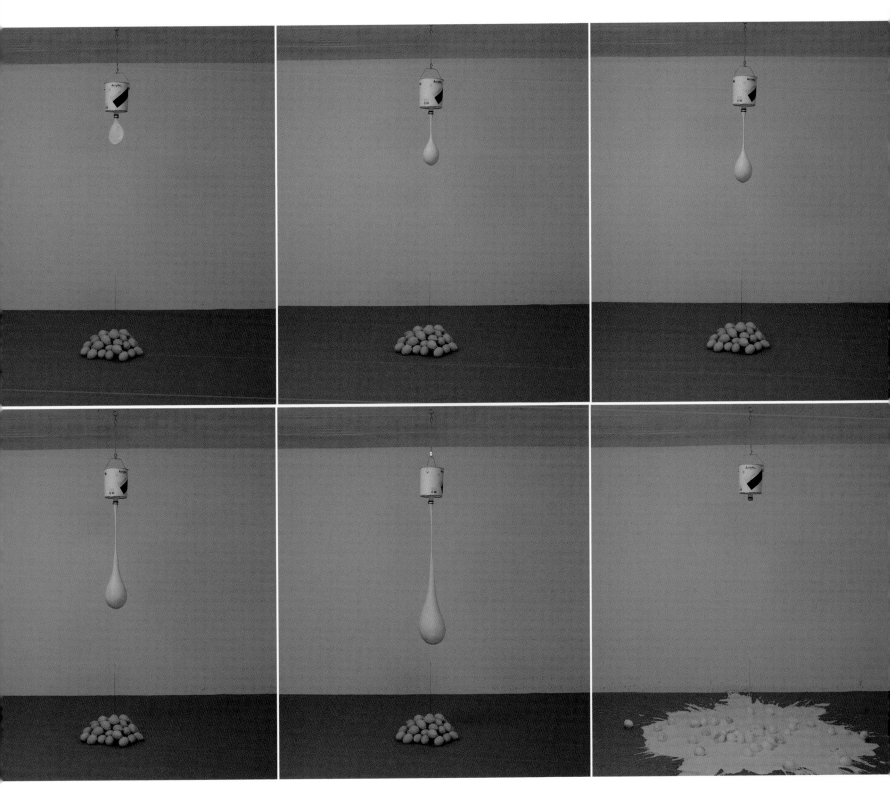

Lemon Incest, 2009
Pierced paint can, yellow paint, balloon, concrete, needle, rope,
dimensions variable, unique

Rona Yefman

Born 1972 in Israel
BFA in Photography & Video, Bezalel Academy, Jerusalem,
Israel, 1999
MFA Columbia University School of the Arts, New York City, 2009
Post Graduate program, Bezalel Academy, Tel-Aviv, Israel, 2003
Lives and works in New York City.

RONA YEFMAN is a contemporary visual artist whose practice questions social norms, from sexual constructs to political ideologies. Yefman's work has been exhibited internationally, and featured and reviewed in publications such as *Artforum*, *The New York Times* and *Frieze Magazine*.

Yefman's work often embodies processes of identity construction and sexual transformation. While her aesthetics combine absurdity and abstraction, they tend to maintain a realist documentary style that explores the human condition. Yefman's practice was originally inspired by her younger brother Gil. Yefman documented Gil's and her own adolescence as they invented multiple identities and constructed imaginative worlds. In this body of work, Yefman and her brother form a symbiotic collaboration that explores and challenges gender roles, social constructs and normative desires.

In her *Martha Bouke* series, Yefman has created photo and video portraits of Martha, a female persona enacted by a holocaust survivor who lives in Tel Aviv. Martha is both an elderly grandfather and an ageless feminine diva-defying stereotypical categorization. She wears a blond wig and an expressionless Venetian mask that has been colored to match her skin tone. Martha embodies an ambiguous and provocative set of identities that highlight the fluidity and performativity of gender.

In this series, Rona Yefman collaborated with Tanja Schlander to appropriate the Swedish children's heroine, Pippi Longstocking, into a contemporary artist and activist. Their grown up version of Pippi portrays an anarchistic champion who is ready to tackle the injustices of the world. In the video *Pippi L. at Abu Dis* (2008), Pippi attempts to dislodge the concrete wall that divides Israel from the West Bank. Even though Pippi is the "strongest girl in the world", her attempts prove futile, but Herculean spirit inspires a re-imagining of alternative and peaceful futures.

OPPOSITE *Garden of Eden*, (from the series *My brother and I* 1996–2008)

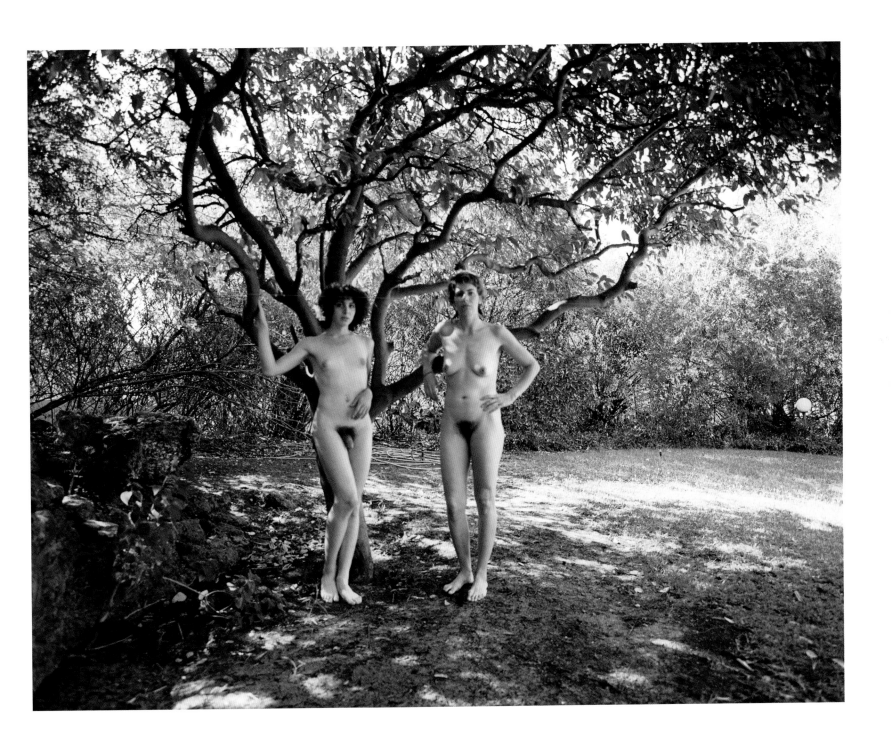

Pippi L. The strongest girl in the world,
Installation View, Art Focus #5, Jerusalem, 2008

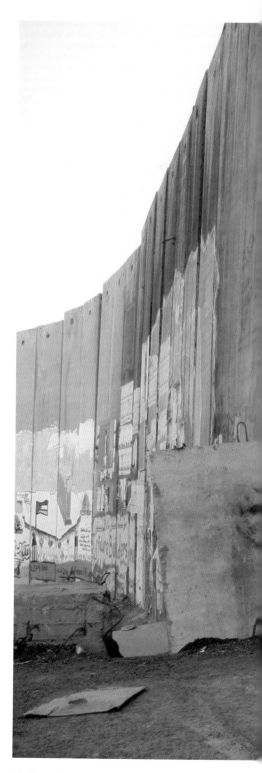

Pippi L. at Abu Dis, 2006

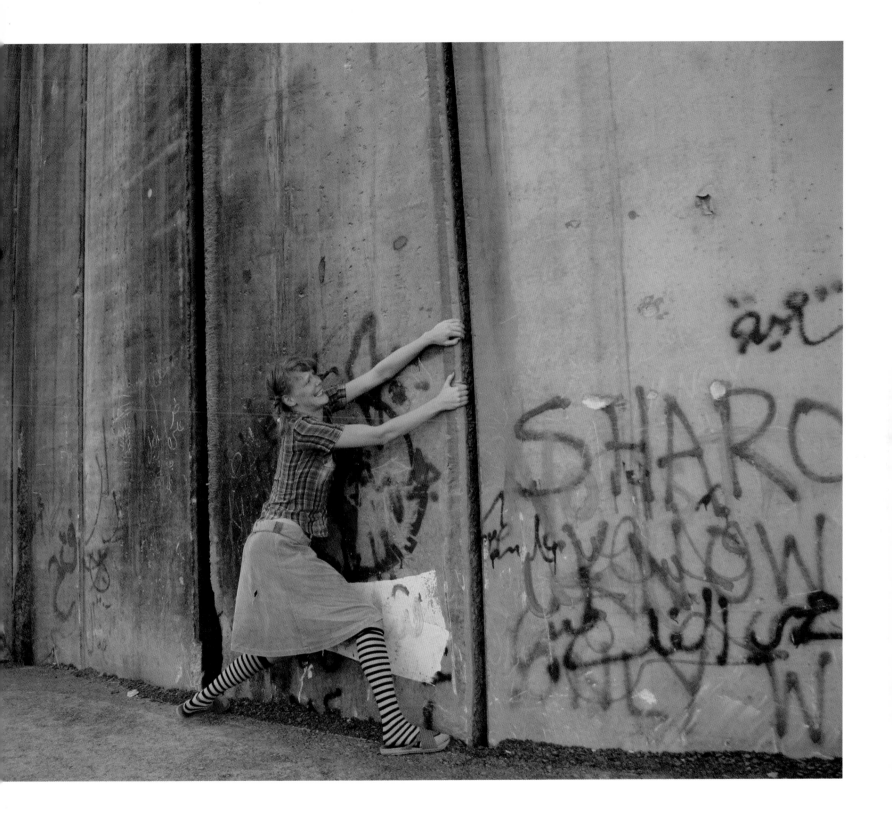

Picture credits

p.12 Photo, Jonathan Muzikar (IN2112.132)/ ©2012. Digital image, The Museum of Modern Art, New York/Scala, Florence/ ©Marina Abramović/ courtesy Marina Abramović Archives and Sean Kelly Gallery, New York. DACS 2012; p.13 ©Marina Abramović/ courtesy Marina Abramović Archives and Sean Kelly Gallery, New York. DACS 2012; p.14 ©Nelly Agassi/Yanai Tolster/courtesy the artist and Dvir Gallery, Tel Aviv; p.15 ©Nelly Agassi/Avraham Hay/courtesy the artist and Dvir Gallery, Tel Aviv; p.16 ©Ai Weiwei/courtesy TonyV3112/Shutterstock.com; 17©Ai Weiwei/ Icenando|Dreamstime.com; p.18 ©Azra Aksamija/courtesy Gallery for Contemporary Art, Leipzig; p.19 ©Azra Aksamija; p.20–21 ©Anonymous; p.23–25 ©Richard Ansett; p26–27 ©Lisa Anne Auerbach; p.28–30 ©Eric Ayotte; p.30 (top) ©Banksy/BMCL/ Shutterstock.com/ (bottom) ©Banksy/Rex Features; p.33 ©Banksy/Film Magic/Getty Images; p.34–35 ©Banksy/Jim Dyson/Getty Images; p. 37 ©Matthew Barney/courtesy Gladstone Gallery, New York and Brussels; p38 ©Matthew Barney/photo Kunsthaus Bregenz/courtesy Gladstone Gallery, New York and Brussels; p.40 ©Aram Bartholl; p.40/41 ©Aram Bartholl/photo Anne Foures; p.42 ©FilmFour/Zentropa Entertainments; p.41 ©Don Arnold/WireImage/Getty Images; p.44–45 Céleste Boursier-Mougenot/ © ADAGP, Paris and DACS, London 2012; p.46 ©Candice Breitz/courtesy the artist; p.48–49 ©Christophe Bruno; p.50–51 ©Roisin Byrne; p.52–53 ©Peter Callesen/ courtesy the artist/photos Anders Sune Berg; p.54–55 © Asger Carlsen/courtesy of the artist; p.56–57 ©Aristarkh Chernyshev; p.58–61 ©Dan Collier; p.62–63 ©Vuk Ćosić; p.64–65 ©e-flux/photo Mila Zacharias; p.66 ©Olafur Eliasson/photo Studio Olafur Eliasson/ the artist/Tanya Bonakdar Gallery, New York/neugerriemschneider, Berlin; p.67 ©Olafur Eliasson/photo Ian Reeves/Collection of the Art Supporting Foundation to the San Francisco Museum of Modern Art; p68–69 ©Olafur Eliasson/ courtesy the artist/Tanya Bonakdar Gallery, New York/neugerriemschneider, Berlin; p.70 ©Shepard Fairey/courtesy the artist/Obeygiant.com; p.72–73 ©Sunshine Frère and Jenny Pickett; p.74–75 ©Alexandra Daisy Ginsberg; p. 76–77 ©Christian Giroux and Daniel Young; p.79 ©Antony Gormley/photo Stephen White, London; p.80– 81©Antony Gormley/photo Vincent Mentzel; p.82–85 ©Usman Haque; p.86–87 ©Damien Hirst and Science Ltd. All rights reserved, DACS 2012/photo Prudence Cuming Associates; p88 ©Carsten Höller/photo Attilio Maranzano/©DACS 2012; p88 Carsten Höller/photo VG Bild Kunst, Bonn/© DACS 2012; p.90–91 ©Jang-Oh Hong; p93–95 © Pierre Huyghe/ADAGP, Paris and DACS, London, 2012/courtesy the artist and Marian Goodman Gallery, New York/Paris; p.96–99 ©Ryoji Ikeda/courtesy the artist; p.100–103 ©INK Illustration; p.104–105 ©Invader; p.106–109 ©Natalie Jeremijenko; p.110–111 ©Michael Johansson/DACS, London, 2012; p.112 ©Miranda July/ photo Brian Paul Lamotte/courtesy the artist, Deitch Archive, NYC Parks & Recreation, and the Union Square Partnership;p.113 © Miranda July; p.114–115 ©Brian Jungen/courtesy Catriona Jeffries Gallery, Vancouver; p.117 ©Eduardo Kac; p.118 ©Eduardo Kac/photo Axel Heise; p.119 ©Eduardo Kac/Collection Gilberto Chateaubriand/Museu de Arte Moderna do Rio de Janeiro; p.121–123 ©Anish Kapoor;

p.124–127 ©Marina Kassianidou/photo Vassos Stylianou; p.128–131 ©Aaron Koblin; p.132–133 ©Alicja Kwade/photo Roman März/courtesy Johann König, Berlin; p.134–135 ©Namhee Kwon; p.136–137 ©Michael Leyton; p.138–139 ©Hrvoje Majer; p.140–141 ©David McCandless/www.informationisbeautiful.net; p.142–143 ©Steve McQueen and ©Steve McQueen/courtesy Thomas Dane Gallery, London and Marian Goodman Gallery, New York; p.144 ©Mike Mills; p.146 ©M/M (Paris)/courtesy M/M (Paris); p.147 ©M/M (Paris)/incorporating representations of: Jeff Koons' Moon (1994–2000), Chainlink (2002) and Wrecking Ball (2002) ©Jeff Koons, courtesy The Dakis Joannou Collection/ M/M (Paris) Figures posters, with Inez van Lamsweerde & Vinoodh Matadin (2005), presented in the sequence of the first 126 digits of the π number/ M/M (Paris), Moquette (Etienne Marcel) (2002), including an interpretation of 06:00PM by Pierre Huyghe & Philippe Parreno/original photograph taken by Gaël Amzalag during the Translation exhibition at Palais de Tokyo, summer 2005/ courtesy M/M (Paris); p.148–149 ©Takashi Murakami/Kaikai Kiki Co., Ltd/photo GION; p.150–151 ©Ivan Navarro; p.152–153 ©Roman Ondák; p154 ©Damián Ortega/courtesy the artist and kurimanzutto, Mexico City; p.155 p154 ©Damián Ortega/courtesy the artist and The Museum of Contemporary Art, Los Angeles, purchased with funds provided by Eugenio López and the Jumex Fund for Contemporary Latin America Art; p.156–157 p154 ©Damián Ortega/courtesy the artist and White Cube, London; p. 158 ©Miguel Palma/photo Paulo Costa; p.159 ©Miguel Palma/photo Peter Abrahams; p.160–161 ©Miguel Palma/photo Giorgio Bordino; p.162–163 ©Bona Park/photo Hitomi Yoda; p.164 ©Bona Park/photo Byung Hwan Baek; p.165 ©Bona Park/photo Hitomi Yoda; p.166–167 ©Cornelia Parker/courtesy of the artist and Frith Street Gallery, London; p.168 ©Katie Paterson/photo MJC©2009; p.169 ©Katie Paterson/ photo MJC©2011; p.170–173 ©Grayson Perry/courtesy the artist and Victoria Miro Gallery, London; p.174–175 ©Stefanie Posavec/courtesy the artist; p.176 ©Gerhard Richter 2012/courtesy Dombauarchiv, Cologne; p.177 © Gerhard Richter 2012; p.178–179 ©Mika Rottenberg/courtesy Nicole Klagsbrun Gallery; p.180 ©Michal Rovner/photo by Kerry Ryan McFate/courtesy The Pace Gallery ©ARS, NY and DACS, London 2012; p181 ©Michal Rovner/photo courtesy the artist and The Pace Gallery © ARS, NY and DACS, London 2012; p.182 ©Wu Shanzhuan/courtesy Thomas Füsser; p.183 ©Wu Shanzhuan/courtesy Long March Space; p.185–187 © Conrad Shawcross/ courtesy the artist and Victoria Miro Gallery, London; p.188–191 ©Lisa Slominski; p.192–193 ©Estela Sokol; p.194–195 ©Mounira Al Solh/courtesy Sfeir-Semler Gallery; p197 ©Sputniko!/photo Rai Royal; p198–199 ©Sputniko!/photo Hitomi Yoda; p200–201 ©Simon Starling/courtesy the artist; p.202–203 ©Simon Starling/photo Jens Ziehe; p.204–207 ©Do Ho Suh 2008/courtesy Do Ho Suh and Lehmann Maupin Gallery, New York; p.208/210 Miralles Tagliabue/courtesy Miralles Tagliabue/© DACS 2012; p.209 Benedetta Tagliabue/Matteocozzi|Dreamstime/© DACS 2012; p.212–213 ©Patrick Tresset; p.214–217 Tatiana Trouvé/photo Stefan Altenburger Photography, Zurich/© ADAGP, Paris and DACS 2012; p.218–221 ©Hannah Westwood; p.222–223 ©Richard Wilson; p.225–227 ©Jeremy Wood; p.228 ©John Wynne/photo Denise Hawrysio; p.229 ©John Wynne; p.230–231 ©Ronnie Yarisal and Katja Kublitz/courtesy the artists and Galerie Bertrand & Gruner; p.232–235 ©Rona Yefman

Acknowledgments

I am especially grateful to Lee Ripley for encouraging me to write this book.

To my sweetheart, Marianna Gorenstein, who patiently put up with me as I burnt the midnight oil each night. To Ray Watkins for her immaculate graphic design, which bring the ideas in the text to life. To everyone who worked with me at Tenderpixel including Sunshine Frere, Lisa Slominski, Liam Murtagh, Stella Sideli, LaToyah Gill, Mandeep Ahira, Jessica Farnham, and Diego Ivan Calderon Martinez, Jeremy Wood, and Jenny Pickett.

Last but not least, I would like to thank the many artists and curators who have shared their visions and inspired my love for contemporary art.

Index

Artists

Marina Abramović
Nelly Agassi
Ai Weiwei
Azra Aksamija
Anonymous
Richard Ansett
Lisa Anne Auerbach
Eric Ayotte
Banksy
Matthew Barney
Aram Bartholl
Björk
Céleste Boursier-Mougenot
Candice Breitz
Christophe Bruno
Roisin Byrne
Peter Callesen
Asger Carlsen
Aristarkh Chernyshev
Dan Collier
Vuk Ćosić
e-flux
 Anton Vidokle
 Julieta Aranda
 Brian Kuan Wood
Olafur Eliasson
Shepard Fairey
Sunshine Frère
Alexandra Daisy Ginsberg
Christian Giroux
Antony Gormley

Usman Haque
Damien Hirst
Carsten Höller
Jang-Oh Hong
Pierre Huyghe
Ryoji Ikeda
INK Illustration
 Rachel Gannon
 Chloé Regan
 Fumie Kamijo
Invader
Natalie Jeremijenko
Michael Johansson
Miranda July
Brian Jungen
Eduardo Kac
Anish Kapoor
Marina Kassianidou
Aaron Koblin
Katja Kublitz
Alicja Kwade
Namhee Kwon
Michael Leyton
Hrvoje Majer
David McCandless
Steve McQueen
Mike Mills
M/M (Paris)
 Mathias Augustyniak
 Michael Amzalag
Takashi Murakami

Ivan Navarro
Roman Ondák
Damián Ortega
Miguel Palma
Bona Park
Cornelia Parker
Katie Paterson
Grayson Perry
Jenny Pickett
Stefanie Posavec
Gerhard Richter
Mika Rottenberg
Michal Rovner
Wu Shanzhuan
Conrad Shawcross
Lisa Slominski
Estela Sokol
Mounira Al Solh
Sputniko!
Simon Starling
Do Ho Suh
Benedetta Tagliabue
Patrick Tresset
Tatiana Trouvé
Hannah Westwood
Richard Wilson
Jeremy Wood
John Wynne
Ronnie Yarisal
Rona Yefman
Daniel Young